WILDLIFE SPECTACLES

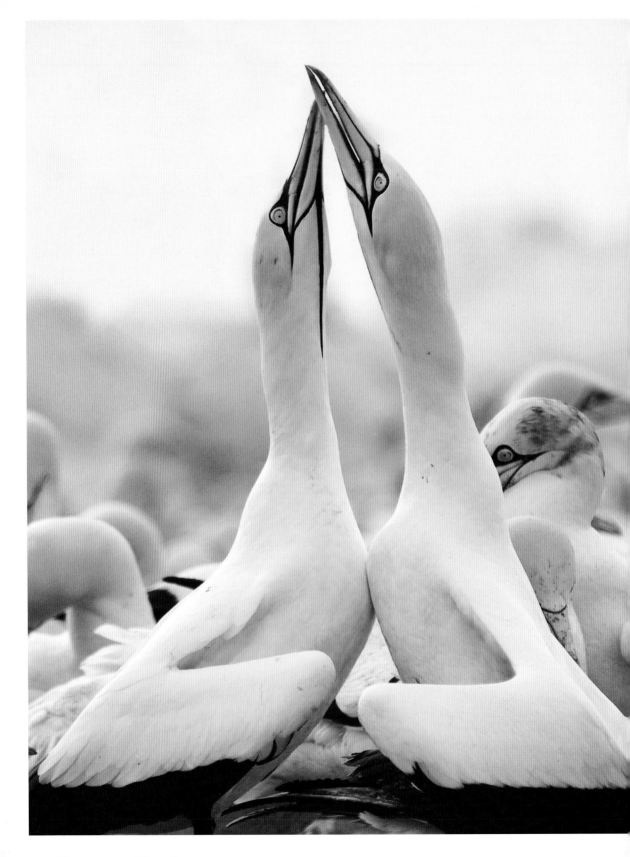

WILDLIFE

Mass Migrations, Mating Rituals, and

SPECTACLES

Other Fascinating Animal Behaviors

VLADIMIR DINETS

Timber Press · Portland, OR

Frontispiece: Northern gannets in a mating display.

The Haseltine Building
133 S.W. Second Avenue, Suite 450
Portland, Oregon 97204-3527
timberpress.com

Printed in China
Book design by Adrianna Sutton
Typesetting by Nina Montenegro

Library of Congress Cataloging-in-Publication Data

Names: Dinets, Vladimir.
Title: Wildlife spectacles: mass migrations, mating rituals, and other fascinating animal
 behaviors / Vladimir Dinets.
Description: Portland, OR: Timber Press, 2016. | Includes index.
Identifiers: LCCN 2016009573 | ISBN 9781604696714 (hardcover)
Subjects: LCSH: Animal behavior—North America. | Animal migration—North
 America. | Sexual behavior in animals—North America.
Classification: LCC QL751.D458 2016 | DDC 591.5—dc23 LC record available at
 https://lccn.loc.gov/2016009573

A catalog record for this book is also available from the British Library.

To Sofia.
Can't wait for you to grow up a bit
so I can show you all these wonders.

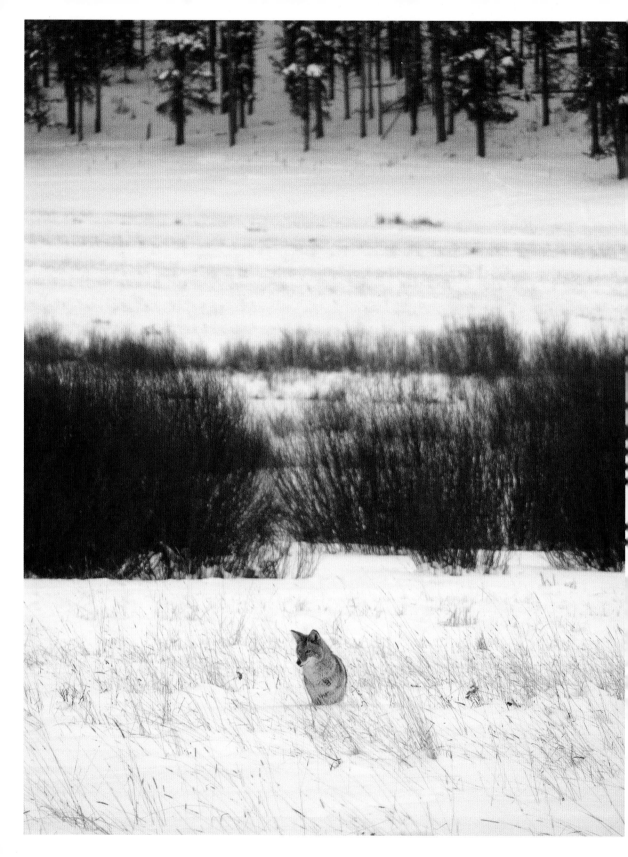

CONTENTS

INTRODUCTION

Wild animals are beautiful. You can enjoy watching them even when they don't do anything special. But they can also do amazing things: travel halfway around the globe, stage impressive light and sound shows, use all kinds of clever tricks, and perform unbelievable athletic feats. If you know what to look for and manage to be in the right place at the right time, you can have an experience you will not forget as long as you live.

Being a zoologist, I've spent much of my life finding and observing animals in their natural habitats, but I still can't get used to the scale and grandeur of wildlife spectacles—some of them happening at people's doorsteps, in urban parks, and on popular beaches (seeing others, of course, requires some wilderness travel). And although I've seen almost all the events described here, some many times, I'll never get tired of watching them.

Many people who live in North America don't realize or appreciate just how lucky they are to have so much wildlife around. Of course, North America has seen its share of horrible abuses of the environment, and there are still powerful political forces bent on sacrificing every last living thing to so-called business interests, which is a politically correct euphemism for greed. But thanks to decades of hard work by dedicated environmentalists, many parts of the continent have been beautifully preserved or restored, and wildlife here is more abundant and easy to see than almost anywhere in the world. You don't have to pay exorbitantly for an obligatory guided jeep ride, as in many African or Indian national parks; you can easily avoid the crowds that are almost inescapable in much of Europe and China; it doesn't take multiple days to reach natural habitats as it does in Indonesia, Madagascar, and much of

Latin America; you don't see silent forests where all wildlife has been hunted out as you would in Southeast Asia and Russia; and you don't encounter vast tracts destroyed by invasive species as in Australia and New Zealand.

Unfortunately, despite the popularity of national parks, nature documentaries, and cute baby animal photos on social networks, learning about many of the continent's natural living wonders can be surprisingly tricky. Some of the most amazing wildlife spectacles in the world, such as mass migrations, mating dances, and predator-prey interactions, occur in North America, but the information on them is often scattered and difficult to find, and many are virtually unknown to nonspecialists. I have yet to meet a person who is not a professional ichthyologist and knows about the annual spawning of giant sturgeon in downtown New London, Wisconsin, or someone who is not an ornithologist and knows of the stunning sunset flights of hundreds of thousands of wintering American robins near St. Petersburg, Florida. Nighttime dances of up to a hundred alligators can be easily seen from a popular boardwalk in Everglades National Park, but these dances remained unknown even to scientists until I accidentally discovered them in 2006. Most people have heard of the famous gatherings of monarch butterflies in Mexico, but few are aware that similar gatherings take place every winter in coastal California.

It is particularly difficult to understand the complex natural history of such events. Why do seabirds gather in immense flocks in particular places in the ocean year after year? Why do Pacific salmon die after spawning? What is the secret code used by fireflies blinking in their vast swarms over Appalachian meadows? How do spadefoot toads manage to breed in desert pools that dry up just two weeks after rain?

In this book I describe the most remarkable wildlife spectacles you can see in North America. I also cover some natural history to explain how they work and why they happen, and end each chapter with a few practicalities for those of my readers who would like to see them for themselves rather than just read about them.

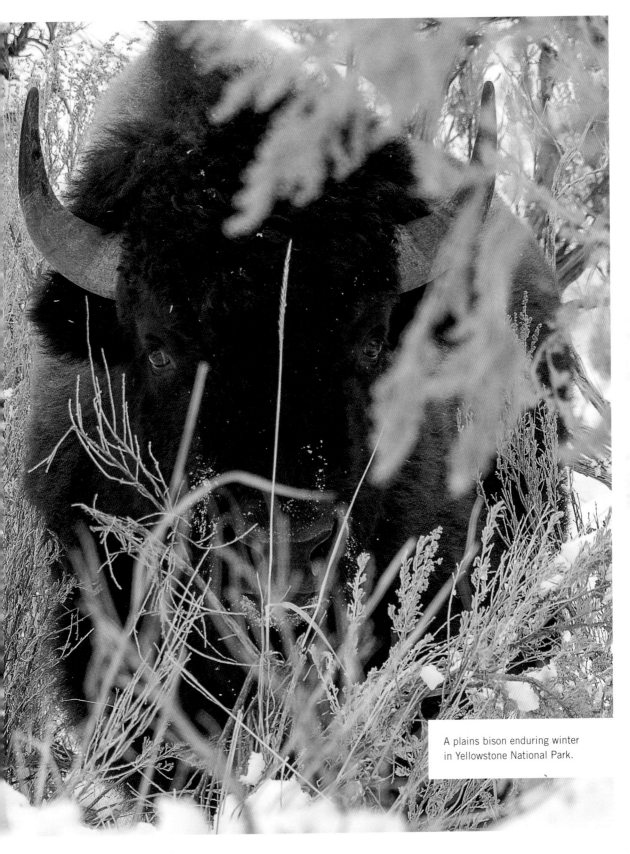

A plains bison enduring winter in Yellowstone National Park.

Whooping cranes migrating
to the Gulf Coast.

GREAT
MIGRATIONS

There was a time when the world was free of fences, highways, sprawling cities, pesticide-laden farms, shipping lanes, dams, and miles-long driftnets. Wild animals could migrate freely, and did so in numbers we can't imagine. The first European travelers to the New World reported bird flocks filling the entire sky for many weeks every year, hundreds of whale spouts visible in the sea in every direction, millions of bison moving across the plains, masses of salmon making rivers flow backwards. And that abundance of life was just a fraction of what the ancestors of the Native Americans must have encountered when they moved here from Siberia fifteen thousand years ago.

Today the migrations of wild animals are less spectacular, but can still be breathtaking. Witnessing them makes you forget the artificial world of climate-controlled buildings and paved streets that most of us live in, and for a short while experience the absolute freedom of our wild, dangerous, fascinating past—of the world filled with life that knew no bounds.

COLD CURRENT HIGHWAYS

Just a short boat ride from the skyscrapers and traffic jams of San Francisco and Boston, you can see the largest animals in the history of our planet, as well as multitudes of smaller creatures, all gathering in certain ocean locations that serve as "roadside restaurants" for marine travelers. To figure out why these feeding places exist where they do—and to understand pretty much everything else about the life of the sea—you have to look at ocean currents and the changes they bring.

Why Cold Currents?

The western and eastern coasts of North America couldn't be more different. If you travel to a beach in southern Alaska in winter, you will be surprised to see no snow on the ground; the water will be cold but not ice-cold. You would think that you could move only a few hundred miles south and the sea would be warm enough to swim in. But you would be in for a huge disappointment: even in summer, the Pacific Ocean is usually too cold for swimming (for most people, at least) until you get to Southern California, three thousand miles to the south. And even there it never gets really warm.

On the East Coast, you can swim in the ocean during the summer all the way up to Rhode Island—at the same latitude as southern Oregon. But once you round Cape Cod, you find yourself in really cold water, even colder than waters off southern Alaska.

The reasons for these variations are, of course, ocean currents. Their patterns off the Pacific and Atlantic sides of the continent are completely different.

In the Pacific, the powerful North Pacific Current from eastern Asia hits the coast of North America in British Columbia, and then

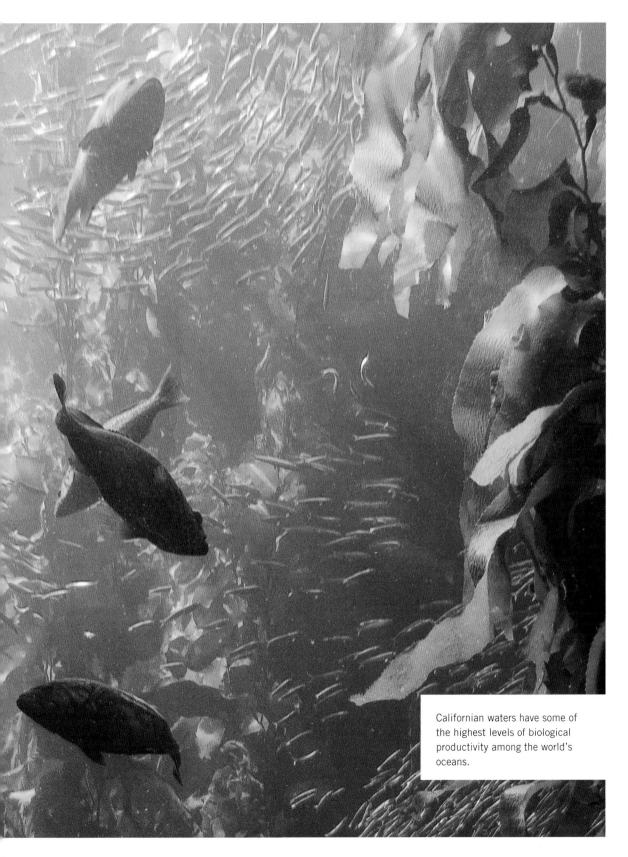

Californian waters have some of the highest levels of biological productivity among the world's oceans.

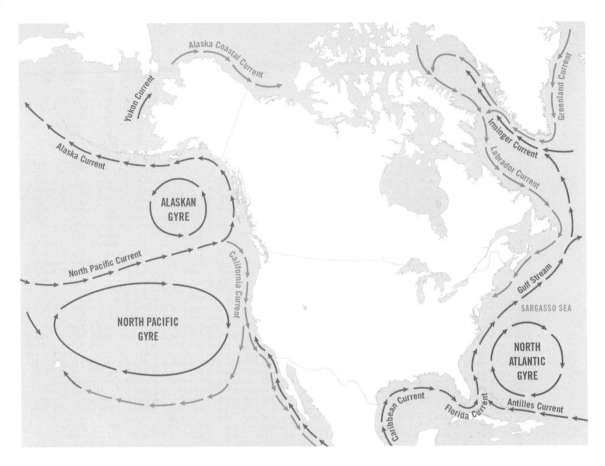

MAJOR OCEAN CURRENTS AROUND NORTH AMERICA

sends its waters north, to Alaska, and south, to California. Since
these waters come from the same current, they differ little in tem-
perature. But because the climates of the lands they reach are so
different, they are felt as cold in California, but as warm in Alaska.
When the cold current reaches California, it meets a small warm
current from Mexico called Inshore Current, which runs fairly
close to the coast. But that little stream is usually too weak to sig-
nificantly raise the water temperature or change the climate.

In the Atlantic, the shores enjoy the warm waters of the Gulf
Stream. That great current emerges from the Gulf of Mexico and
flows parallel to the coast until it reaches Cape Cod; usually a stream
of cold water from Canada wedges itself between the great cur-
rent and the coast, somewhat cooling the water for southern New

England. North of Cape Cod the ocean is dominated by the Labrador Current, which comes down from the Arctic and is intensely cold. In summer months, small side branches of the Gulf Stream can bring warm water to Nova Scotia, but only very briefly.

All these currents have a strong influence on the climate of the continent, but they have an even greater impact on the marine life. The cold seas of the western coast have much higher biological productivity than the warm seas of the eastern shore. That is why, if you travel along the shores of California or Oregon, you can see huge numbers of large marine animals: sea lions, seals, and whales, as well as crowded seabird colonies on almost every offshore rock. On the eastern coast you might occasionally spot a small group of dolphins or a few seagulls—and in winter, seals and whales that come down from the north to find warmer waters—but generally the marine life is much sparser.

Why do cold seas have higher biological productivity? In cold oceans, there is more mixing of the water between the surface and the bottom. Warm water is lighter than cold water, and floats on top of it. All nutrients in the surface layer of a warm ocean are quickly consumed by the plankton; then the plankton dies and sinks, taking the nutrients with it and leaving the surface barren. In a cold ocean, the water is about the same temperature from top to bottom, so there is more vertical mixing and it's much easier for the nutrients to return back to the surface. Every time a current hits an underwater mountain, or the wind from the shore blows away the surface layer, or two currents meet and create turbulence, the nutrient-rich waters from the deep begin to rise to the surface, allowing for a profusion of life.

Off the western coast of North America all those mechanisms come together to create one of the most productive marine areas on Earth. The powerful North Pacific Current arrives from the open ocean and supplies the entire coast, from the Aleutian Islands to Baja California, with nutrient-rich water. Strong winds blow off the top layer, particularly in summer in the area between San Francisco and San Diego. The bottom of the ocean is dotted with seamounts (underwater mountains) and cut by deep submarine canyons that

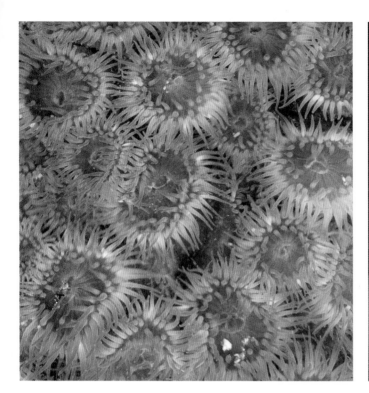

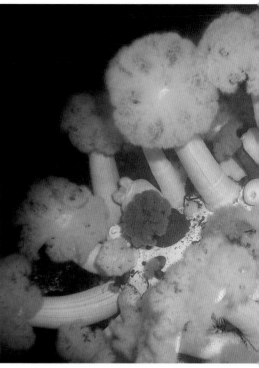

Beautiful "forests" of sea anemones (left and right, above) are a sight familiar to northern divers. Anemones feed on the abundant plankton of coldwater seas.

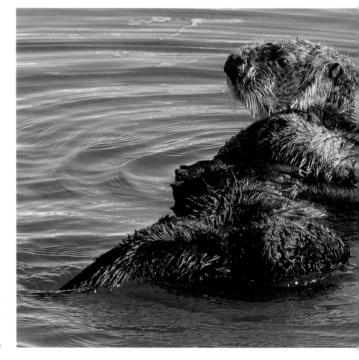

Cold currents allow sea otters with their warm coats to live as far south as the Channel Islands off California.

serve as funnels, bringing even more nutrients to the surface. The largest of these, Monterey Submarine Canyon, is over two miles deep. In addition, the small Inshore Current mixes warm and cold waters, creating turbulence. The result is a wildlife spectacle like no other: one of the world's greatest gatherings of marine life.

Whale Central

A few years ago I volunteered as a spotter for a whale-watching company based in Monterey, California. For an unpaid position it was fairly hard work, but it was one of the best jobs I've ever had (and as a field zoologist, I get some really exciting jobs from time to time).

I had to get up well before dawn and drive for two hours through dense coastal fog, swallowing motion sickness pills every half hour as I drove (my blood had to be saturated with dimenhydrinate in time for sailing, because I am somewhat prone to sea sickness and the swell could get brutal, particularly in winter and spring months). Then I would spend another half hour carefully dressing in layers and giving a safety talk to passengers.

Our boat trip began with circling the harbor. The jetty was taken over by sea lions and pelicans; sea otters were playing in kelp banks. As we moved out, our captain would get on the radio and ask other boats in Monterey Bay about whale sightings. Fishermen and the Coast Guard were always very helpful. If there were no tips, we usually started our search from the area where the whales had been seen the previous day, looking for whale spouts or dorsal fins.

Being surrounded by thousands of dolphins and seabirds was great, but our main goal was finding whales. In winter and spring we looked for gray whales. This species has the longest migration route of any mammal: from summer feeding grounds along the coasts of Alaska and Siberia, to breeding lagoons in Baja California. There were usually a fair number of them around, but they were difficult to follow because their movement was fast and determined. Besides, they seldom did anything other than travel across the bay, slowing down only briefly to feed in the plankton-rich waters. They moved south from November to January, and in December we would start

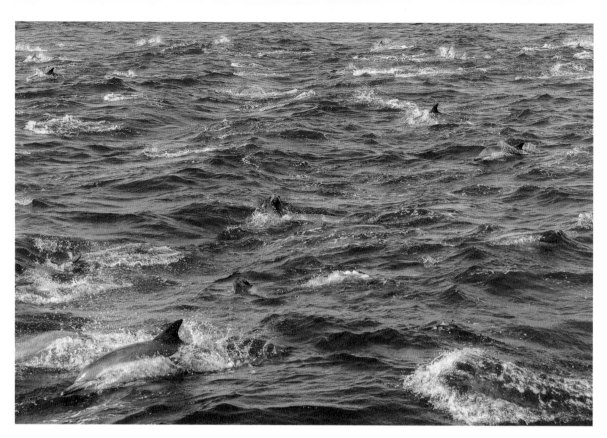

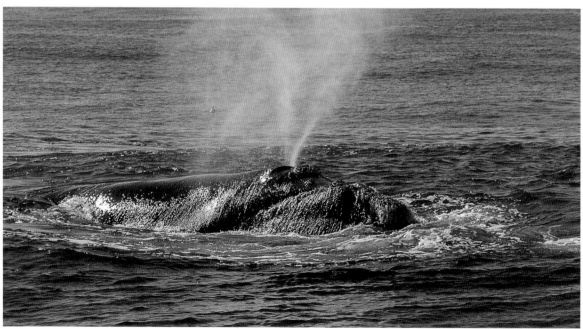

seeing some of them heading back north. By February, many were females accompanied by newborn calves.

Unlike dolphins, most whales don't have sonar. Nevertheless, they are able to navigate for thousands of miles through murky, plankton-filled waters and the maze of islands and fjords along the coasts of British Columbia and Alaska, all the way to the Arctic Ocean. Recently it was discovered that some gray whales make an even longer journey, traveling to Mexico from the cold, remote Sea of Okhotsk, a round-trip of eight thousand miles.

Summer and fall were the most interesting times in Monterey Bay. During the warm months (July to October), nutrient-rich water from the ocean floor rises to the surface from Monterey Submarine Canyon in the middle of the bay. The sea in that area often turns into plankton soup; krill (tiny shrimplike crustaceans) breed in such numbers that the masses look like billowing thunderclouds on a fish-finder screen. Sometimes we would have more than a hundred whales feeding around us. Blue whales were particularly impressive: longer than our boat, fast and powerful, they resembled nuclear submarines. Finding them was usually easy, for they had spouts up to fifty feet high. In October they disappeared; at the time, nobody knew where they were going, but now we know they winter in the open ocean far off Central America. In years with unusually warm water they didn't show up at all, because there was no krill in the bay, and that's normally the only thing blue whales eat. Other whales didn't mind, because instead of krill, there were plenty of anchovies.

Blue whales were great, but humpback whales provided the most fun for our customers. They are very playful and inquisitive. Every day we'd see them jumping out of the water, harassing blue whales, joining sea lions in herring hunts, or sunbathing on the surface, their long flippers up in the air like narrow white sails. They often approached the boat to get a better look at people, to scratch their backs against the boat, or to shoot a spout in passengers' faces. And they sang their long, weird songs that we could listen to by dropping a hydrophone into the water.

Thanks to the deep canyon, we could occasionally see rare visitors from the open ocean that feed on deepwater squid: sperm whales

Long-beaked common dolphins and California sea lions feeding together in Monterey Bay, California.

Different whale species can be easily recognized by the mammals' silhouettes and spouts. For example, right whales have V-shaped spouts.

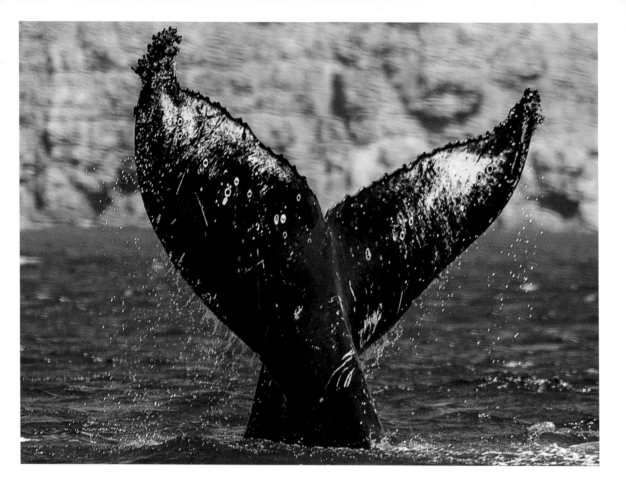

(giant predators that look like battleships with their dark-gray skin and determined movements), and beaked whales (so rarely seen by scientists that almost nothing is known about them). In addition to finding whales, we had to photograph them for scientific databases. Individual blue whales could be identified by the unique patterns of spots on their backs; humpbacks, by the black-and-white outlines on the undersides of their tail flukes. Using those photos, local scientists could follow some whales for many years.

There were always smaller creatures around as well, each with its own traveling route and schedule: elephant seals, fur seals, basking sharks, blue sharks, sea turtles, oceanic sunfishes, tuna, and, of course, seabirds. Abundant food attracted them from all corners of the Pacific. Every month brought something new: albatrosses from Hawaii in May, skuas from the Antarctic in June, storm-petrels from

Each humpback whale has a unique black-and-white pattern on the underside of its tail.

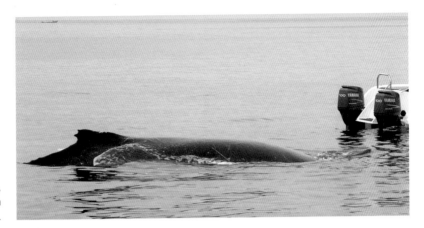

Playful and inquisitive, humpbacks often approach boats.

Heermann's gulls are unusual among migrants: in the fall they move north rather than south, from their breeding colonies in Mexico to the more productive waters of California.

Mexico in July, petrels from New Zealand in August, phalaropes from Siberia in September, Arctic terns from Alaska in October, guillemots from Canada in November. And, there were shearwaters.

The shearwaters gave us a spectacle of their own. For a few weeks in late summer and autumn they migrated south along the coast of California in an immense, riverlike flow, up to a mile wide. Most of them were sooty and (later in the season) short-tailed shearwaters, born on small islands thousands of miles away, near Australia, and traveling around the Pacific in a giant circle, spending the northern summer off Alaska and the austral summer in the Southern Ocean.

They use a special flying technique—utilizing the difference in wind speeds near the water surface and higher up—to cover huge distances while expending very little energy. Sometimes the stream of birds was so close to the shore that it was visible from beaches; local birdwatchers, alerted by online message boards, flocked to those beaches to see the colossal flock. But usually the birds were farther offshore.

The smallest travelers we saw were by-the-wind sailors, beautiful relatives of jellyfish that look like strangely shaped plastic lids with dark blue edges and a little sail on the top. The sail is S-shaped and makes the creatures float at an angle to the wind. The prevailing winds in the North Pacific generally form a giant circle, and theoretically the tiny sailors always move slightly toward the center, thus avoiding the shores. But off the coast of California the winds blow toward the land for half a year, and almost every spring millions of helpless sailors wash up on the beaches. This doesn't seem to be too damaging to the species: by-the-wind sailors are among the world's oldest travelers, with one fossil dating back 370 million years.

The most exciting thing about this job was never knowing what the day would bring. I participated in more than a hundred trips, and there was something new every time: the birth of a gray whale, a seal playing with a giant jellyfish, a rare bird. But some days were particularly special. You could sense it almost immediately: sea lions were strangely quiet; dolphins didn't leap in the air; gray whales didn't play or sing. They all knew that a killer whale tribe specializing in hunting mammals was in the area.

As with blue whales, the spots on the backs of killer whales are individual, enabling them to be identified. Most family groups have been studied for many years and an extensive database has been compiled. In the 1990s, scientists discovered that there are three separate "ethnic" groups of killer whales in the North Pacific, each with its own language, hunting culture, and migration routes. **Oceanic** orcas (as killer whales are often called) live far from shore, chasing tuna and small sharks. **Resident** orcas inhabit particular areas along the coast, feeding on herring,

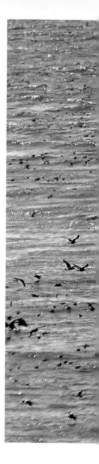

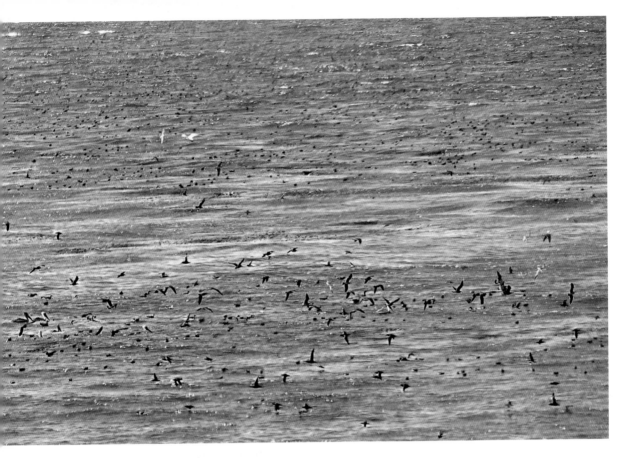

A small part of the "shearwater river." Shearwaters fly effort-lessly in strong wind, but prefer to rest when the sea is calm.

By-the-wind sailors are colonies of tiny animals that have been fearlessly circling the oceans for half a billion years.

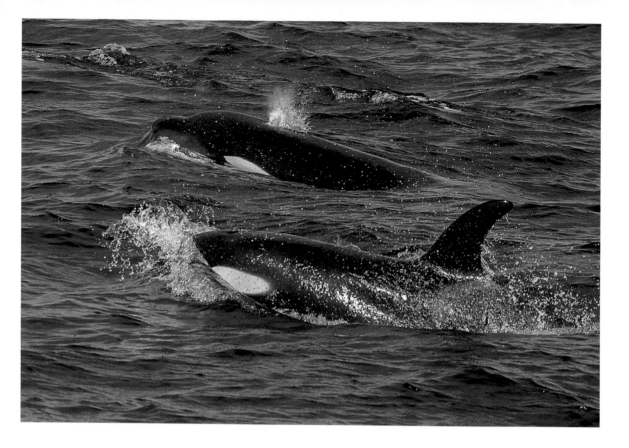

salmon, and other medium-sized fish. They are not as nomadic as others, although we did get occasional visits by packs from Puget Sound and Mexico. **Transient** killer whales are very different. They have more pointed dorsal fins; their packs are small, quiet, and fast, able to cover great distances in search of warm-blooded prey. All three kinds visited the bay from time to time, and, amazingly, all local marine mammals could distinguish them by their language. Whales and seals were not afraid of oceanics and residents, and even joined them in fishing occasionally. However, they were absolutely terrified if transients were in the area.

We were fascinated by killer whales, and never missed a chance to follow them for as long as we could. They are the smartest and the most beautiful creatures of the sea. But if you watch them, especially the transients, you should be ready for some of the most violent and bloody scenes in nature. It takes orcas no more than

Killer whales on the move. Tall dorsal fins probably make it easier for them to follow each other as they porpoise through murky water.

a few minutes to tear apart a seal or a dolphin. Finishing off a family of big whales can take hours, with the sea turning red for hundreds of feet around.

Once we saw a particularly strange event. We were following a pack of transient killer whales as they looked for sea lions to kill. Huge herds of sea lions were hanging out with humpback whales, fishing for anchovies together. The orcas tried to attack one such sea lion herd, but a humpback whale surfaced directly between them and the sea lions, blocking their path. The orcas swam around for a few minutes; it looked like a large male orca was trying to block the humpback while others tried to approach the sea lions. Then two more humpbacks moved in and joined the first one. All the humpbacks were giving elephantlike trumpeting calls when spouting. The killer whales moved on, and tried to attack another group two miles away. Again, several humpbacks appeared and remained near the surface, preventing the orcas from attacking the sea lions. The orcas took off again, found another group of humpbacks and sea lions, and we saw the same spectacle play out a third time. What was particularly interesting was that three different groups of humpbacks separated by distances of about two miles all behaved in the same way, as if they could somehow communicate between groups. I have talked about this with many whale researchers, but still don't know what to make of it.

Dizzy from the wind, the waves, and the intensity of the chase, we would return to harbor. We were always greeted by tame harbor seals and seagulls, who took us for a fishing boat and expected scraps. I would carry the most seasick passengers to the pier, have a cup of coffee, and drive home. Sometimes the tourists wouldn't let me go for a while. Japanese folks often wanted to take a group picture. Europeans had to write down scientific names of the animals. Mexican visitors tried to kiss their loved ones on the bow. Americans came up with questions like "Which is stronger, an orca or a white shark?" or "How powerful is your engine?" But everybody was happy, even those who got seasick, because the spectacle of the cold current bonanza always left us all impressed.

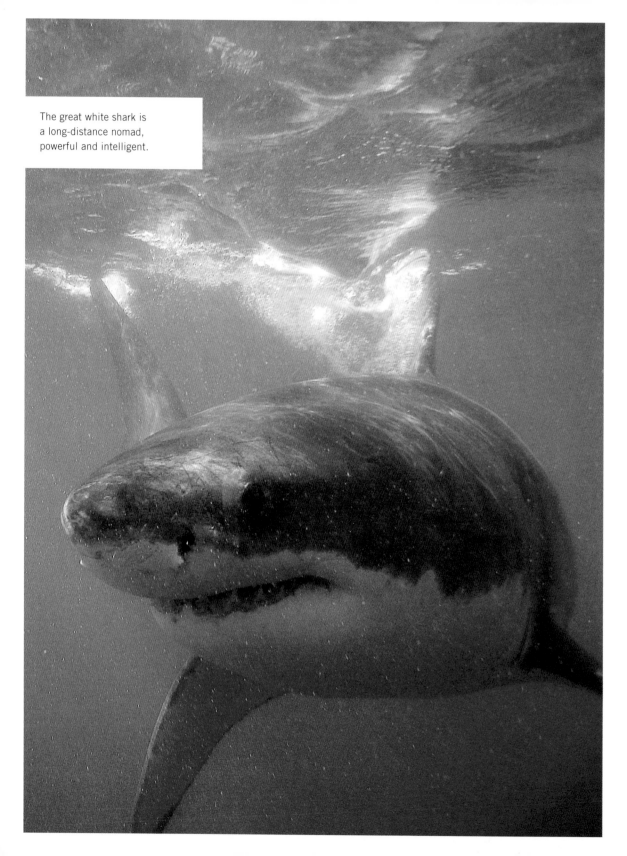

The great white shark is
a long-distance nomad,
powerful and intelligent.

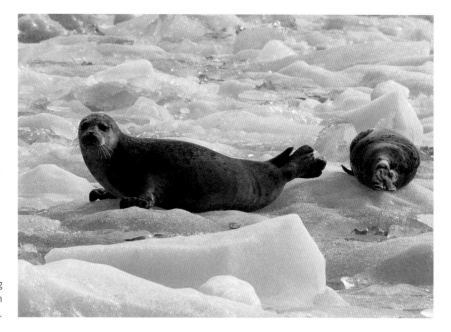

Harbor seals often hang out in icy, oxygen-rich waters around glaciers.

Some Like it Cold

If you have at least some interest in nature, you definitely should take a late summer or early fall whale-watching trip out of Monterey in your lifetime. Of course, Monterey Bay is just one stop in the long journeys of its marine visitors. In Alaskan waters from the Aleutians to the Panhandle you can see a similar, but not identical cast of characters—humpback, gray, beluga, and killer whales; sea otters; seals; sea lions; salmon sharks; and countless seabirds— feasting on smaller marine organisms in deep fjords, amidst an unearthly scenery of calving glaciers and jagged icy peaks. Harbor seals are particularly fond of glacier fronts, and can often be seen calmly resting on ice blocks, rocked by the waves created by ice chunks the size of buildings falling into the nearby water. Most people travel through these waters by taking an Alaska ferry (there are a few routes to choose from), but you can also drive or fly to one of the coastal settlements and take a boat tour.

Even farther north, along the windswept Arctic coast of Alaska, the migration looks very different. Here, the most productive waters are those at the edge of the pack ice. As the ice slowly melts in summer, cold meltwater sinks and nutrient-rich water from the

deep rises to take its place. In late spring, seals, whales, and walruses enter the Arctic Ocean through the Bering Strait and travel north and east, trying to keep up with receding ice floes. In early fall, as the ocean cools down and the ice floes are about to start growing, they move back toward the Pacific. Belugas, bowhead whales, and spotted seals winter in the Bering Strait area or the northern part of the Bering Sea and gray whales travel as far as Baja California or even central Mexico, while some humpbacks, fattened during the endless days of Arctic summer, leave the world of cold water and head straight to Hawaii. They don't care that there's little food for them in the tropics—they have enough fat to last until spring, and choose warm water for giving birth and mating.

Some Like it Even Colder

The most wildlife-rich part of the Arctic is the maze of islands, channels, and fjords that surrounds Greenland and stretches west across Canadian waters, almost to the Alaskan border. Here, numerous cold and (relatively) warm currents slither around in a complex dance, providing a rich banquet for plankton, fish, and larger predators. Unlike the waters off northern Alaska, the straits between the islands of the Canadian Arctic are very deep, so in addition to surface-feeding whales there are frequently narwhals (predators of deep-sea squid) frolicking near the shore. On Baffin Island you can often get close to narwhals, belugas, and bowhead whales by taking a short ride by snowmobile or kayak.

The largest of those currents, the ice-cold Labrador Current, breaks out of the island labyrinth and flows far, far south, all the way to Cape Cod and sometimes even to the northern tip of Long Island. This current is the reason you can find coastal tundra in Maine, at the latitude of southern France, and wintering seals in New Jersey. Thanks to this current, residents of the East Coast can enjoy whale-watching trips as far south as Massachusetts; even farther south, the migrating whales stop feeding and move offshore on their way to the breeding grounds around Bermuda, off the Bahamas, and in the Caribbean. The best whale feeding grounds along

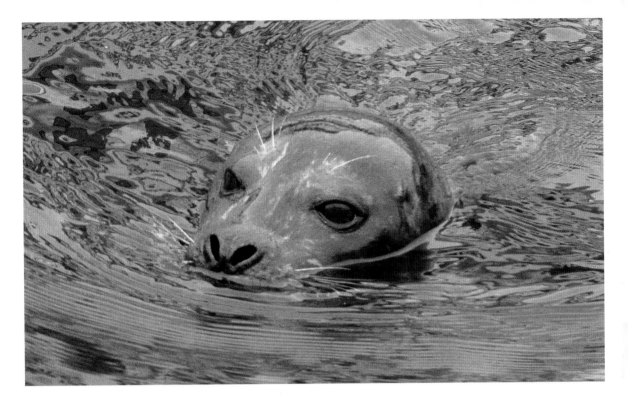

In winter, harbor and gray seals follow cold currents all the way down to New Jersey.

the East Coast are around islands and peninsulas sticking out into the ocean, where currents create strong turbulence: off the northern and southern tips of Nova Scotia, around Newfoundland and Île Buonaventura in Quebec, and near the tip of Cape Cod. Another good place is the Gulf of St. Lawrence, where nutrients are provided by the river of the same name, flowing from the Great Lakes. If you take many whale-watching trips at different locations, you should eventually see blue, humpback, fin, minke, right, and pilot whales, as well as a few dolphin species and many seabirds ranging from dovekies to gannets. There is also an area of deep submarine canyons called "the Gully" where beaked whales gather, but it is far offshore and very difficult to access.

What about Warm Currents?

You can see a completely different assortment of marine mammals and seabirds in the waters of the Gulf Stream off North Carolina. This warm area is visited in summer by tropical dolphins, petrels,

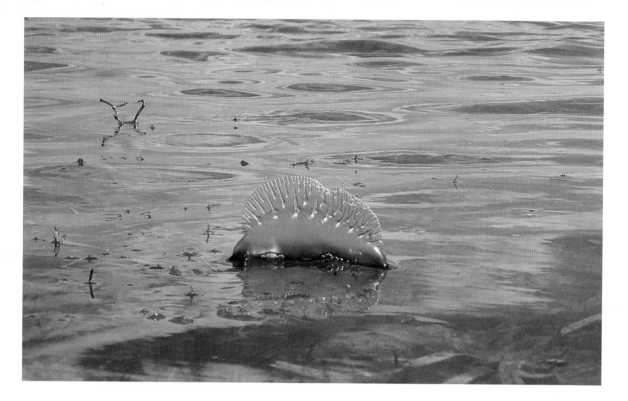

A Portuguese man o' war drifting with sargasso weed.

and fishes such as flying fish and sailfish, but here the productivity is low and you don't often encounter large flocks, herds, or schools. Sometimes the ocean looks empty for many miles. Devoted birders who take numerous trips to these waters eventually see a lot of different species, because the biodiversity in warm waters is actually higher (nobody knows why), but if you are not one of these repeat visitors, you might be disappointed.

One oceanic traveler you are almost certain to see in summer is the fearsome Portuguese man o' war. From the surface it looks like a blue or purple plastic bubble, shaped like a rooster's crest. Like the harmless by-the-wind sailor, it uses wind to travel and is actually a colony, with numerous organisms forming tentacles under the transparent float. But the man o' war is anything but harmless. Below the float are tentacles up to 160 feet long, covered with stinging cells, which cause extremely painful burns. A few small animals have developed resistance to man o' war venom, and travel with it, hiding between the tentacles. The most beautiful of these hitchhikers, a dark blue sea slug, even feeds on the man o' war. Murres

know about this, and often dive around the man o' war, searching its tentacles for small fish; feathers and foot scales apparently give them sufficient protection.

Low productivity means that there is little plankton in the water, so it is clear and you can look for travelers under the surface (warm temperatures also help). If you jump into the water far offshore, the first thing you'll probably see will be golden-brown clumps of sargasso weed. There are many species of these algae; some begin their life growing on the bottom, then break off and switch to a nomadic existence, while others live only in the open sea. If you look through many large clumps, you might see a tiny, beautifully camouflaged sargasso crab or a sargasso clownfish; sometimes a baby loggerhead sea turtle will use the weed as a cover during a leg of its own long journey around the ocean. Beyond the Gulf Stream, where the currents form an area of closed circulation (such areas are called gyres), huge masses of sargasso weed accumulate and sometimes completely cover the ocean; this part of the Atlantic is known as the Sargasso Sea.

One of the most charming travelers of the warm currents is the Florida manatee. Manatees feed on algae, eelgrass, and other bottom vegetation, so they don't care that there is little plankton in warm water. In summer, manatees migrate north, all the way up to the Carolinas and sometimes to New Jersey, but in winter they retreat to Florida and hang around underwater springs or power plant outflows where the water temperature is a bit higher. Winter is the best time to see them, sometimes in groups of hundreds.

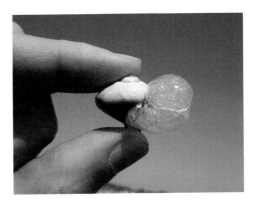

Violet snails are predators of the Portuguese man o' war. The snail uses a float made of foam to travel with winds and currents.

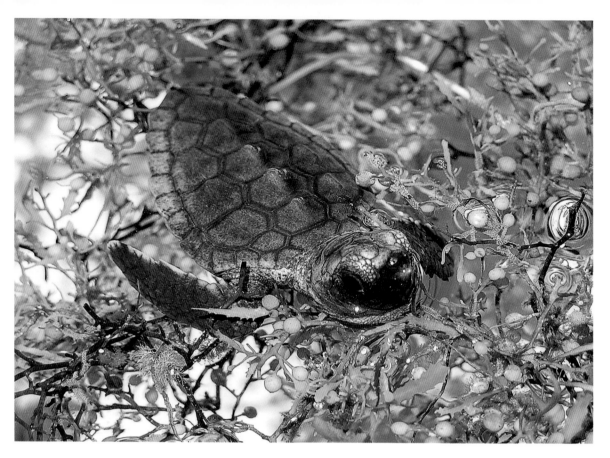

A baby loggerhead sea turtle rests in a clump of sargasso weed.

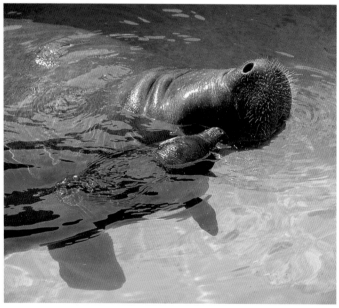

Florida manatee with a baby.

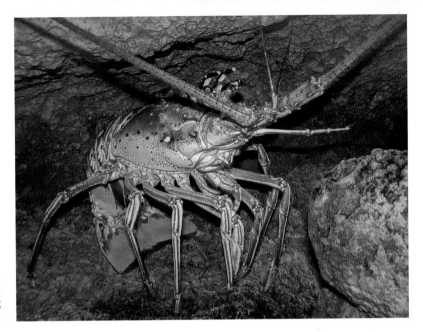

When not migrating, spiny lobsters hide in underwater caves during the day and hunt at night.

Of course, the spectacular gatherings of oceanic migrants that we can see from the surface are just a tip of an iceberg. Most migrations take place underwater, sometimes at great depths, as trillions of marine organisms swim or drift in all directions. Among the fastest travelers are the bluefin tuna; tagging has shown that they can cover thousands of miles in a matter of weeks. The slowest travelers are tiny planktonic organisms; most of them rise closer to the surface at night and sink deeper during the day, probably to avoid overheating. And some marine creatures walk rather than swim. King crabs and lobsters can walk for very long distances; spiny lobsters are particularly famous because their herds move in single file, each animal placing its long antennae on the back of the one in front of it. Seeing spiny lobster migrations is difficult and usually requires mounting a serious expedition; the movements of clawed lobsters have never been directly observed and are inferred from tagging data.

The Last Giants

The immense concentrations of marine life described in this chapter were long under the threat of human-caused extinction. People

living along the shores affected by cold currents have developed cultures completely dependent on marine resources for survival, spent thousands of years perfecting their hunting and fishing methods, and made amazing technological progress. Kayaks used by Aleuts, an ancient seafaring nation that lived in the Aleutian Islands off Alaska, were so sophisticated that some details of their design still cannot be understood or recreated by modern engineers. (The Aleuts' whaling technique, however, was extremely wasteful. They would hit a whale with harpoons covered with aconite poison, and hope that the carcass would wash up on one of their islands. Only a small fraction of poisoned whales actually did.) The Inupiat Eskimos of Barrow, a town on the Arctic coast of Alaska, developed the world's most advanced whaling methods. These involved using marvelously designed skin boats, harpoons with detachable tips, systems of floats, and special techniques for towing whale carcasses. Hunting for seals, Inuit Eskimos of Greenland and the Canadian Arctic bravely navigated the dangerous world of ice floes and open-water passages; they also rappelled down sea cliffs to collect thousands of seabird eggs.

As a result of this hunting prowess, many of the cold-current travelers suffered huge losses even before the modern era. Probably within a few hundred years of human arrival to North America, the slow, defenseless Steller's sea cow went extinct everywhere except the uninhabited Commander Islands. Numerous seal, walrus, and sea lion rookeries and seabird colonies along the mainland shores of North America were destroyed; the only evidence of their existence are massive deposits of bones and eggshells near Stone Age settlements found by archeologists. However, only one marine mammal and a few seabirds are known to have been extirpated before the European contact, compared to virtually all larger land mammals being hunted to extinction long before the Vikings and other early European explorers.

In the eighteenth century, modern technologies and market-oriented hunting arrived in North America, and massive slaughters of everything that moved began anew. The last Steller's sea cows were killed off within twenty-seven years of the 1741 discovery of

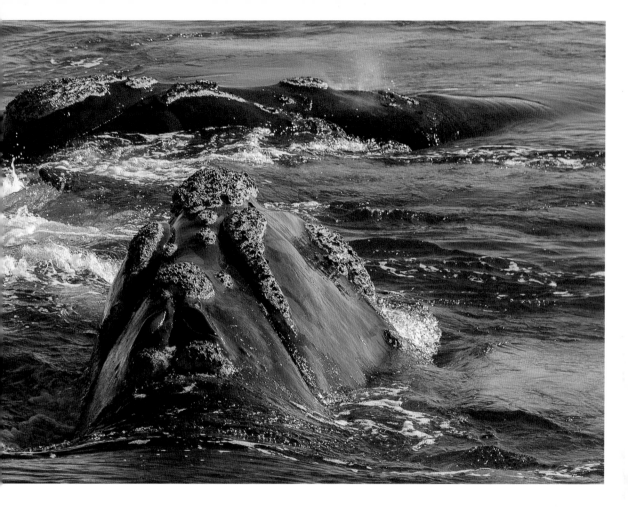

Courting North
Atlantic right whales.

the Commander Islands. Gray whales were driven to extinction in the Atlantic Ocean in the eighteenth century; great auks, flightless cormorants, Labrador ducks, and Caribbean monk seals soon followed. The North Pacific right whale, once the most common whale off California, was hunted so heavily that the population fell to double digits and still hasn't recovered, despite having been fully protected for decades. Sperm whales were hunted mercilessly for their oil, which was indispensable for early cars. The great mammals were saved largely because newer car engines operated at higher temperatures and had to use synthetic oil. California sea otters and northern elephant seals became so rare that for many years they were considered extinct. Foxes and rats brought by humans to remote islands destroyed countless seabird colonies.

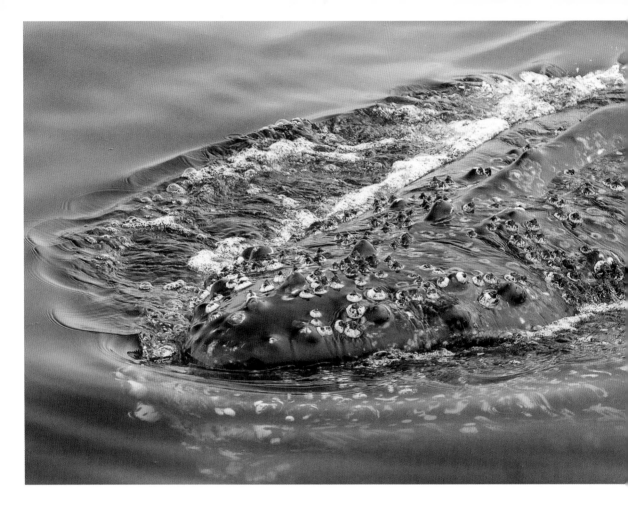

Nowadays most species of marine mammals and seabirds are formally protected, and many have rebounded to some extent. Summer whale gatherings in Monterey Bay grow more spectacular every year, and blue whales' numbers in the Atlantic are rising. But that doesn't mean they are completely safe. North Atlantic right whales are killed by collisions with ships in alarming numbers. Many dolphins and whales drown after getting entangled in fishing gear; albatrosses are killed by longline fisheries; leatherback sea turtles mistake floating plastic bags and party balloons for jellyfish (their main food) and perish from intestinal blockages; bottlenose whales die horrible deaths after their inner ears are burst by navy sonars; bluefin tuna are being pushed toward extinction due to the increasing popularity of sushi. The population of Steller's sea

Interacting with friendly humpback whales is a lot of fun, but you risk losing your camera to salt spray.

lion in Alaska crashed due to overfishing of their prey fish; killer whales that used to hunt sea lions had to switch to sea otters and almost drove them to extinction. There is the ever-present danger of catastrophic collapses of marine ecosystems due to major oil leaks, overfishing, or destruction of bottom communities by trawls. But the main threat is the rising concentration of carbon dioxide in the atmosphere: it pushes numerous marine organisms toward extinction by turning seawater more acidic, and causes the global warming that can completely destroy the fragile world of cold currents in just a few decades. Sadly, it's becoming increasingly obvious that those who wish to see these wonders must do so in the near future—before it's too late.

VIEWING TIPS

○ **Gray whale** migration can be seen from November through April from numerous vantage points along the Pacific coast, from central Oregon to Southern California. The best lookouts are Point Reyes Lighthouse, Point Sur State Historic Park, and Cabrillo National Monument (all in California).

○ Migrating **bowhead whales** can be seen from Barrow, AK, in October. Barrow is still a major whaling center; unused parts of whale carcasses are dumped at nearby Cape Barrow, where they attract **polar bears**; you can see them by taking a bus tour.

○ The best starting points for summer boat trips to see **whales, dolphins,** and **seabirds** in nutrient-rich waters are Monterey, CA, Victoria, BC, Seward and Gustavus, AK, Mittimatalik, NU, Percé, QC, Point St. Lawrence and East Ferry, NS, and Provincetown, MA.

○ **Transient killer whales** are most often seen in Monterey Bay, CA, from March through May, as they chase gray whale females migrating north with their calves.

○ **Belugas** and **minke whales** can often be seen from shore at Beluga Point near Anchorage, AK, and around Tadoussac, QC, or by taking a short boat trip from the latter town or from Churchill, MB. You can also kayak among **seals** and **whales** in Gros Morne National Park, NL, or swim with **California sea lions** in La Jolla, CA. **Harbor seals** gathered around calving glaciers can be seen in Glacier Bay, near Yakutat, and in Kenai Fjords National Park (all in AK). **Harbor seal haulouts** are now a common sight along many parts of the Pacific coast. On the East Coast, wintering **harbor** and sometimes

gray seals can be seen in Monomoy National Wildlife Refuge, MA, at Sakonnet Point, RI, Montauk Point State Park, NY, and Sandy Hook, NJ. A large **walrus haulout** can be seen at Round Island near Dillingham, AK. The most scenic place to see lots of **Steller's** and **California sea lions** is a huge grotto called Sea Lion Caves in Oregon. **Steller's sea lions** are common north to Alaska, and winter in great numbers in Nanaimo Harbor, BC, while **California sea lions** are a more southern species; most tourists see them at Pier 39 in San Francisco or in Monterey Harbor.

○ The **"shearwater river"** can sometimes be seen from shore around Moss Landing, Half Moon Bay or Point Lobos State Park (all in CA), while immense flocks of feeding shearwaters are often encountered by ferries to Kodiak and Aleutian Islands, AK. A good way to see lots of **shearwaters** and other **seabirds** in the East is to take a ferry to Îles de la Madeleine, QC, or Newfoundland in summer.

○ As for the wildlife of warm currents (mostly **dolphins** and **seabirds**), try taking summer birding boat trips from Hatteras, NC, Cape May, NJ, or San Diego, CA, as well as taking a boat to Channel Islands National Park, CA, or Dry Tortugas National Park, FL.

○ There are many places in Florida to see wintering **manatees**. You can snorkel with them in Crystal River, or watch them from viewpoints at the Big Bend Power Plant Manatee Viewing Center in Tampa, Manatee Observation and Education Center in Ft. Pierce, and Blue Spring State Park.

○ **Migrating spiny lobsters** can be seen by scuba diving in the fall in the waters surrounding Dry Tortugas National Park, FL. The same waters are a major spawning area of Atlantic **bluefin tuna**; huge shoals can sometimes be seen moving through the straight between Florida and Cuba.

SUPERHERDS
OF THE PLAINS

More than half of North America is covered by plains. The Great Plains that stretch from the Mississippi River to the foothills of the Rocky Mountains are, indeed, great and impressive (especially if you obey the speed limits while crossing them), but they are neither the largest nor the best preserved on the continent. The immense Boreal Plains of Canada and Alaska cover a larger area and look much like they did before the arrival of the Europeans. There are also the extensive coastal plains of the Atlantic and Gulf seaboards, the intermontane plains of the West, and many others. They might not look as scenic as mountains and seashores, but each plains region is an interesting world worth exploring.

Are All Plains Great?

To understand the dynamics of natural life on the plains, the first thing to keep in mind is the major difference between the plains of the North and those in other parts of the continent. In the North, on the Boreal Plains, the overruling factor is the length of the snow-free season. This simple reality determines where the forest gives way to the open tundra, which parts of the tundra are full of birds in summer and which ones are silent, and how far the inhabitants of the open landscapes have to travel to find shelter from brutal Arctic winds in winter. But on the plains of the continental United States and adjacent parts of southern Canada, the amount and seasonal distribution of the annual precipitation are much more important. Summer rains make grass taller and herds fatter; winter snows make life difficult for some inhabitants and easy for others.

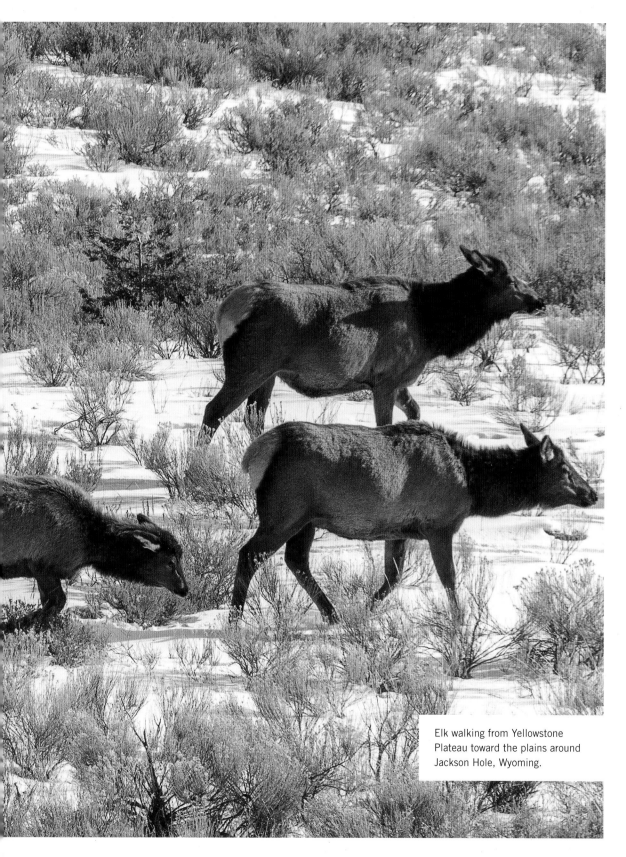

Elk walking from Yellowstone Plateau toward the plains around Jackson Hole, Wyoming.

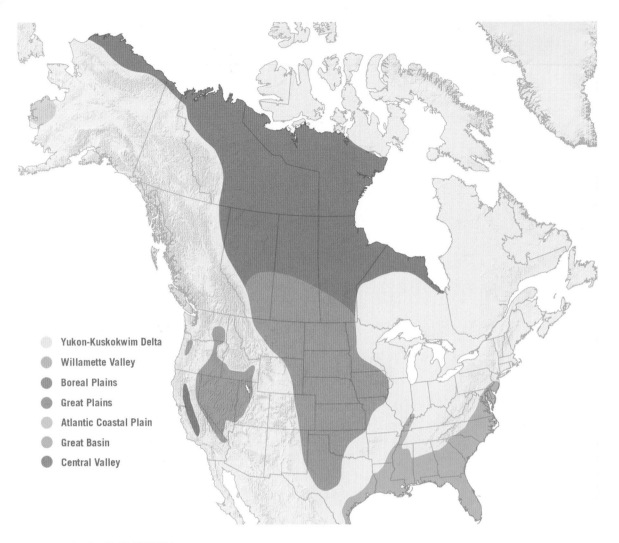

Yukon-Kuskokwim Delta
Willamette Valley
Boreal Plains
Great Plains
Atlantic Coastal Plain
Great Basin
Central Valley

PLAINS OF NORTH AMERICA

The plains of North America have seen many changes of climate, but throughout their history they have been inhabited by an incredible variety of large animals. Just fifteen thousand years ago there were mammoths, mastodons, wild horses, onagers, tapirs, camels, llamas, long-legged peccaries, shrub-oxen, wild yaks, saiga antelopes, stag moose, giant sloths, giant armadillos, and giant tortoises.

These herbivores provided food for numerous predators and scavengers, such as lions, saber-toothed cats, short-faced bears, and

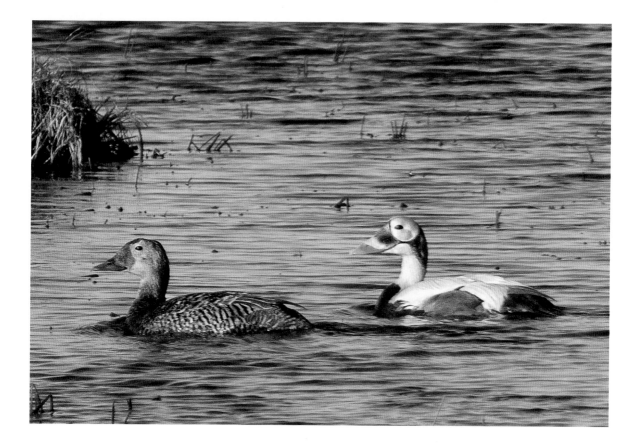

Like many tundra birds, spectacled eiders prefer to nest in places where the snow melts early.

giant birds called teratorns. Then the last ice age ended, and humans managed to cross from Alaska to the rest of the continent. Soon after that, almost all large animals went extinct. The reasons for their extinction are still hotly debated, but it is gradually becoming clear that human overhunting is the only reasonable explanation. An even more controversial theory suggests that the extermination of large herbivores caused the dry open plains of Canada, Alaska, and Siberia to be covered by coniferous forests and wet tundras—and that in turn caused the climate to become warmer, ensuring that ice ages would never return.

Over the following ten thousand years, things were relatively stable on the plains of North America. But in the last four centuries the ecosystems of the plains have been stricken by some of the worst environmental disasters in the history of the planet. Let's start with the Great Plains, the broken heart of the continent.

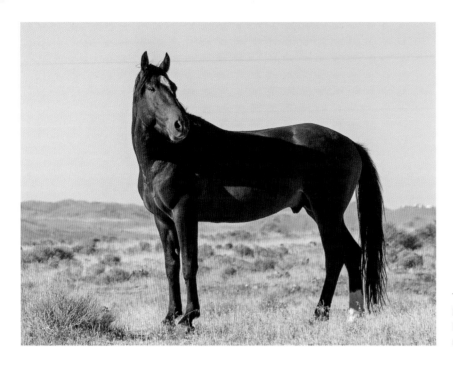

The niche left vacant by extinct native horses has been filled by feral mustangs.

Land of the Big Sky

The Blackfoot Indians called the Great Plains the Land of the Big Sky, and it was a good name. The sky here is the most spectacular and dynamic part of the landscape, in part because of the unusual mechanics of local weather: clouds mostly come from the west, but the moisture that allows them to grow comes predominantly from the south, especially in spring and summer, when hot, humid air creeps up from the Gulf of Mexico. Since the gulf is located "under" the eastern part of the plains, but not the western part, and because the Rockies create a so-called "rain shadow" by capturing much of the moisture coming from the west, the amount of precipitation increases dramatically from west to east. In many other parts of the world, different types of vegetation form belts stretching from east to west. But on the Great Plains, unusually, these belts stretch from north to south.

If you descend from the Rockies onto the Great Plains, you find yourself in the shortgrass prairie, a type of landscape many geographers classify as desert or semi-desert. This is a tough place to live: summers are brutally hot and winters are cold and windy. There are

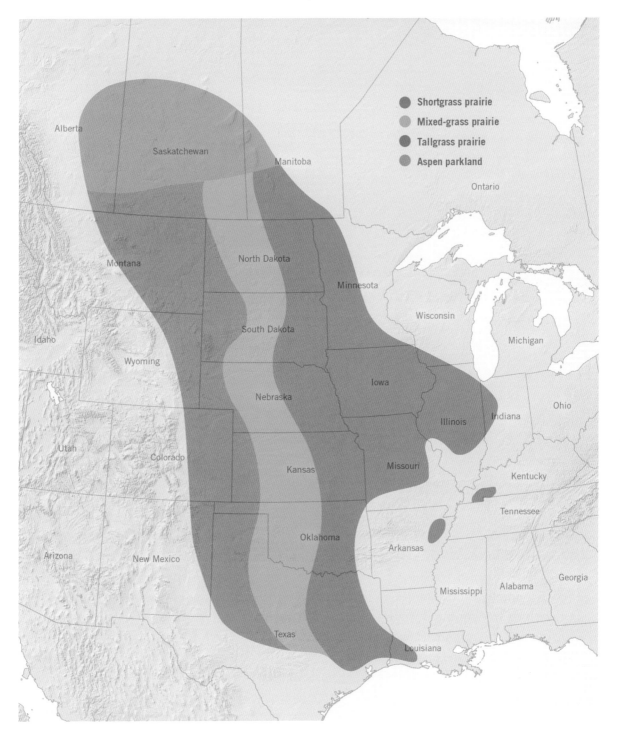

Shortgrass prairie
Mixed-grass prairie
Tallgrass prairie
Aspen parkland

VEGETATION OF THE GREAT PLAINS

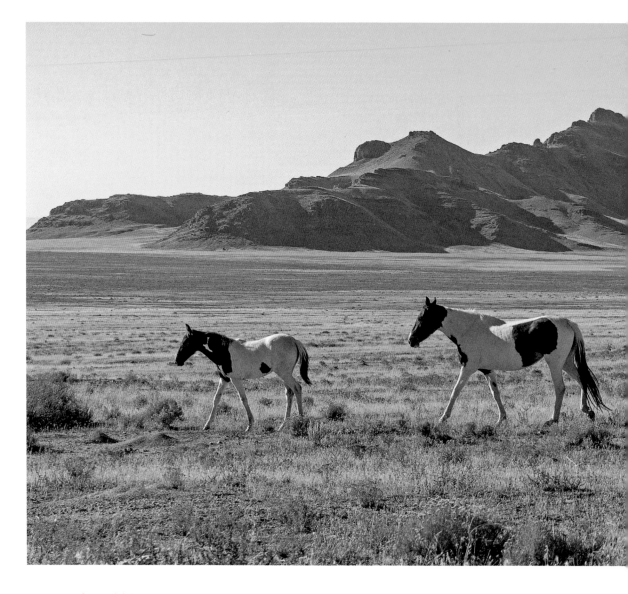

very few edible plants here and animals are not easy to catch; they either hide underground when threatened or run very fast. Not surprisingly, these prairies had few human inhabitants until the Europeans arrived in North America.

Feral mustangs in the shortgrass prairie.

As you move east, the elevation above sea level slowly decreases, so the sunlight is less brutal and the water doesn't evaporate as quickly as in shortgrass prairies. There is more rain in summer and more snow in winter. At some point you hit the so-called "dry line," the ever-shifting border between the dry air of the West and

the moist air coming up from the Gulf of Mexico. If you are driving, that change can be rather dramatic: suddenly your hands are wet on the wheel and your windows are all fogged up. When thunderstorms coming from the Rockies hit that line, they gorge themselves on the moisture and then explode in the planet's most spectacular storms, often producing tornadoes or unusually large hail. The grass here is tall and lush; this was once the beautiful tallgrass prairie, although now the fertile soils are almost entirely plowed and the impressive diversity of native plants and animals survives only in small nature reserves.

As soon as you cross into the tallgrass prairie belt, you start seeing small trees, first in broken lines along ravines, then in groves. This is a relatively recent development. Until the sixteenth century, Native Americans managed this landscape by setting fires to the grasslands, thus killing tree saplings, pushing the edge of the forest almost all the way to the Mississippi River, and creating perfect pastures for deer, elk, and bison.

The Great Plains are a place where nothing is certain. Rains can fall in one area this year and in another area next year. Periods of

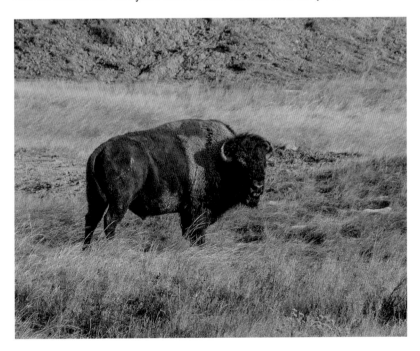

Plains bison are the largest surviving animals of the Great Plains.

high rainfall can be followed by major droughts. So historically a lot of native wildlife species were nomadic. Bison (commonly called buffalo by the European settlers), pronghorn (commonly called antelope), deer, elk, and grizzly bears escaped summer droughts and winter snows by moving hundreds of miles, while birds, bats, butterflies, and migratory locusts migrated for thousands of miles every year. In many cases, they followed well-worn paths, but even those routes were flexible, allowing them to adjust in response to shifting weather patterns.

For a long time after European discovery, the Great Plains were found to be an almost impenetrable wilderness; the name explorers gave this area was Great American Desert. However, the Europeans still managed to have a huge impact on the plains even without setting foot there. The diseases they brought swept over the continent. Native cultures of the Mississippi Basin were hit particularly hard because they depended heavily on long-distance trade, so the epidemics could easily spread. Human populations dropped so catastrophically that societies collapsed, cities were abandoned, and landscape management practices were forgotten. The forests immediately started their westward march, stopping only after reaching the areas where the climate was too dry for them. In a short time, the area covered by tallgrass prairies was halved.

In the shortgrass prairies it was a very different story. Here the diseases didn't spread much, but horses did. The Spanish brought a few horses to Mexico in 1519. In an astonishingly short period of time, many Native American tribes managed to acquire horses, learn horsemanship, and become true horseback nomads, much like those of the Eurasian steppes where horses were first domesticated. By 1610, Navajo horsemen began raiding Spanish settlements. As more and more tribes acquired horses through war and trade, they suddenly gained the ability to travel fast across the plains and, more importantly, to hunt the immense herds of bison and other game. Within a century, more than a dozen tribes moved to the shortgrass prairie, made it their home, and became almost entirely dependent on bison for food and clothing.

Was their hunting sustainable in the long term? That's still debated by scientists, but the question is now only of academic interest. What happened next is well-known: the European settlers arrived on the Great Plains. They first entered the grasslands from the east, where the vegetation was particularly lush, and called the area *prairie* (French for "meadow"). The Native Americans desperately tried to resist the invaders, managing to slow them down for many decades and even pushing back in some cases (the Comanche and Sioux tribes were particularly effective). But eventually the settlers' numbers became too dominant; the defenders were mostly killed. The Europeans slaughtered all the bison to starve the remaining natives into submission. They also killed all other large animals. Elk, bighorn sheep, grizzly bears, and wolves disappeared from the plains, except for the far northern reaches in Canada. Deer and pronghorn were also driven almost to extinction. For a few decades, the newcomers were interested only in raising cattle, but in 1837 the invention of the steel moldboard plow allowed the settlers to begin cultivating dense prairie soils. The tallgrass prairies, where the soils were very fertile and the rains plentiful, were virtually all converted to cropland. The shortgrass prairies became open-range cattle country; later the invention of barbed wire and the spread of irrigation led to the conversion of these regions into a mosaic of irrigated land and smaller pastures. But they were not destroyed as thoroughly as the tallgrass prairies.

As a result of these changes, the most populous traveling animal of the prairies (and possibly the most prolific land creature of historic times), went completely extinct in just thirty years. It was called the Rocky Mountain locust. It bred in the sandy river valleys of the prairies, and exploded in numbers during years of high rainfall; the flocks then took to wing and moved in all directions, but mostly to the east. In 1875 one such flock was estimated to cover 200,000 square miles (an area larger than California), weigh 27.5 million tons, and number 12.5 trillion. The last sighting was in 1910; the extinction was so sudden that nobody bothered to preserve any specimens in museums, although a few were later found frozen in

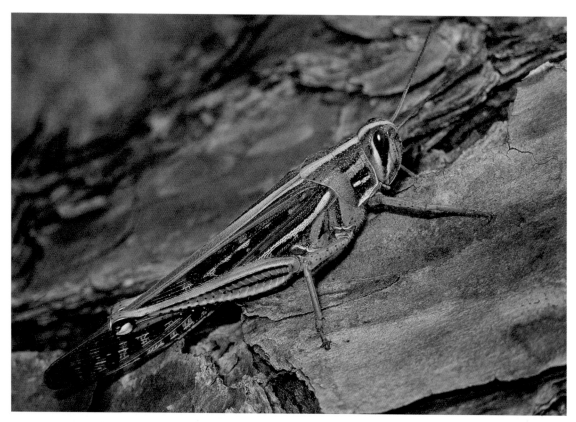

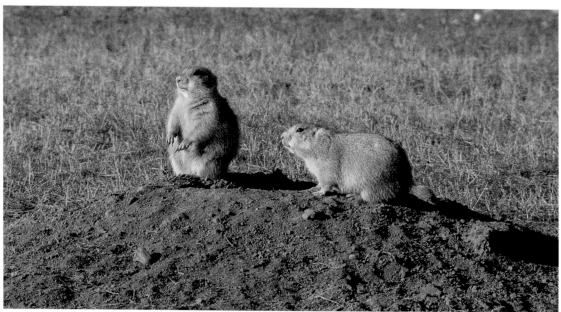

a glacier in Montana. Locusts of other species often exist in two morphs, one sedentary and the other migratory; the latter develops only under high-density conditions following good rainfall. For a long time it was thought that some common grasshopper species still living on the Great Plains could be the sedentary morph of the Rocky Mountain locust. Scientists tried to breed every species in high-density conditions, hoping that one would morph into the migratory type. But it never happened, and recently genetic analysis showed that the Rocky Mountain locust is, indeed, extinct.

The troubles of the plains were not over. In 1900, plague was introduced to North America. First brought to San Francisco by ship rats, the disease jumped to ground squirrels and then to numerous other rodents. In the plains it caused mass mortality among prairie dogs. Prairie dog towns once stretched for hundreds of miles; now they are all very small, except for one remaining supertown near Janos in Chihuahua, Mexico. Prairie dogs were a keystone species, on which the life of numerous prairie inhabitants depended; their loss was a huge blow to native soil productivity and wildlife diversity.

A surviving relative of the Rocky Mountain locust rests on a downed tree trunk.

In the 1930s, as tractors replaced horses and plowing even the hardest soils became possible, farmers attempted to plow the entire shortgrass prairie belt, causing catastrophic wind erosion, better known as the Dust Bowl. The federal government had to intervene; it spent huge sums on planting trees, buying out farmers' starving cattle, and even awarding them for using novel methods of farming that were less destructive of the soil. But it wasn't until 3.5 million people left the plains that the Dust Bowl came to an end; the fertility of the soil in many original Dust Bowl areas still hasn't recovered.

A similar disaster is now brewing on the plains, from Nebraska to Texas, as farmers use too much groundwater for irrigation, depleting the aquifers. In some areas the groundwater has been used up completely and cropland has had to be abandoned; much greater calamities will happen in the near future.

You would think that an area so thoroughly modified by agriculture would have little wildlife at all left, let alone wildlife spectacles. Indeed, ecologists often informally refer to the once-lush plains stretching from the Detroit area to Iowa as the black hole of

Prairie dog towns once covered the Great Plains for hundreds of miles.

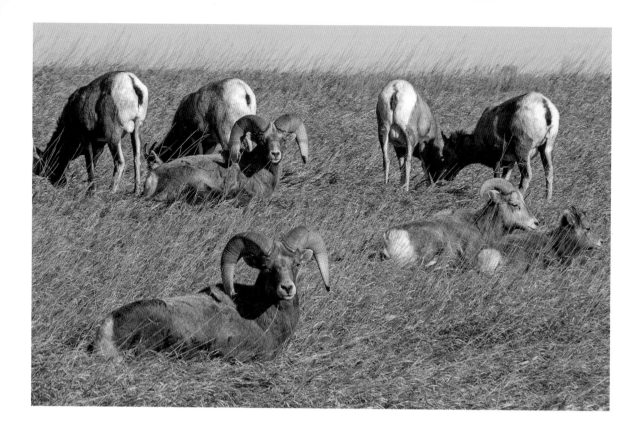

biodiversity. There are, of course, numerous small nature reserves and areas unsuitable for agriculture (such as Nebraska's Sandhills) where you can still see the prairie in its former glory, but the huge migrating herds are mostly gone. Yet, there is hope.

It was long ago realized by ecologists that raising bison on the plains can be much more profitable than raising cattle. Domestic cattle are the descendants of aurochs, recently extinct animals of Eurasian deciduous forests. They are poorly adapted to arid plains. They can't graze well on short grass and so can't coexist with prairie dogs; they can't make use of irregular rainfall by migrating; they need drinking water, so they congregate around small ponds and destroy them by trampling the shores. Bison can actually create prairie ponds (called potholes). The massive mammals like to wallow in the sand, using the same places year after year, and these wallows often develop into ponds over time. Bison love grazing in prairie dog towns, don't need drinking water, and can follow the rains looking for better pastures. So it would seem to make a

Bighorn sheep normally stay close to steep slopes, but in the absence of wolves they lose their anti-predatory defenses and begin to graze on the open prairie.

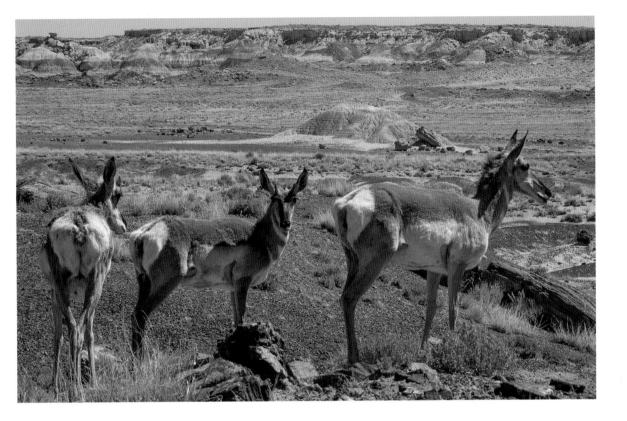

Pronghorn, the fastest land mammals of the New World, are still very common on the plains of Wyoming.

lot of sense to replace domestic cattle with restored herds of wild bison. The problem is, to make the most of raising bison you need to let them migrate, and that means a switch from small private farms to huge communal holdings spanning hundreds of miles. It's a concept that traditionally minded American ranchers—who for decades have hemmed in their property with wire and wood— are unlikely to easily accept. Migrating bison can also be a major traffic hazard, and there are now countless highways crisscrossing the plains.

These problems are formidable, yet in at least one place they are being solved. That place is northeastern Montana, the area of the Great Plains where private agriculture has been particularly unsuccessful. Much of the land there is still public, private ranches don't have much cattle and are often on the verge of bankruptcy, the population is slowly declining, and prairies are better preserved than in any other large area of the plains. For the last fifteen years, a private nonprofit organization called American Prairie Reserve has been

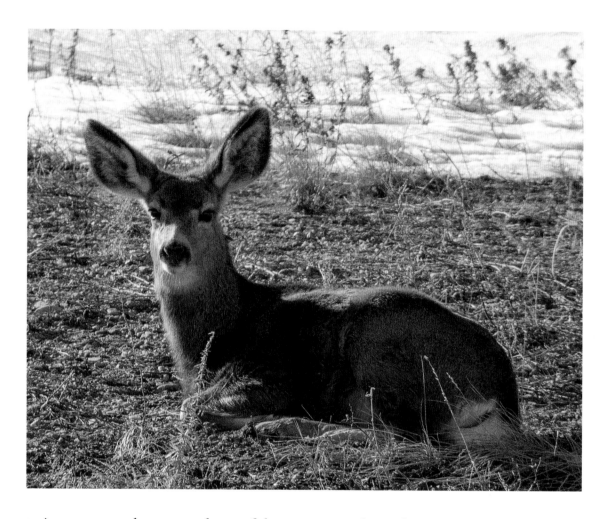

trying to create a huge natural area of the same name there. The idea is to buy and lease enough private land to link together existing public lands and Indian reservations, so that four million acres of prairie could become available for free-roaming bison herds. It is hard work; local landowners sometimes view the effort as a conspiracy to destroy the traditional ranching lifestyle, although it's nothing of that kind. If it somehow succeeds, you may one day be able to see thousands of migrating bison.

For now, you can see small bison herds in national parks, national grasslands, and other protected areas scattered throughout the Great Plains. You can also see plenty of pronghorn—its numbers have largely recovered, particularly in eastern Wyoming,

As soon as spring comes, deer immediately move to the first snow-free patches.

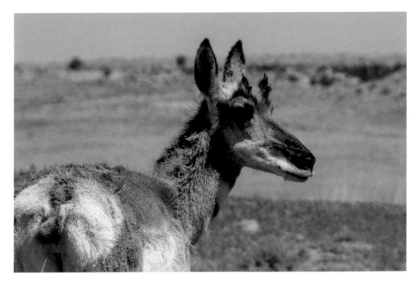

Pronghorn are the last survivors of a unique North American family—the only mammals that annually shed their horns (deer shed their antlers, but it's not the same thing).

although long-distance migrations are still hampered by fences and highways. But generally, wildlife viewing is much better on smaller plains to the west.

Between the Mountains

The mountains of western North America shelter a lot of smaller plains. The largest of these is the Great Basin, a sea of sagebrush desert that covers most of Nevada and huge chunks of adjacent states. To a nonnaturalist, the Great Basin looks a bit boring, but biologists know it is home to a lot of unique wildlife, such as the gorgeous sage grouse and the impossibly cute pygmy rabbit.

Europeans reached many of these valleys later than they did the Great Plains, so the slaughter of local wildlife was less thorough. Also, much of the land here is too dry for agriculture because of the rain shadows created by surrounding mountains; this also helped large mammals survive a bit more successfully in this area. Some pronghorn still conduct annual long-distance migrations. One such migration route is the Path of the Pronghorn in western Wyoming. It leads from Grand Teton National Park, where winter snows are too deep for pronghorn, to the open plains of the Green River Valley. It is more than a hundred miles long, but less than a

hundred and fifty yards wide in some places. Another route has been recently discovered in Idaho, from the foothills of the Pioneer Mountains to those of the Beaverhead Mountains via Craters of the Moon National Monument, a round-trip of one hundred sixty miles.

In many places there are shorter migrations undertaken by herds of deer and elk as they move from summer pastures in the mountains to winter pastures on the plains. Deer in particular find it difficult to survive in deep snow. They solve this problem by concentrating in small, flat areas where large numbers of deer create a network of trails in the snow; these trails are used to escape predators. Hunters often call such places deer parks; in Colorado the word "park" is now used for any enclosed valley in the mountains that deer and elk use to winter. One place where huge herds of deer and elk still gather every fall is the eastern Rocky Mountains National Park.

Probably the most important migration hub for large mammals of the West is the Greater Yellowstone Ecosystem. Its core is, of course, Yellowstone National Park, the largest protected natural area in the lower forty-eight states (at least until the American Prairie Reserve is completed). But when the national park was created, there was a major flaw in its planning. The entire park is a high-elevation area, so almost everywhere within, winter snow can become too deep for large herbivores to survive. Only the bison are powerful enough to plow through the snow with their massive heads, and even they mostly leave the park in winter, moving into the valleys of Montana to the east and north. The pronghorn, deer, and bighorn sheep do more or less the same, while most of the elk move south and winter in one huge herd in the National Elk Refuge near Jackson Hole, Wyoming. This herd once almost starved due to overpopulation after wolves were eliminated from the ecosystem, but now the wolves are back and the numbers are more stable. You can see herds of animals moving up and down the valley of the Yellowstone River that leads out of the park. Unfortunately, the state of Montana sees these herds as legitimate game, and many, particularly the bison, are slaughtered. Since there isn't enough winter

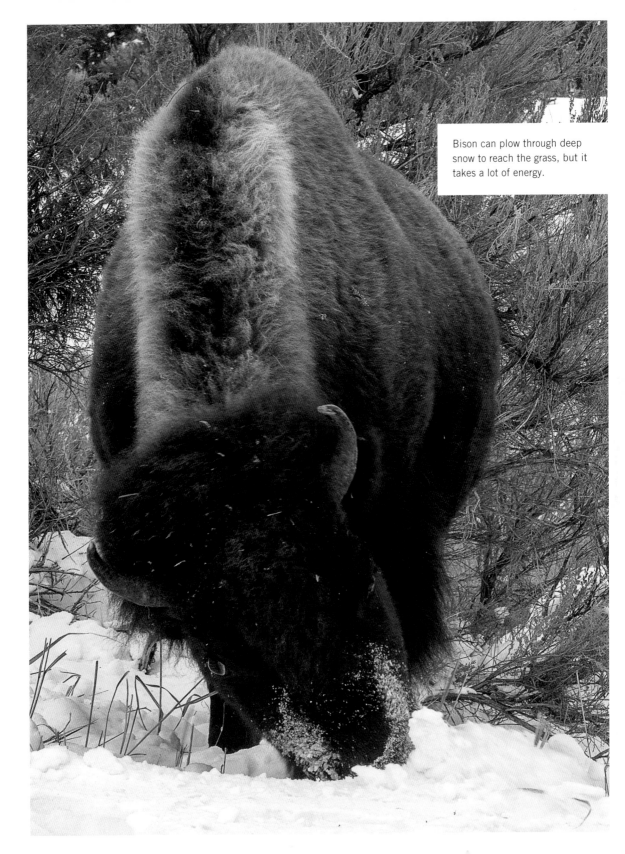

Bison can plow through deep snow to reach the grass, but it takes a lot of energy.

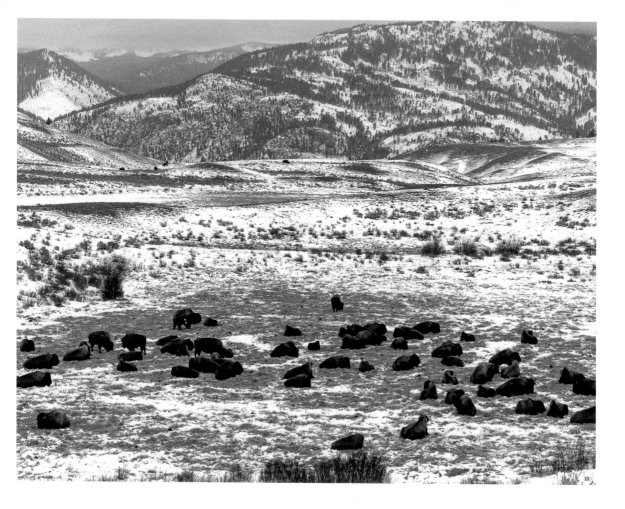

pasture, some bison are also quietly trapped and slaughtered inside the park, away from the public eye.

Some herds don't leave the park in winter, but attempt to survive in Lamar Valley, where the snow is less deep. This is probably the best place for viewing large herds of wild animals in the lower forty-eight states; it's also complete with predators such as bears and gray wolves.

One species that migrates in the opposite direction is the grizzly bear. If not hunted, it prefers to spend summers in open areas, but moves into deep woods and onto rocky slopes in winter to hibernate. Grizzlies used to travel deep into the Great Plains, but now there are very few places (Lamar Valley is one) where you can see them in open grasslands.

Throughout the year, Lamar Valley is one of the best places in North America to see large mammals.

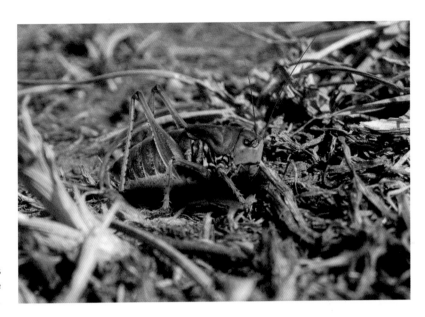

A Mormon cricket is well disguised among the debris-laden prairie floor.

The most numerous migrating herds of the western plains aren't those of large mammals. They are formed by a rather unpopular creature called the Mormon cricket (it is actually a katydid rather than a true cricket). Its name was coined after some of its herds (commonly called bands or swarms) laid waste to the crops of Mormon settlers on the shores of the Great Salt Lake in 1848. The Mormons later credited God-sent seagulls with eliminating the crickets, although contemporary accounts don't corroborate the story.

The natural history of this insect is a bit similar to that of the extinct Rocky Mountain locust. It exists as a solitary morph at low density, then suddenly switches to a migratory morph and rolls over the plains in immense swarms. But there are important differences: the crickets can't fly (although they can walk over a mile per day), their outbreaks can last for many years and even decades, and nobody knows what causes these outbreaks to begin and end.

A moving band of Mormon crickets is a spectacular sight. It looks like a brown blanket, with hundreds of animals per square yard; some herds stretch for miles. The crickets eat mostly herbs, but would consume any plant or animal they encounter, including other Mormon crickets. A recent theory claims that while the crickets in the rear of the band keep moving because there's little food

left for them, those in the front have to stay active to avoid being eaten by others. Just as migrating herds of bison used to be followed by wolves across the plains, Mormon crickets are followed by all kinds of predators, ranging in size from coyotes to shrews. Grasshopper mice are particularly fond of the insect delicacy; as night falls, you can hear the high-pitched howls of the mice all around the cricket bands. Native Americans used to consider Mormon crickets a delicacy and incorporated them in elaborate dishes; now people living on the plains where these insects occur mostly detest them—the swarms devastate crops and can be a major traffic hazard.

Being a zoologist, I find all animals fascinating, so I always enjoy a chance to watch a moving cricket band, with all the predators following it, and all the weird dynamics of the movement. Sometimes you will see mass fights erupting as females battle over males. Male crickets produce packages of sperm called spermatophores; a female eats most of the package and uses the leftovers to inseminate

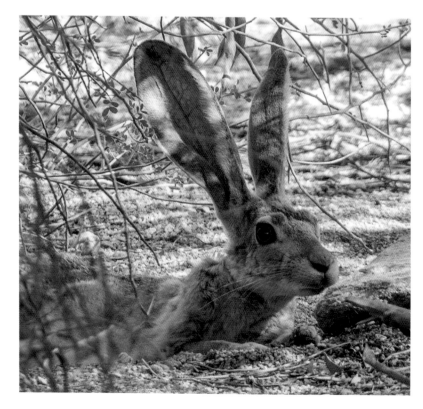

Huge ears help black-tailed jackrabbits of southwestern deserts shed excessive heat.

herself. Since the crickets moving in the rear of the band are always malnourished, fights over males can get pretty severe. Heavily injured females can't keep up with the band and end up being eaten by others. The only part I don't like is having to scrub the underside of my car after driving over a band—if you don't wash it, your car will attract swarms of flies for months afterward.

Another small animal of the intermontane plains known for dramatic population explosions is the montane vole. Its swarms don't move much and try to stay under cover most of the time, but they also attract an astounding variety of predators, particularly birds of prey. In some places the vole populations peak at more regular intervals, usually once every ten to twelve years. Black-tailed jackrabbits can also occur in impressive numbers, especially in the sagebrush deserts of central Nevada.

The Precious Plain

One plain that is unique in North America is the Central Valley of California. It is the largest lowland area of the Pacific coast, and the only large plain on the continent with a Mediterranean climate (with warm, rainy winters and hot, dry summers). The southernmost part is technically desert, but the rest used to be covered with

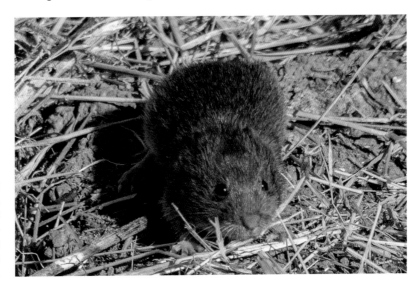

In the years their populations peak, voles and lemmings often become fearless—females will attack if they think you're a threat to their nest.

lush subtropical grasslands and extensive wetlands fed by snow-melt runoff from the Sierra Nevada and other mountain ranges. Nowadays most of the valley floor is covered with orchards and irrigated fields. Until 2010, when a catastrophic drought began, this area had the world's most profitable agriculture, producing about half of North America's fruits, nuts, and vegetables. Almond orchards were particularly cherished. The surrounding hills were heavily grazed by cattle.

The once-large herds of elk (here represented by a small subspecies called tule elk), mule deer, and pronghorn are now gone from the Central Valley, although small groups still exist in protected areas. But elk are not the most interesting of the Valley's herbivores. The region is inhabited by five species of kangaroo rats, all of them endemic to California.

Kangaroo rats are unique to western and southern parts of North America (including Mexico); they live in burrows and show up on the surface at night. Unlike many other rodents, they sometimes react very calmly to a flashlight or headlights, especially if you cover your flashlight with red film. Their numbers in the Central Valley of California peak in spring months, following the rains, when you can sometimes see more than a hundred in one hour if you can find a good remnant of their natural grassland habitat. By the end of the dry season they can virtually disappear, especially if it's a dry year. Right now California is enduring an unprecedented drought, so the kangaroo rats have become all but impossible to find. Considering that three of the five species have lost almost all their range to agriculture and survive in small, isolated populations in marginal habitats, there is sadly a considerable risk of their extinction.

In the deserts of Southern California and other southwestern states you can see other species of kangaroo rats; they can also be a lot of fun to watch.

Nowadays the Central Valley is a sad sight. There's been almost no winter rain since 2011, and little snow in the mountains. The reservoirs and irrigation channels are running dry, and so are many wells. Dead and dying orchards and dusty fallow fields go on for hundreds of miles. It's like the Dust Bowl all over again. There is a

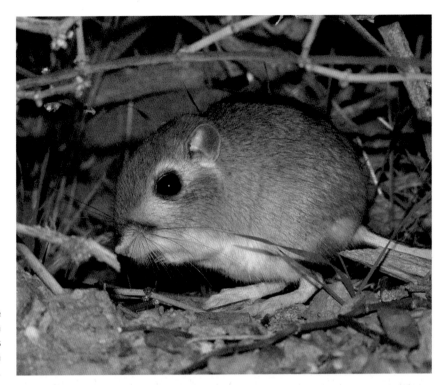

Giant kangaroo rat, the largest species, lives in the remaining grasslands of California's southern Central Valley.

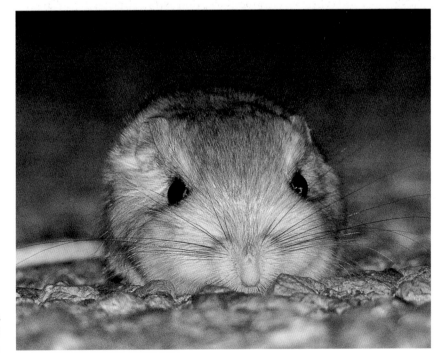

Ord's kangaroo rat is the most widespread species of kangaroo rats.

lot of pressure on the remaining nature reserves as desperate farmers fight for the last water from rivers. It is possible that California agriculture as we have known it might never return; for example, almonds and strawberries might have to be replaced with more drought-resistant, less-profitable crops such as quinoa and dates. Will farming and cattle grazing destroy the last natural habitats in and around the Central Valley before collapsing? It remains to be seen.

The White Silence

If you think driving for two days to cross the Great Plains is boring, try the Alaska Highway. It has a few stretches crossing or skirting unbelievably scenic mountains, but most of the time you're on rolling plains covered with endless forests. And most of these forests are just spruce and aspen; spruce and aspen is all you see for many, many days.

Quaking aspens first appear in small patches in the northernmost part of the Great Plains. This area is the breadbasket of North America, producing lots of wheat. Recently it became a major source of tar sand oil and gas, so it's hardly a wilderness. But a bit farther north there lies a unique region, the crossroads between the Great Plains to the south, the granite plateaus of the Canadian Shield to the east, the Rocky Mountains to the west, and the endless Boreal Plains to the north. Much of this area is protected in the huge Wood Buffalo National Park, the largest in Canada. And one of the park's gems is its population of—you guessed it—wood buffalo, or, more properly, wood bison.

The wood bison is the largest land animal in North America; males can weigh up to 2800 pounds. Just like the smaller subspecies, the plains buffalo, it was on the verge of extinction at the end of the nineteenth century, but is now slowly recovering. The herds at Wood Buffalo National Park have been accidentally infected with brucellosis and bovine tuberculosis; subsequent culls couldn't fix the problem, but there is hope that growing numbers of wolves in the park will be able to weed out sick animals. One particularly

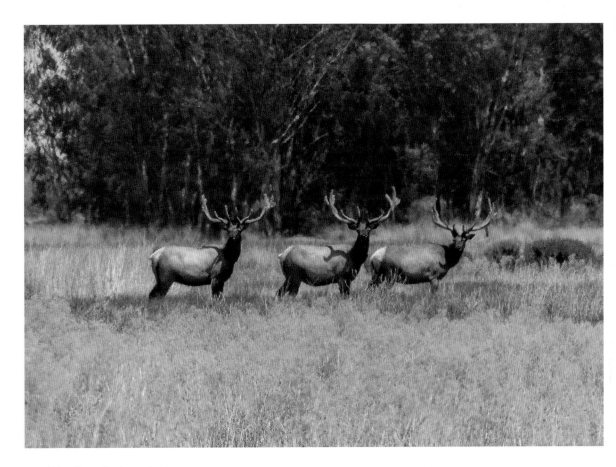

Tule elk are the less migratory of North American deer; they often spend the entire year in the same marsh.

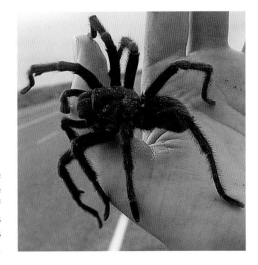

A spectacular sight in the Central Valley of California is the annual migration of hundreds of thousands of male tarantulas that leave their burrows and look for females.

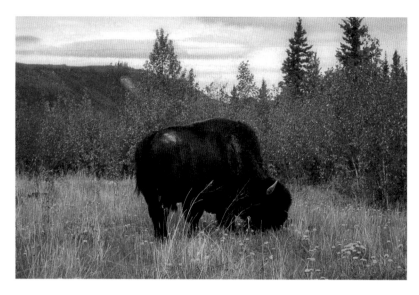

A wood bison in its namesake national park.

thrilling aspect of looking for bison in the park is that you often encounter them in dense forest—suddenly walking into a six-foot-tall bull is an unforgettable experience.

Despite the ongoing reintroduction attempts, wood bison are still very local in their distribution. The Boreal Plains of Canada stretch all across the country, from Labrador in the east to the Yukon in the west, and into Alaska, where they cover the interior of the state and its northern and western coasts. But the only large mammals you can frequently see on these plains are moose, caribou, bears, and wolves, plus a few smaller predators like wolverines and lynxes. Moose and bears don't gather in herds and don't migrate much (although some move far into the open tundra in summer). But caribou do.

The great caribou migration is still one of the largest animal movements in the world. In eastern Canada it is now only a shadow of what it used to be, but in western Canada and Alaska you can see countless herds covering the tundra all the way to the horizon. The length of these migrations differs between populations; some herds living on islands or in the southernmost part of the species' range move only a few miles, while those living in northern Quebec undertake the longest migration of any land mammal, sometimes over 3000 miles per year. These migrations allow them to enjoy the summer on the Arctic coast (where the wind blows away the

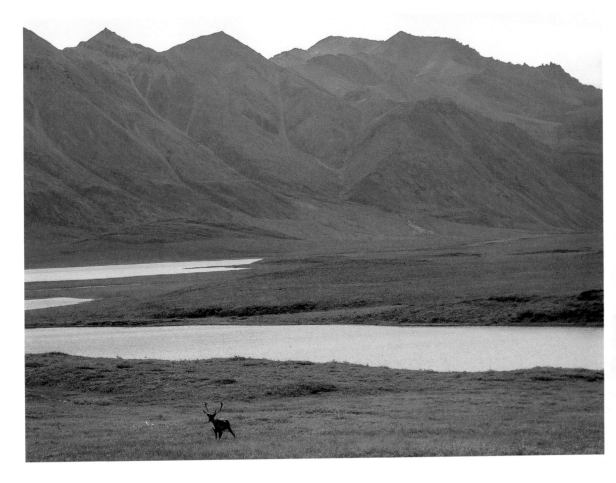

A lone caribou in the Alaskan wilderness.

mosquitoes and other biting insects) and to spend the winter protected from blizzards in dense forests.

This is, of course, a sight to behold, especially in early summer, when females are followed by their newborn fawns, and in late summer and early fall, when males carry huge antlers. Uniquely among deer, female caribou also have antlers. Unlike males, they don't shed them in the fall, and these antlers give the females a critical advantage in winter, when caribou often fight over digs they make in the snow to reach lichens, their favorite food. The lichens grow very slowly, so the migration routes tend to shift a bit every year, although the locations of river crossings remain permanent (many native peoples of the Arctic used to conduct annual hunts in such places). Wolves and sometimes grizzly bears and wolverines follow the herds, killing weaker animals and feasting on carrion.

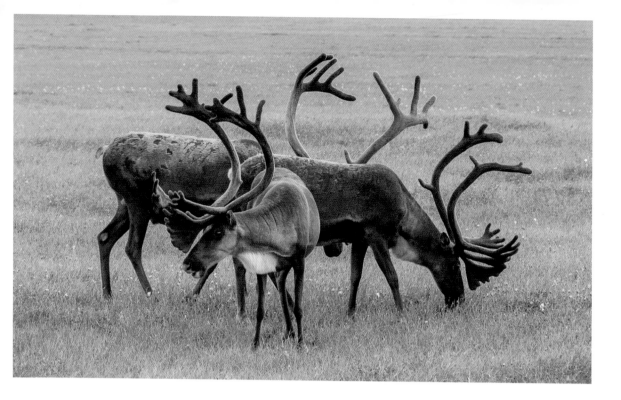

In addition to being a very special sight, moving caribou herds produce spectacular sounds. They make a lot of noises, but the most unusual and persistent one is the loud clicking of their knee and elbow joints. Nobody knows what purpose (if any) these clicks serve in caribou; a recent study found that in eland antelopes of Africa, the clicks are signals of good health and fighting ability. You can sometimes find caribou herds in the forest by that sound.

Male caribou migrating along the Trans-Alaska Pipeline.

The northern part of the Boreal Plains, where the caribou spend the summer months, is covered with tundra. The first European travelers hated the tundra and called it "Barren Grounds," but it is an exceptionally scenic place, especially in the fall when it explodes with purple and golden colors of dwarf shrubs and herbs. The tundra often reminds me of a coral reef: to get the best view of its delicate beauty, you have to lie on your stomach and take a really close look.

The southern parts of the tundra are mostly made up of grasses, sedges, and taller shrubs, often growing in endless bogs. But the drier tundra of hilly areas and the Arctic coast is a marvelous carpet

of lichens and other miniature plants, and prime hiking country. The hikes you can do in places like Denali National Park and Baffin Island are among the best in the world, and you can often see more large wildlife there than in Africa.

The caribou come and go, but the other large herbivore of the tundra remains there all year. It is the muskox. As with almost all large animals mentioned in this chapter, the muskox was once on the verge of extinction, but in this case, the Europeans had little to do with its demise. Native people killed off all muskoxen of Eurasia in prehistoric times, and in North America, this wonderful creature survived only in the remotest corners of Arctic Canada and Greenland. Now the herds are growing and being reintroduced all over its former range.

If you are lucky enough to find muskoxen in the tundra, you can sometimes get very close to them. But be careful: both males and females can charge. If you approach upwind, they can sometimes fail to recognize you as a human and use a defensive behavior normally reserved for wolves and bears: adults make a circle, facing outward and protecting their calves inside. The young calves can be very playful, and once the herd gets used to your presence,

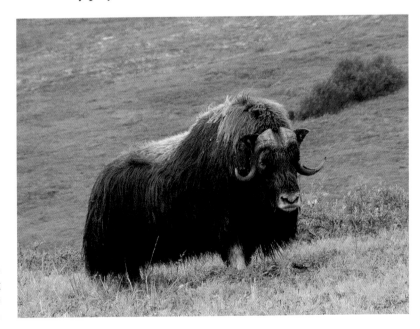

Bull muskox on the tundra. Photographing him at closer range would not be advised.

muskoxen can sometimes approach you and even invite you to play—I once had just such a wonderful experience in the tundra near Nome, Alaska.

Even farther north, on the northernmost islands of the Canadian Arctic, the tundra gives way to the Arctic Desert, a sparse patchwork of crustlike vegetation scattered over mostly bare rock. Muskoxen can survive here, too, and you can also see a strikingly beautiful subspecies of caribou, the small, snow-white Peary caribou. Unfortunately, flying to these islands is so expensive, very few people have had the opportunity to travel there.

If there are no muskoxen or caribou to be seen, don't despair. The most famous migrants of the tundra can be running literally under your feet. They are, of course, the lemmings. Contrary to popular

A muskox family. Calves usually stay inside the herd for better protection.

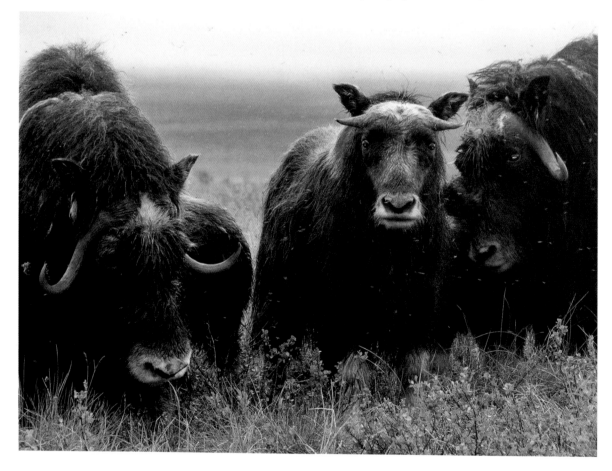

myths, they don't jump off cliffs or drown themselves in the ocean, but they do produce spectacular population explosions once every few years. It is still unclear what causes these explosions, and why they seem to have become less dramatic in the last two decades. It is known that "lemming years" happen at different times in different parts of the Arctic, that on offshore islands they don't coincide with those on the mainland, and that they involve all species of lemmings and voles (close relatives) living in the area.

In normal years, lemmings behave just like most other rodents. They try to stay under cover as much as possible, spending a lot of time in their burrows made in the soil in summer, and in the snow in winter. They are generally very shy. But in lemming years, these creatures become fearless, running around in the open, threatening people, and even trying to bite your feet (a bit unnerving if you are wearing your only pair of rubber boots). There are many similar species of lemmings in the Arctic, belonging to two genera: the true lemmings are mostly brown, sometimes reddish-brown; the collared lemmings are mostly gray in summer and white in winter, and grow claws shaped like shovels in winter months to dig through the snow. The true lemmings prefer wet lowland tundra,

In low-density years, brown lemmings are very shy and inconspicuous.

In lemming years, brown lemmings become common in Arctic towns.

while collared lemmings prefer uplands and other drier areas; the latter occur much farther north than the former. Visiting the tundra during a lemming year is an exciting experience. Not only do you see hundreds of lemmings running around, but you can also find lots of nesting snowy owls, jaegers, and rough-legged hawks. Other birds raise a lot of chicks in these years as well, because the predators are too well fed to bother the chicks. An extra bonus for those lucky enough to be in Alaska during a lemming year is a chance to see singing voles: these small rodents live in compact colonies and greet every visitor with a chorus of high-pitched alarm calls.

The Humid Plains

Compared to the brutal world of the Arctic, the humid plains of North America's Atlantic and Gulf Coasts are the complete opposite. The only similarity is that you can be eaten alive by mosquitoes and biting flies in both places.

Despite the mosquitoes, the East once had plenty of large mammals. Bison migrated in such tremendous numbers that their paths were later used for railroad construction; one such trail can still be

seen in Cumberland Gap National Historic Park (located in the place where the states of Tennessee, Kentucky, and Virginia come together). But European settlers made short work of them; soon the only surviving large herbivore was the white-tailed deer, and even this ubiquitous species was vanishingly rare—hard to believe nowadays. Minimal protection plus habitat alteration and removal of predators have together resulted in a catastrophic population explosion of white-tailed deer all over the East. For most people, the only problems caused by deer are road accidents and occasional damage to gardens, but many forest plants are being pushed toward extinction by overgrazing. The root cause of this problem is the extinction of large predators; although black bears, coyotes, and bobcats kill fawns sometimes, they almost never hunt adult deer. The East used to be inhabited by small wolves known as red wolves in the United States and eastern timber wolves or Algonquin wolves in Canada; these were specialized deer predators. There are very few of these wolves left, but reintroducing them widely into the former range is the only way to make deer populations smaller and healthier.

Being so widespread across the East, the white-tailed deer has evolved into many distinctive subspecies. The most interesting of those are the tiny race (Key deer) living on some of the Florida Keys, and the long-hooved race (McIlheny's deer) that inhabits the lowlands of the Gulf Coast. McIlheny's deer use their long hooves to avoid sinking into the swamps.

VIEWING TIPS

- **Plains bison** herds can be seen in many places, but one of my favorites is Lamar Valley in Yellowstone National Park, WY, where you can also see lots of **pronghorn**, **elk**, and sometimes **mule deer**, **bighorn sheep**, and various predators. Unlike the rest of the park, Lamar Valley can be visited year-round. Other scenic locations are Grasslands and Prince Albert National Parks, SK, Wind Cave and Badlands National Parks, SD, Custer State Park, SD, and Theodore Roosevelt National Park, ND; these places also have lots of other plains species. The American Prairie Reserve is far from being fully created, but you can visit its southern part, Charles M. Russell National Wildlife Refuge, MT. **Wood bison** can be found in Wood Buffalo National Park, AB and NT, and along Aishihik Road, YT.

- The best places to see spring and fall **pronghorn** migration are Craters of the Moon National Monument, ID, and the vicinity of Kendall Campground north of Pinedale, WY. The timing of the migration changes slightly every year, so it's best to call in advance. Large herds can also be seen year-round in Thunder Basin National Grassland, WY, and in Sheldon National Wildlife Refuge, NV; during the summer in Hart Mountain National Antelope Refuge, OR; and in winter near Kremmling, CO.

- Large wintering herds of **elk** can be seen in National Elk Refuge, WY, in the newly created Rio Grande del Norte National Monument, NM, in Sun River Canyon, MT (where they are often joined by **bighorn sheep**), and in the eastern part of Rocky Mountains National Park, CO. Wintering herds of **mule deer** gather along Upper Colony Road north of Wellington, NV, in Boise River Wildlife Management Area, ID, and at Oatman Flat north of Silver Lake, OR; the best place to see their spring and fall migration is Hwy 30 east of

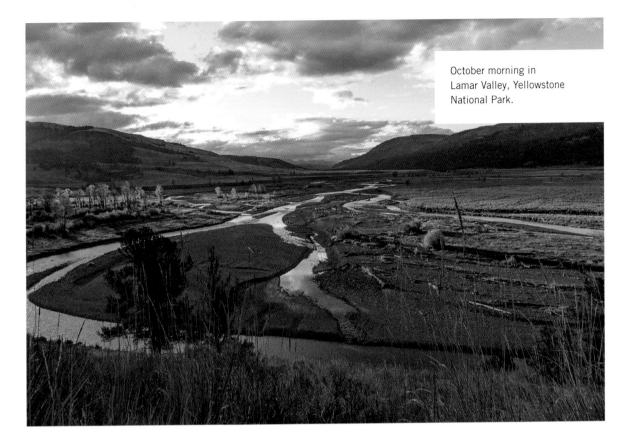

October morning in Lamar Valley, Yellowstone National Park.

Sage Junction, WY, where horrible numbers of roadkill deer attract dozens of **golden eagles** and other scavengers. For large wintering herds of **white-tailed deer**, try the eastern border of Algonquin Provincial Park, ON, Aiguebelle National Park, QC, Dawson Wildlife Management Area, ND, Wenlock Wildlife Management Area, VT, and Maquam Bog in Missisquoi Wildlife Management Area, VT. **Newborn fawns** can be best seen at Big Meadows in Shenandoah National Park, VA. **Key deer** are common at dusk along backcountry roads of Big Pine Key, FL, while **McIlhenny's deer** is most common in Lake Fausse Pointe State Park, LA.

o **Caribou** migration is trickier to see as it mostly takes place in remote areas. Large herds can often be encountered somewhere along Dalton Hwy, AK, Dempster Hwy, YT, Alaska Hwy on both sides of the U.S.-Canadian border, Trans-Taiga Road, QC, and Translabrador Hwy, QC-NL. But to see the best of it you need to arrange a trip

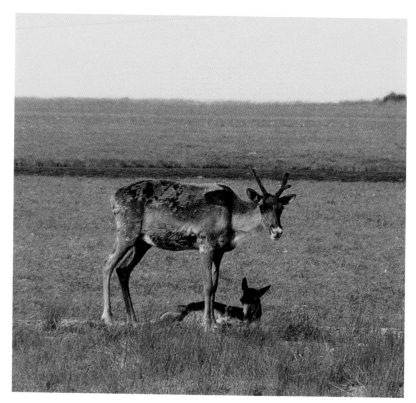

Female caribou with a fawn.

to Kobuk Valley National Park, AK, Noatak National Preserve, AK, or Thelon Wildlife Sanctuary, NU-NT. **Muskox** can also be seen in huge numbers in Thelon; more accessible locations include Anvil Mountain and surrounding hills near Nome, AK, and the northern part of Dalton Hwy, AK, while the largest population inhabits Banks Island, NT. Aulavik National Park on Banks Island is also a good place to see tiny white **Peary caribou.**

○ The last places to see **grizzly bears** on the prairie are Lamar Valley in Yellowstone National Park, WY, and Blackleaf Wildlife Management Area, MT. They are easy to see on the open tundra in Denali National Park, AK.

○ **Montane vole** outbreaks are unpredictable, but one place where they occur somewhat regularly is Silver Creek Preserve, ID. Another place to see vole "plagues" is on Amherst and Wolfe Islands, ON,

where **meadow voles** breed in huge numbers once every few years and attract huge numbers of owls (of up to ten species) in winter. **Lemmings** can be easily seen in lemming years around Nome and Barrow, AK, along Dalton Hwy, AK, and Dempster Hwy, YT, and around any settlement in Nunavut, but figuring out when and where it happens might be tricky; try contacting local departments of fish and wildlife. **Singing voles** can be particularly common around Nome, AK. The best places in California to see large numbers of **kangaroo rats** are Little Panoche Valley (especially Panoche Hills area), Carrizo Plain National Monument, Lava Beds National Monument, and (with a different set of species) Joshua Tree National Park. **Black-tailed jackrabbits** are often particularly numerous along Hwys 50, 6, and 375, NV.

o **Mormon crickets** are also highly unpredictable, but one area where huge bands can often be seen is the vicinity of Dinosaur National Monument, CO and UT.

o At the very edge of the Great Plains, a spectacular snake migration takes place every April and September across LaRue Rd (locally known as "Snake Road") in Shawnee National Forest, IL. The road is closed for vehicles during that time, but you can walk there and see numerous species of snakes and other wildlife. For details, visit http://www.fs.usda.gov/Internet/FSE_DOCUMENTS/ stelprdb5106391.pdf.

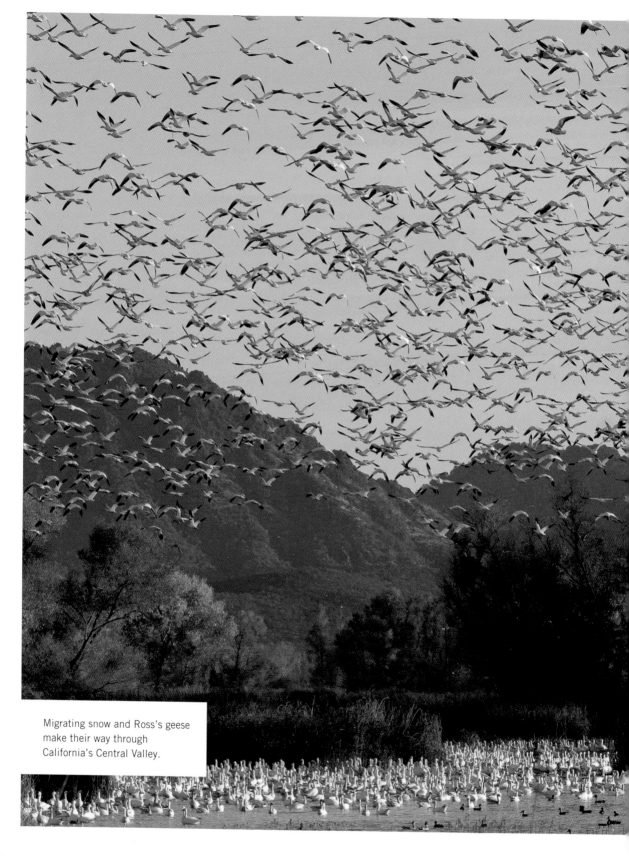

Migrating snow and Ross's geese make their way through California's Central Valley.

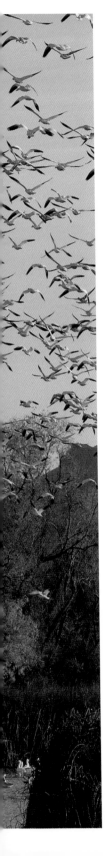

THE GREAT FLYWAYS

Almost all North American birds migrate every year. For some, the migration is less than a mile long, but most have to embark on a long, exhausting, increasingly dangerous exodus spanning hundreds and even thousands of miles. Every species and even subspecies has its own unique routes of migration, but the geography of the continent is such that many get channeled into the same routes for parts of their journeys. These routes, where huge numbers of birds can be seen at the same time, are called flyways. Traditionally, four major flyways are recognized; each of them could be subdivided into smaller ones—but it's easier to not get too technical.

How Do Birds Know Where to Fly?

It's a difficult question, and the answer is far from clear despite centuries of research. We know that they use many different methods of navigation: they can sense the magnetic field, see polarized light (which allows them to know where the sun is even on cloudy days), and follow familiar landmarks. Some theories suggest they also use smells and infrasound (sound waves too low for us to hear). At least some songbirds appear to have built-in star charts in their heads, although exactly how this works is a mystery.

Many large birds such as cranes and geese lead their chicks on their first fall migration, so the knowledge of where to go is transmitted from generation to generation by example and learning. Biologists call this mechanism cultural transmission. But in other species, adult birds leave their breeding grounds earlier, and the young have to find the wintering grounds by themselves. One theory suggests that they have an innate knowledge of compass directions, as well as a pre-programmed switch that tells them to stop when they

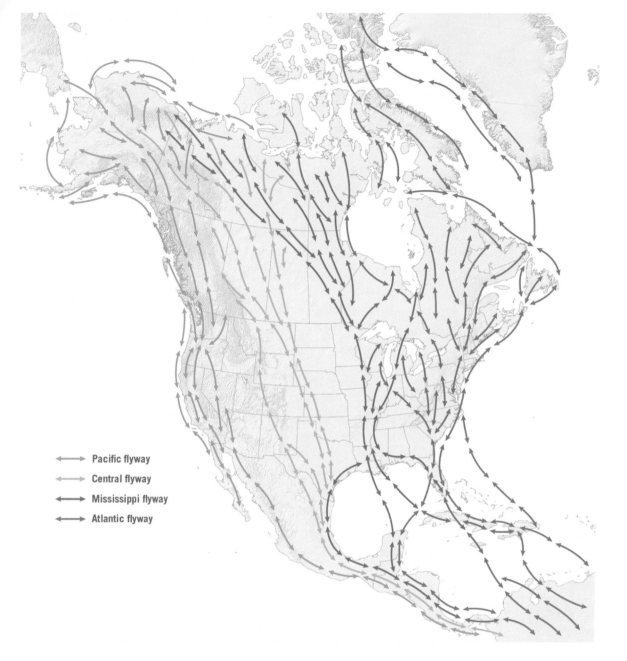

MAJOR FLYWAYS OF NORTH AMERICA

Some species don't stick to the "easy" routes shown here, but do crazy things. A small songbird called the northern wheatear (that breeds in the dry tundras of Alaska and Canada) crosses the Atlantic and winters in Africa. Many Alaskan shorebirds fly across the Pacific and winter in Hawaii, other tropical islands, or even in Australia. To understand the audacity of their choice of route you have to remember that many shorebirds can't rest in the open sea. A medium-sized shorebird called the bar-tailed godwit flies nonstop for seven thousand miles, from Alaska to New Zealand, using a few ounces of fat as its only fuel.

Legend:
→ Pacific flyway
→ Central flyway
→ Mississippi flyway
→ Atlantic flyway

A bar-tailed godwit in the Alaskan tundra.

reach their destination; the cue could be length of daylight, the angle between the Earth's magnetic field and the ground, or something else. This system is less flexible than cultural learning, which might explain why northern wheatears keep flying to Africa instead of wintering in similar habitats in Mexico. Other wheatears all breed in Eurasia and Africa; perhaps as northern wheatears colonized northwestern Europe, Iceland, Greenland, and finally North America, they kept flying to the same area to winter despite having to fly much, much farther. But the cultural learning system has its own weakness: orphaned juveniles have no idea where to fly.

Both systems are prone to errors such as overshooting or flying in a completely wrong direction. Why these errors happen is still unknown, but they result in birds showing up very far from their normal habitats. This is a mixed bag: often a tragedy for the bird, but a delight for birdwatchers. Until recently, dedicated birders paid a sizable sum of money to spend the last week of May on Attu, the westernmost of the Aleutian Islands, where many Asian birds end up after overshooting their breeding grounds in Siberia (now visiting Attu is even more expensive, as the airfield there has been closed). In the fall, unusual Asian visitors often show up in

The California condor has the largest wingspan among North American birds, but migrates only for relatively short distances.

California, probably due to flying southeast instead of southwest. It looks like some birds memorize wrong routes and then stick to them, showing up in unusual locations year after year. Right now there is a beautiful male falcated duck that was supposed to breed in Siberia and winter in China or Japan, but instead has been wintering in a particular marsh in California for four years. An obvious error—but perhaps this is how new migration routes develop.

The Pacific Flyway

The Pacific Flyway begins in the Arctic and ends in the Antarctic. It is so long that only one bird, the Arctic tern, actually flies its entire length—28,000 miles round-trip. Unlike waders, terns can rest on flotsam (if the weather permits) or ship rigging; their reward for traveling six months out of each year is that they can enjoy twenty-four hours of daylight for the other six months (May–July in the Arctic and then November–January in the Antarctic). Other birds use only parts of the Pacific Flyway; in some cases just a hundred miles (like some Allen's hummingbirds that nest near Santa Barbara and winter around San Diego).

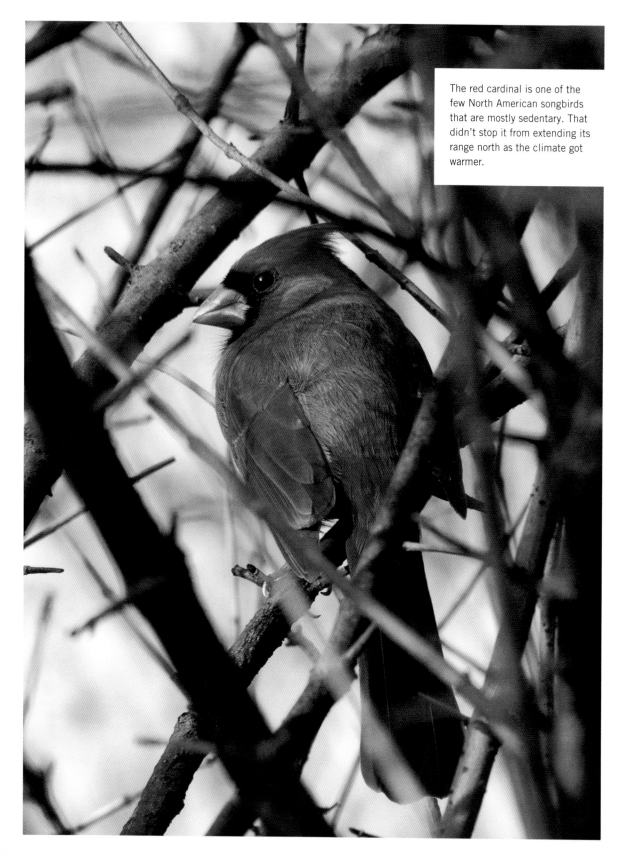

The red cardinal is one of the few North American songbirds that are mostly sedentary. That didn't stop it from extending its range north as the climate got warmer.

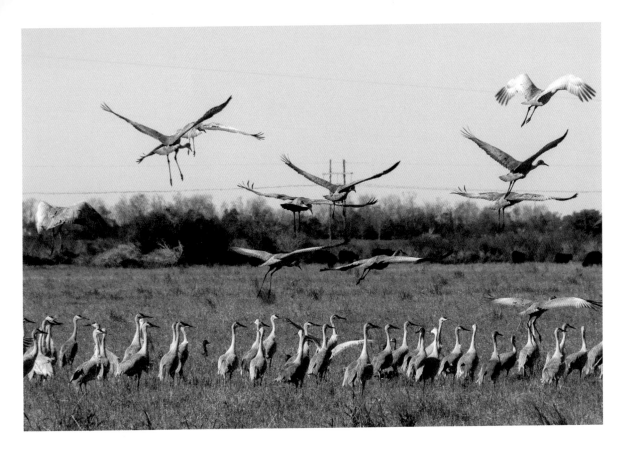

In recent years an increasing number of birds using this flyway have been coming from Siberia. There are two interesting processes involved here. First, some species learn to travel to California, where natural habitats are relatively well preserved and protected, instead of risking a trip to China where wintering birds are slaughtered and poisoned and much of the country has become an endless city with patches of rice fields. That falcated duck I mentioned might be just a scout; other Siberian ducks such as Eurasian wigeons are now regular visitors to California's wetlands. Second, the species that keep wintering in Asia are declining in numbers and being replaced by those that winter in America. The common crane's numbers in Asia are dwindling (it mostly winters in China), while its range is being invaded by the sandhill crane (which winters in California). This is good for American bird lovers who are able to see more birds that would typically winter in Asia, but bad for bird populations in general, as more birds face the dangers of longer migration.

Sandhill cranes are rapidly expanding their range in Siberia, but still prefer to winter in North America.

Birds that don't have to worry too much about aerial predators tend to fly during the day. Raptors, pelicans, and cranes always move during the day as they use the thermals to soar. They often follow landmarks, particularly mountain ridges where the air rises as the wind hits the slopes. In some places raptors congregate in large numbers; ornithologists often set up raptor counting stations (called hawk watches) at such locations. A few raptors such as Swainson's hawks and turkey vultures form "kettles": dozens of birds circling together in particularly good thermals, using them to effortlessly gain altitude. Large birds moving in flocks often use a V formation to reduce drag. Many waterbirds spend late fall and early winter on the inland lakes of Washington, Oregon, and northeastern California, but as these lakes freeze, they move to California's Central Valley, where some of the world's largest and most diverse waterfowl flocks can be seen in January. At sunset, when millions of birds fly from the fallow fields where they feed to the lakes where they roost, the entire sky seems to be moving.

Songbirds avoid hawks and falcons by moving at night and feeding in dense vegetation during the day. They use stars for navigation, and often get lost if there's too much fog. The coast of California is particularly hazardous for them, and on foggy nights certain points shelter numerous helpless songbirds that have lost their way. The most famous such place is a tiny cypress grove near the lighthouse at Point Reyes. The night flight of these birds makes studying their migrations difficult; it's done by recording species-specific flight calls, or by watching the moon through a telescope and counting silhouettes of birds flying across. But most studies are done by catching birds and banding them. There are numerous banding stations around North America. They usually welcome visitors, so if you happen to be near such a station, be sure to stop by. Seeing birds in hand is always fascinating because even familiar species look completely different when you can see the minute details. Their plumage is designed to create seamless color patterns, but up close you can see how these patterns are formed by hundreds of tiny feathers. The only North American birds that can't be banded are vultures. On hot days they cool themselves by spraying liquid

Arctic tern.

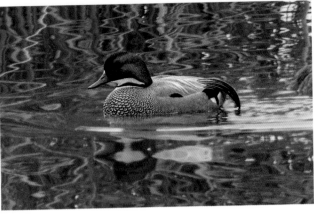

Male falcated duck in California: a lost soul or a brave scout?

feces on their legs, so if you band them, the feces accumulate under the band and can cause a severe inflammation.

Owls also migrate at night; those that try flying during the day usually end up being harassed by crows, jays, and other birds that often become owls' prey after the sun sets. There are a few banding stations specializing in owls; the birds are lured into nets using playbacks of their calls. One species, the long-eared owl, is unusual in its habit of roosting in flocks in winter; some of these roosts can have dozens of birds.

The most mysterious migrants of the Pacific Flyway are black swifts. They nest in sea cliffs and behind mountain waterfalls, but their wintering places are still unknown (swifts fly twenty-four hours a day when they are not breeding, and identifying them as they feed or sleep high in the sky is often impossible). Swifts are too small to fit with radio transmitters or GPS data loggers, but recently a few were equipped with tiny chips recording the changes in daylight timing. When the birds returned to their nests the next spring, the chips were collected, and the data suggested that the swifts had spent the winter somewhere in the Amazon lowlands.

Shorebirds mostly fly along the coastlines. Each species has particular spots where the birds stop at a certain time every year to refuel; these stopover sites are critically important for them. The recent destruction of one such place in Korea has resulted in

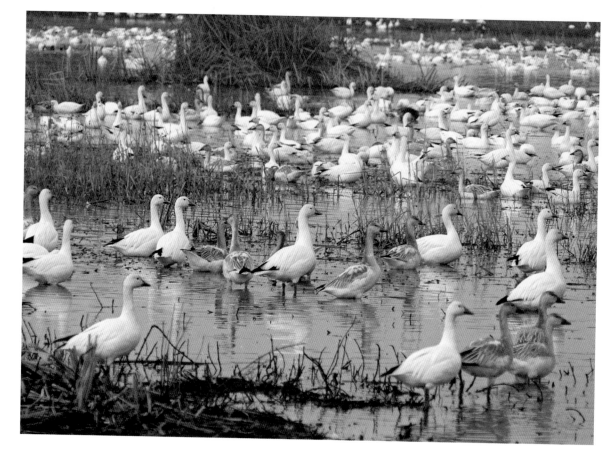

Snow and Ross's geese in California's Central Valley.

catastrophic declines of many Siberian shorebird species. There are numerous stopover sites along the Pacific coast, but the most famous one is Bowerman Basin in the state of Washington, where over a million western sandpipers and other shorebirds can be seen for a few days each spring. The most unusual shorebirds are phalaropes; they breed on the shores of small inland lakes (on the tundra or on the prairie, depending on species), then gather on large lakes and fly to the open ocean, where they spend winters feeding on plankton. Their method of feeding is worth watching: they rapidly swim in tight circles, creating a waterspout like that in a draining bathtub, but moving upward. They then snatch plankton that is sucked to the surface from a depth of ten to twenty inches.

Some migrants are so elusive that they are virtually never seen. One such bird is the tiny black rail. The only place in the world

Two ruby-crowned kinglets.

where your chances of seeing it are better than your chances of winning the lottery is San Francisco Bay—but you have to be there during the highest tide of the year (usually in winter). Rising water forces the rails out of the dense vegetation where they normally live, allowing brief glimpses of them.

The Central Flyway

The Central Flyway is a braided labyrinth, made up of routes that twist their way between and around the numerous mountain ranges of the West before coming together in Mexico. Most of the birds using it choose to avoid the mountains altogether by flying over the Great Plains.

The problem with all these routes is that they cross vast expanses of arid, open landscapes with little food or shelter for waterbirds, shorebirds, and arboreal songbirds. So the available stopover sites such as riparian forests, desert wetlands, prairie potholes, and even

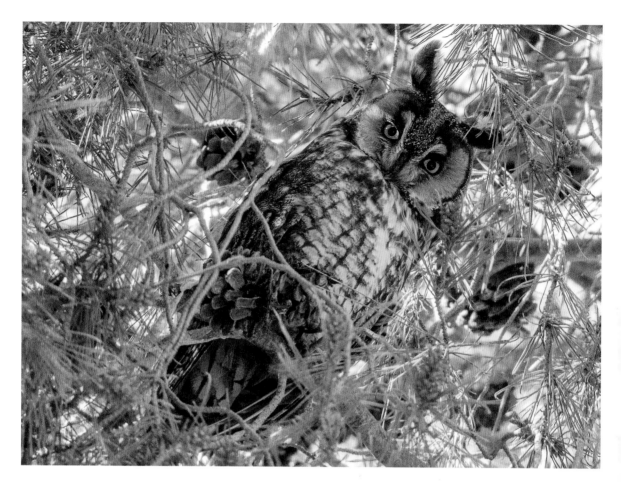

A long-eared owl
at a winter roost.

Ruddy turnstones migrate from
the Arctic coast to tropical
beaches all over the world.

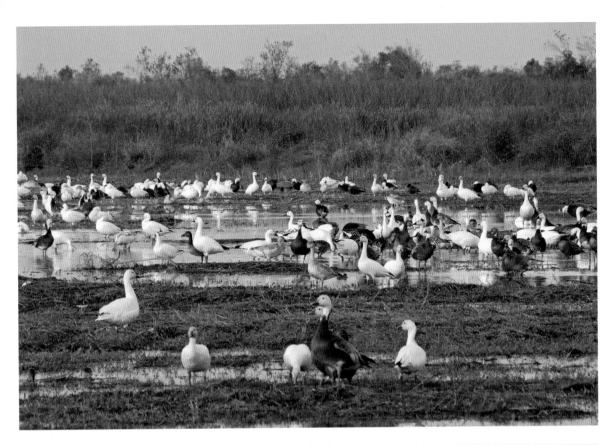

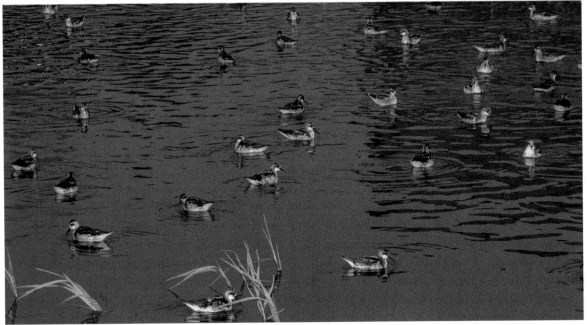

urban parks are precious. So many such places were converted to agricultural land in the early twentieth century that the entire flyway was in danger of being lost. Today it is being painstakingly restored.

Among the most numerous of this flyway's travelers are little waterbirds called eared grebes. They are so small, they can feed on tiny crustaceans that breed in salt lakes, and these lakes are used as stopover sites. In the fall, the surface of large salt lakes is often covered by hundreds of thousands of grebes, all feeding nonstop to fatten up before the next leg of migration.

Eastern snow geese, unlike those in the West, come in two color morphs, white and blue.

In spring, many songbirds fly north along the western coast of the Gulf of Mexico, preferring the warm, moist lowlands to the dry interior plateaus, still a bit cold for insects at that time of year. Two to three times per spring, storm fronts from the northwest roll across Texas, bringing cold weather, rain, and overcast skies. Huge numbers of little migrants have to stop for a day or two, waiting out the storm and desperately trying to find some food on the largely treeless shores. Birdwatchers call these events fallouts and await them eagerly, since they offer the chance to see a lot of birds that are shy and difficult to spot in summer. The main targets are wood-warblers, or simply warblers, members of a subfamily that has spectacularly diversified in North America. Wood-warblers inhabit every patch of forest on the continent, but many of these colorful birds nest high in the forest canopy, or hide in dense undergrowth, or live in just one particular type of forest that isn't that common, so they are much easier to see during the spring migration (fall migration is much less exiting, since many warblers are in dull nonbreeding plumage).

Red-necked phalaropes feeding on plankton at night.

The most famous bird of the Central Flyway is, of course, the majestic whooping crane. Due to regular harvesting of its eggs by Native Americans, it was already rare by the time of European arrival, and firearms brought it almost to extinction. Some accounts by early naturalists praise the heavenly beauty of this species, then proceed to report how the authors massacred nesting pairs to obtain a rare trophy. By 1941 there were just twenty-three whooping cranes

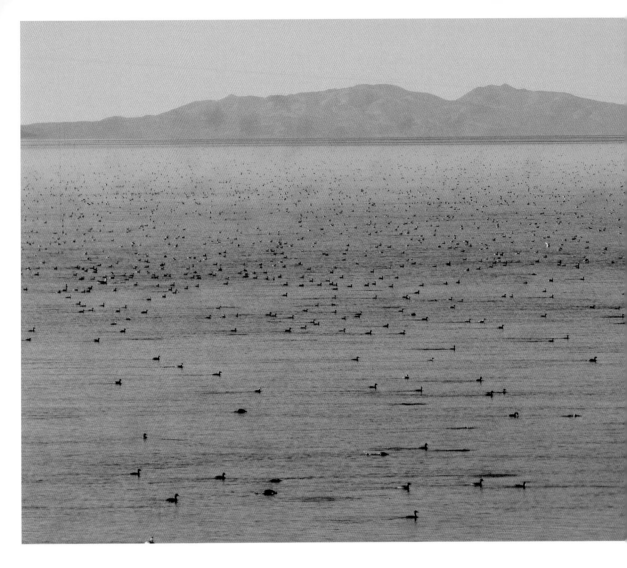

left in the world, and their breeding grounds remained unknown. Later it was discovered that they nest in Canada's Wood Buffalo National Park; the wintering area is a small stretch of Texas coast. Thanks to decades of painstaking work by conservationists, shootings became rare and the flock grew to over two hundred birds; its further growth is limited by die-offs caused by diversions of water from the cranes' wintering habitats.

The risk of the entire population going extinct due to a disease outbreak or some extreme weather event is still high, so there have been many attempts to create new breeding populations in places

Eared grebes feeding on brine shrimp at the Great Salt Lake.

where whooping cranes have historically occurred. Many years ago attempts were made to restore the westernmost population, which once bred in the intermontane valleys of the Rockies and wintered in New Mexico and Mexico. Whooper eggs were placed in the nests of sandhill cranes. But the hatchlings considered themselves sandhill cranes and didn't even try to mate with each other. An attempt was also made to create a nonmigratory population in Florida, where the birds once wintered. This effort also failed, in part because the number of biting insects was too high for the birds to breed. Currently there are two more restoration projects underway, both using whooping cranes from eggs laid by captive adults in a huge breeding center near Baltimore. The hatchlings are raised by people wearing white cover-all costumes and using model crane heads to dispense food. Some of them are then released in Wisconsin, taught to follow an ultralight aircraft, and led on their first fall migration to Florida; they are then expected to return home in spring by themselves. Other hatchlings are released to flooded prairies of southwestern Louisiana, where a nonmigratory population had existed until the early twentieth century.

I once spent a year working on the Louisiana project. It was an extremely emotional experience. The amount of work that goes into such efforts is staggering; few children receive as much love and attention as the precious whooping crane chicks. The rust-colored juveniles are brought to the release site by airplanes and boats; for a few weeks they are kept in a covered pen in the middle of the marsh to let them get used to the surroundings. Then one day the cover is removed and the birds fly out; from that moment they are on their own. They suddenly find themselves in a brutal world where much of their habitat has been replaced by a treacherous landscape of towns, power lines, intensively farmed fields, and hunting lodges, while the numbers of predators such as coyotes, alligators, and bobcats remain high. The primary problem was shooting. We plastered the area with leaflets and conducted talks about whooping cranes at all possible places, from schools to prisons. Local Cajun people were mostly very supportive of our work; farmers would find time to help us even in their busiest weeks of the year. But, not surprisingly

for a place where hunting is a foundation of local culture and even young teenagers carry guns, some birds were shot. Besides shooting deaths, a few died from disease, predation, and other causes—but, amazingly, the majority of chicks survived. It takes three to four years for whooping cranes to mature, so this work is only for the very patient. The program has just welcomed the first chicks to hatch in Louisiana in roughly a century. And if you ever see a flock of these beautiful birds flying over the prairie, you will immediately know why they were worth all the effort.

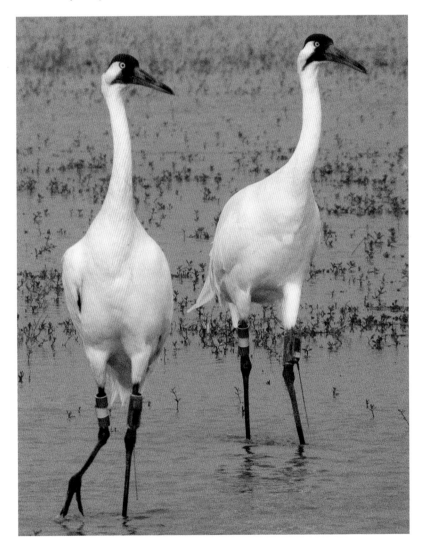

Reintroduced whooping cranes are equipped with satellite and VHF transmitters, so that their movements can be tracked.

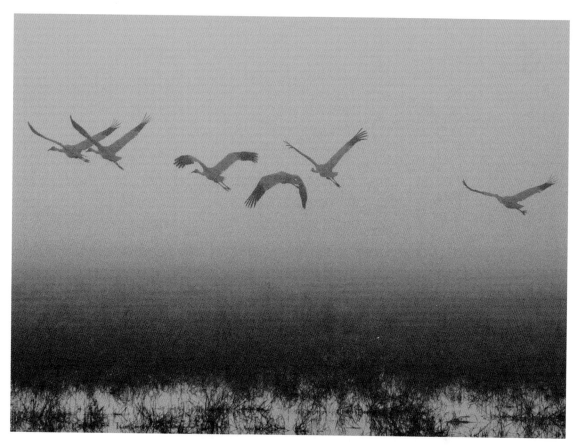

Whooping cranes in
morning fog.

Scissor-tailed flycatcher,
one of the birds using
the Central Flyway.

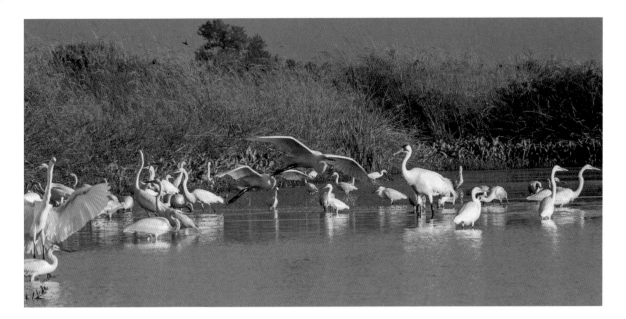

The Mississippi Flyway

Birds that need large wetlands during migration are the predominant travelers along the Mississippi Flyway. Flocks gather from all over the North and the Great Lakes region, fly down the Mississippi Valley, then either spend the winter on the shores of the Gulf Coast, follow the coast to Mexico, or cross the sea to South America.

Waterbirds are particularly abundant on this flyway. The first to arrive in Louisiana in the fall are the green-winged teals, but unlike most ducks, they don't stay here, but continue on to Colombia and Venezuela. The flocks of snow geese and various ducks are no less impressive than in California. In addition to the remaining natural wetlands, waterbirds use rice fields and crayfish ponds; these man-made habitats are perfect for wintering flocks (although trying to nest there usually doesn't work out). Unfortunately, growing sugar cane is often more profitable due to government subsidies, so sugar cane fields are increasing in area. These fields aren't suitable for most birds, and the wonderful world of Louisiana wetlands is now in danger of becoming a dead zone.

Among the birds wintering in the rice fields are rails: soras, Carolina rails, and rare yellow rails. They are very difficult to see

Whooping cranes are again becoming a part of Louisiana's spectacular bird fauna.

unless you watch a farming combine as it harvests the rice and flushes the birds out. Every year, the Yellow Rail Festival takes place in Louisiana; one can either pay to ride a combine, or volunteer to help catch the escaping birds with mistnets and band them. Both experiences are a lot of fun, offering a close view of secretive creatures that few people even know about.

Surprisingly, some of the largest flocks that move though the wetlands of the Mississippi Valley are formed by birds we don't normally think of as wetland species: swallows and martins. Their natural breeding habitats are rocky areas and old forests with lots of hollow snags; recently they have learned to breed in nest boxes or, in the case of some species, under bridges and roofs. But in the fall they form huge flocks and roost in wetlands, spending nights in reeds and cattails before moving south one night. This habit led many early naturalists to believe that these small birds spent winter months hibernating in the mud on the bottom of lakes. Some species spend all winter roosting this way in wetlands; others fly farther south to the tropics and disperse there, feeding over the forests or along rivers. Hundreds of thousands of tree swallows or purple martins coming to their roosts at dusk can be an unforgettable sight.

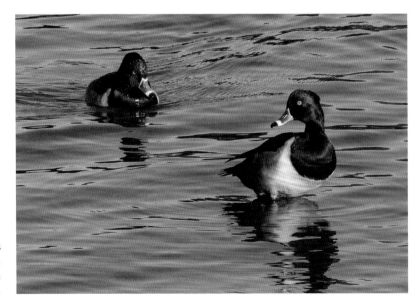

Many beautiful waterbirds can be seen up close on the lakes in downtown Baton Rouge, Louisiana.

In the last few decades, the climate of our planet has changed dramatically. Birds are usually capable of adapting to climate change (those who couldn't aren't around anymore), but this shift is happening faster than anything experienced by our planet in millions of years. The effects of the change on birds are as diverse as the birds themselves. Most species now migrate earlier in the spring and later in the fall; many have expanded their ranges north or to higher elevations, while others are cornered on mountaintops or in the high Arctic and have nowhere to go. Increasingly unstable winter weather in the East, catastrophic droughts in the West, and more frequent hurricanes in the South are all taking their toll. And some birds attempt to adapt in the most unexpected ways. I witnessed one of these adaptations when I lived in Louisiana.

There are many species of hummingbirds in western North America, but only one breeding species in the East, the ruby-throated hummingbird. Although hummingbirds can survive short cold spells by dropping their body temperature and going into torpor, they have to move to warm places in winter, so the northernmost species are accomplished travelers. Some rufous hummingbirds in

A seldom-seen Virginia rail, flushed from a Louisiana rice field during harvest. The birds are banded and tracked.

Cliff swallows, sitting pretty in their mud-pellet nests.

the West migrate between Mexico and Alaska (occasionally over-shooting into Siberia), while many ruby-throated hummers in the East cross the Caribbean to winter in Central America; the eastern migrants cross 600 miles of open water in about twenty hours, burning just four one-hundredths of an ounce of fat as fuel! Their mastery of the air is truly impressive: when our home in Louisiana was hit by Hurricane Isaac, I saw numerous hummingbirds hover at our feeders in winds of fifty miles per hour, something I would never have believed if I hadn't seen it with my own eyes.

In the last few years, western hummingbird species have been increasingly recorded in the East, particularly in Louisiana, in winter. At first they were thought to be just lost vagrants, but their numbers have been steadily increasing, and some individuals have been found to ply the route between the Rocky Mountains and the cities of southern Louisiana year after year (to band hummingbirds, researchers usually trap them in little cages with feeders inside; the birds tolerate this remarkably well and can even be hand-fed if needed). It is now believed that these birds are evolving an entirely new flyway. Instead of traveling from the Rockies to drought-stricken deserts of the Southwest and then to badly

deforested Mexican tropics, they winter in Louisiana, crossing the inhospitable shortgrass prairies by using gardens, hummingbird feeders, and flowering ornamental trees as filling stations. Once in Louisiana, they take advantage of increasingly warm winters, evergreen shrubs in cities, and, again, numerous hummingbird feeders. It is even possible that they have learned to escape cold spells by making quick trips to southern Texas. Of course, this reliance on feeders and planted vegetation makes them increasingly dependent on humans, but this might be a winning strategy, as we continue to modify even the remotest corners of the Earth.

The Atlantic Flyway

The Atlantic Flyway is used mostly by seabirds, waterbirds, and shorebirds. Of course, songbirds and other dry-land migrants travel that route as well, but they usually move in a broad wave across the great forests of the East, and only later separate into two streams, one going to Texas and the other to Florida. Surprisingly, many species (including small songbirds such as blackpoll warblers) take a dangerous shortcut over hundreds of miles of the Atlantic Ocean, flying from the Carolinas straight to the northeastern coast of South America. Others migrate in a clockwise pattern, using the Atlantic Flyway in the fall and Central or Mississippi Flyway in the spring. Why they do it is a mystery; such behavior seems highly counterintuitive, as fall migrants on the Atlantic highway risk running into hurricanes, while spring migrants on the Great Plains often suffer huge losses to sudden snowstorms and thunderstorms. Recent banding studies have shown that at least some birds can sense an approaching hurricane and seek shelter. One godwit fitted with a satellite transmitter began to make the long, straight crossing from Virginia to Guyana, then turned sharply west as a hurricane approached, and made an emergency landing at a small Caribbean island—only to be shot by a local hunter.

The Atlantic Flyway is the most hazardous of the four major routes. Hurricanes often carry tropical seabirds such as frigatebirds far inland, while landbirds get blown out to sea and perish in great

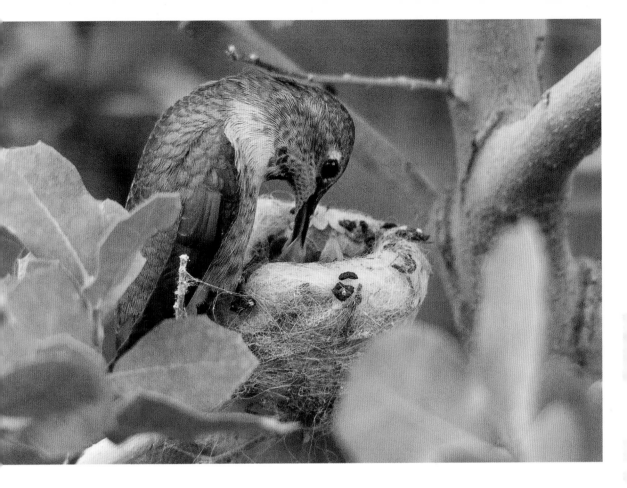

Tiny hummingbirds can be courageous travelers and explorers.

numbers. In 2013, Hurricane Sandy disturbed the surface waters off New England so much that many seabirds there starved; thousands of razorbills had to travel far south of their normal range, showing up in the Gulf of Mexico for the first time in history (I happened to be the lucky birder who recorded the farthermost appearance, at Flower Gardens Banks National Marine Sanctuary, off Texas). Hurricane Wilma of 2005 is believed to have killed more than half of all chimney swifts in eastern North America; many were carried as far as Europe. In addition to hurricanes and northeasters, birds are also vulnerable to cities with millions of outdoor housecats and reflective, glass-covered skyscrapers. The East also has a higher density of power lines and high-speed highways. Overhunting and habitat destruction in the United States are not as pronounced as they once were, but these problems are now

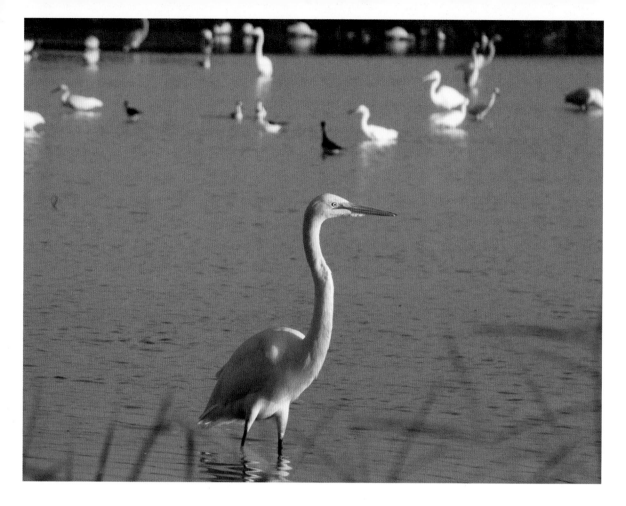

of grave concern in the West Indies and parts of South America.

Not surprisingly, the Atlantic Flyway has lost more bird species than all other flyways combined. The Labrador duck was hunted to extinction in its wintering range in the Northeast; Bachman's warbler couldn't survive the massive loss of its breeding habitat in the Southeast; the Eskimo curlew died out when the pampas of Argentina, where it used to winter, were plowed over. The only North American bird that migrated by swimming rather than flying, the great auk, was hunted to extinction by 1800. Sad facts, indeed, but there is still much to see along this avian byway.

Spring warbler migration can be as spectacular as in Texas; when I lived in southern Florida, I could sometimes count ten to twelve species of these colorful travelers simply by watching the tree

Large numbers of wading birds arrive in Florida come fall, joining the growing local populations.

outside my window. Huge flocks of snow geese and other waterfowl winter in coastal wetlands and shallow bays, particularly from New Jersey to Virginia. The seabirds in the Atlantic Flyway are not as diverse as on the Pacific coast, but they travel in great numbers, and their massive flocks (often called rafts) are easy to see from numerous ferries. In addition, the geography of the land in the East is such that huge numbers of migrating landbirds get funneled into small peninsulas. The most famous sites for fall migrants are Cape May on the northern side of Delaware Bay and Cape Charles on the northern side of Chesapeake Bay; you need only take a quick look at the map to see why.

In spring, hundreds of thousands of northbound shorebirds stop on the coast of Delaware to feed on horseshoe crab eggs. Such bounty is not available to them on the Pacific coast, where there are no horseshoe crabs. Immense flocks of sandpipers include a large portion of the global population of red knot, a particularly beautiful small shorebird. Clouds of sandpipers are always interesting to watch, especially when a passing peregrine falcon tests their aerobatic skills.

Some birds opt to winter in southern Florida's small area of

American robins are as plentiful as they seem—a winter roost can host over a million birds.

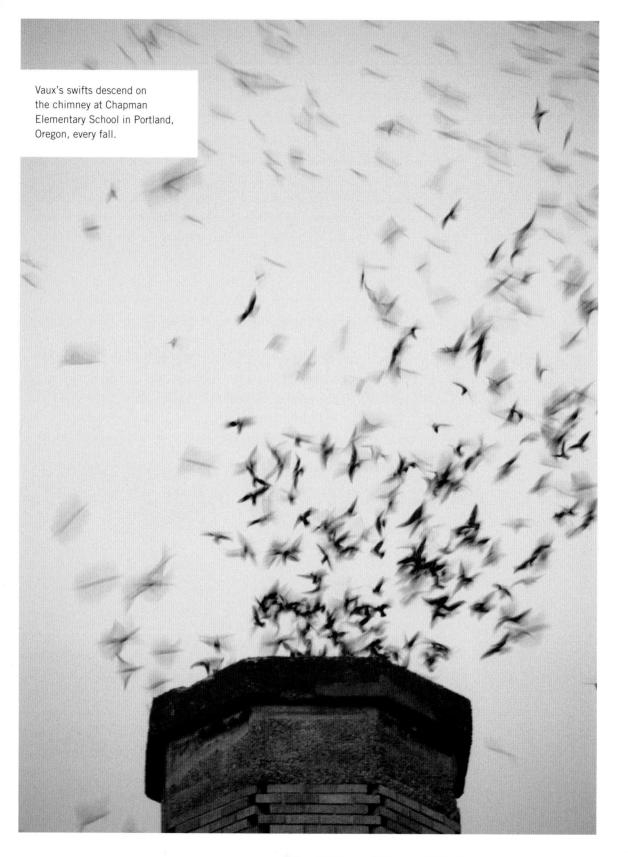

Vaux's swifts descend on the chimney at Chapman Elementary School in Portland, Oregon, every fall.

tropical climate rather than risk a sea crossing. The most numerous of these are American robins: their winter roosts can have over a million birds, weighing close to a hundred tons. Evening flights of thousands of egrets, roseate spoonbills, white ibises, and wood storks over the Everglades are also a sight to behold.

Perhaps the strangest bird gatherings are those of chimney swifts. These small birds feed on so-called aerial plankton (small flying insects); they breed in eastern North America and winter in South America. They used to nest in hollow trees, but now prefer man-made structures such as abandoned wells, old smokestacks, and particularly chimneys. In August, chimney swifts begin gathering at night in certain chimneys, and soon over 100,000 can be seen entering the chimney at dusk. They first fly above it in circles, and then form a living tornado, entering the chimney at dangerously high speed. The entry usually begins about fifteen minutes before sunset and takes about half an hour. Peregrine falcons sometimes attempt to catch them, but are usually more successful in the morning, when the swifts emerge from the chimney and need time to gain speed and altitude. In spring, the swifts also form communal roosts, but these are much smaller. Unfortunately, changes in architectural styles have created a shortage of nesting sites for urban chimney swifts, so many don't breed and stay in communal roosts all summer. You can create a swift colony by building a chimney swift tower; cheap designs can be found online.

Chimney swift has a close relative in the West, called Vaux's swift. Vaux's swifts usually have smaller communal roosts, but the largest known roost has over 30,000 birds.

Short-Range Migrants

Of course, not all birds fly great distances every year. Migration is costly and dangerous, so if a bird can find enough food closer to home, it would rather stay there. The colder it is outside, the more food birds need to maintain body temperature; this is one of the reasons the proportion of sedentary birds increases from north to south. Many birds are short-range migrants; they do leave home,

but don't go very far. This lifestyle requires less complex navigation than long-distance migrations, so many such birds don't have well-defined migratory routes, but are nomadic and spend winters moving opportunistically around the continent. Such behavior is particularly common among birds that depend on unreliable food sources. Crossbills and piñon jays have to look for areas where the conifers they feed on have produced enough seeds that particular year; many raptors and owls have to find places with peaking populations of lemmings and voles. In some species, such as ravens, goshawks, and large owls, younger birds are more migratory than older ones, probably because the adolescents don't have good territories and have insufficient foraging skills for surviving the northern winter.

In some years, such nomadic birds suddenly show up in great numbers outside their normal range. The reasons for such invasions (called irruptions) are poorly understood; they might be caused by a food shortage, an unusually successful breeding season, or both. In most cases it is also unknown if such birds mostly perish in alien habitats or successfully return home. In the winter of 2012-13 there was an unprecedented irruption of red-breasted nuthatches in the Gulf Coast, far south of their usual wintering range. To everyone's surprise, most of them appear to have survived, since this species' numbers up north the following summer were even higher. This is not always the case—the irruption of razorbills into the Gulf of Mexico the same year resulted in mass mortality, with thousands of dead birds washing up on Florida beaches.

Perhaps the most spectacular of North American irruptions are those of snowy owls. These strikingly beautiful birds cause excitement even among those typically uninterested in nature and its creatures. In most years, snowy owls winter in open landscapes north of the U.S.-Canadian border, but once or twice per decade they invade the United States in considerable numbers. One of the greatest recent invasions was in the winter of 2013-14, and involved many hundreds of birds. About twenty showed up on the grounds of Logan International Airport in Boston, and a dozen could be seen in one day on the coast of Rhode Island. These cold-eyed denizens

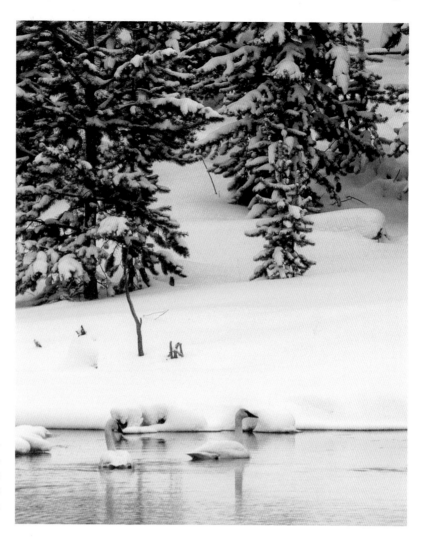

The migratory behavior of birds can be very flexible. Trumpeter swans mostly migrate, but some overwinter at hot springs in Yellowstone National Park.

of windswept Arctic tundras looked thoroughly out of place among landing airplanes, quaint weekend homes, and green golf courses. One owl even made it to Hawaii; it would probably have had trouble surviving there with no voles or lemmings, but we'll never know: when it settled at Honolulu International Airport, local authorities considered it an air traffic hazard and shot it. A few years earlier another snowy owl had suddenly appeared on the coral sand beaches of Bermuda; it quickly learned to hunt critically endangered cahows (Bermuda shearwaters) and killed off a sizable chunk of their global population before also being shot. Of the owls that invaded the Great Lakes area, New England, and the mid-Atlantic

Crossbills are among the best-known irruptive species.

states in 2013, some died before the year's end, but most survived until spring and presumably returned safely to the Arctic.

Nomadic birds often form immense flocks. Unfortunately, the species that once formed the largest flocks (about three and a half million birds in one case) has been hunted to extinction. It was the passenger pigeon: a typical irruptive nomad, traveling around the great deciduous forests of the East, and nesting in humongous colonies wherever the forest trees produced a good crop of acorns, nuts, and other fruit. Since the passenger pigeon's extinction, tree species that depended on the bird for spreading their seeds, particularly the white oak, have gone into decline. Passenger pigeons represented about thirty to forty percent of all birds in North America, so their loss was probably a heavy blow for many predators as well. Another spectacular nomad, the Carolina parakeet, was also hunted to extinction around the same time.

Now the remaining nomadic landbirds with the largest flocks are two closely related species of blackbirds, the red-shouldered and the tricolored. You can still see flocks of red-shouldered blackbirds, up to a hundred thousand strong in some places, despite the fact that local farmers often hate them and illegally shoot or poison the

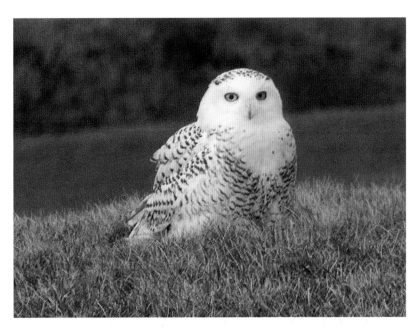

This snowy owl spent three months on the coast of Rhode Island.

birds. But the tricolored blackbird, which used to have even larger flocks, is in serious trouble. Most of the natural wetlands within its range have been lost to agriculture, so it has to nest in fields, where entire colonies end up being destroyed by harvesting equipment.

Large feeding flocks of blackbirds look quite impressive; they move in leapfrog manner, with birds from the back of the flock constantly flying forward to take the lead. Two other species, the still-common brewer's blackbird and the increasingly rare rusty blackbird, often join these mixed flocks, as do cowbirds and European starlings. But the largest flock I've ever seen consisted only of tricolored blackbirds; I estimated the number of birds to be around 60,000. This sighting was in the plowed ex-prairies of southwestern Louisiana.

The introduced European starling is another nomad that forms huge flocks in winter. These flocks are famous for the amazing aerial maneuvers performed by thousands of birds apparently in absolute synchrony. Scientists have gone through many years of research and a lot of computer modeling to figure out how the birds do this, but they still don't fully understand the dynamics. There is no leader in a flock; each bird is capable of simultaneously

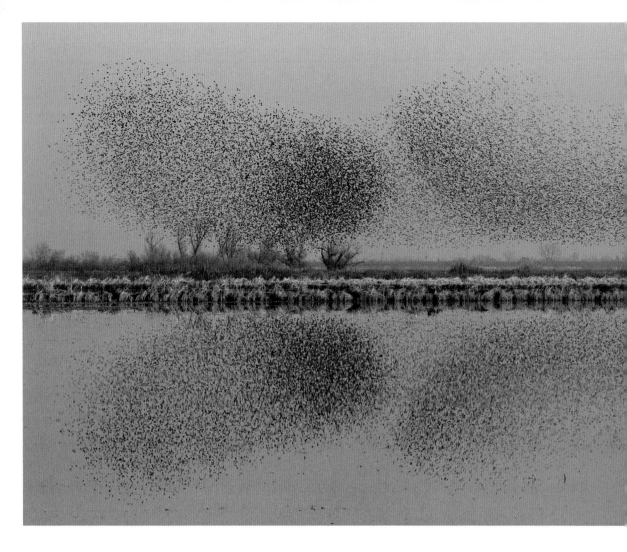

Starling flocks can form cloudlike masses.

monitoring up to seven of its nearest neighbors and tries to maintain a position that gives it a clear view of its surroundings. How does this create the beautiful undulating motion of starling flocks? The (partial) answer is five pages of complex mathematical equations best not reproduced here.

The European starling is an invasive species, often destructive for native birds and agriculture, but it's not the most unpopular bird in North America. That honor belongs to a rather harmless native, the American crow. Despite being persecuted as "vermin," crows have managed to increase their range and numbers as the destruction of native habitats progressed. Highly intelligent, they

gradually learned to live side by side with people, and in the second half of the twentieth century started forming huge urban roosts, often on university campuses. These roosts allowed them to escape shooting by farmers and predation by great horned owls, but there was a price to pay: such huge concentrations of birds were susceptible to disease and parasite infestations. In the 1970s and 1980s, some roosts numbered over a million. Local authorities, swamped with residents' complaints about the noise and the increasing need for cars to be washed, tried to scare the birds away by using fireworks or even shooting some of them, but the crows would simply move a few blocks away.

After peaking around the turn of the century, the number of crows in roosts nationwide began to decline, probably due to intensifying agriculture and improved garbage processing. Great horned owls began breeding in cities, too. West Nile virus was accidentally introduced and hit dense crow populations particularly hard. The cost of spending nights in urban mega-roosts apparently became too high. Nowadays there are almost no roosts with more than 10,000 birds. They are still quite impressive and worth watching,

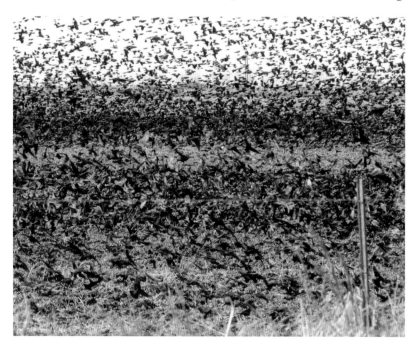

A mega-flock of red-shouldered blackbirds.

of course. Flock after flock arrive from faraway fields and settle in a few trees, silhouetted beautifully against the sunset. Sometimes crows will gather in one place (called a staging area), and then just before complete darkness falls, they all take off and move to the real roost nearby. Nobody knows why they do this. Roost locations tend to change with time: every few weeks or months the birds will find another clump of trees and gradually move there, probably in an attempt to leave some of their parasites behind.

Other birds also form large roosts in cities. You've probably seen noisy roosts of starlings and common grackles at brightly lit gas stations or freeway rest areas. In many towns there are egret, vulture, pigeon, and sparrow roosts, but none as large as those of crows.

Some birds conduct very short migrations. For example, many species of grouse feed on conifer needles in winter and can spend many weeks in the same clump of trees. But to digest this hard food, they need to swallow small pebbles; the pebbles are stored in the stomach and, as the stomach contracts periodically, the stones grind the needles (the scientific term for this mechanism is a gastric mill). But finding small pebbles in boreal forests is not easy,

The willow ptarmigan feeds on conifer needles, swallowing small pebbles to help grind and digest the needles.

A large crow roost assembles at dusk.

particularly in winter. So every fall and spring the birds make trips to gravel roads and load up on pebbles on roadsides. Driving forest roads in the North, particularly in remote parts of Canada and Alaska, you can sometimes see hundreds of birds per hour: ruffed grouse, spruce grouse, blue grouse, and rock and willow ptarmigan. Many of these birds have never seen a human or a car before, and are amazingly tame.

Hoary bats travel long distances during migration, reuniting in Mexico in the fall.

Bats

Birds are not the only animals traveling along the flyways. Bats also migrate. Their routes are much less known, but it is thought that almost all North American bats migrate in winter. Many species move only short distances to hibernate in caves, but others fly to Mexico or even to South America. Just as with birds, some species partially migrate and partially winter within their summer range.

This is apparently the case with beautifully colored red bats and yellow bats: they are sometimes found in winter, hibernating in clumps of Spanish moss or in a thick layer of fallen leaves, or even flying around on warm nights. But every fall a few of them show up on Bermuda and other remote islands, apparently on their way to the tropics.

The greatest traveler among North American bats (and, consequently, the one most often killed by wind turbines) is the hoary bat. It is such an excellent flier that it has colonized Hawaii (at least twice, according to recent genetic data) and has shown up in Europe a few times. Its migratory pattern is very strange. Males mostly spend the summer in the Southwest, while females spread out as far as Hudson Bay. In the fall they reunite in Mexico, although some females overwinter in trees growing along the seashores, or fly to South America via the Caribbean.

Insects

Insect migrations are even more mysterious than those of bats. Many North American butterflies are known or suspected to migrate south in the fall, including the mourning cloak, the West Coast lady, the American lady, the painted lady, the red admiral, the Gulf fritillary, the long-tailed skipper and the American snout. The painted lady is a nomadic species known to produce occasional irruptions in many parts of the North where it doesn't normally occur. Its migrations in the Southwest can be quite spectacular, but have never been studied; research in Europe has shown that painted ladies from Britain migrate as far as North Africa. The American lady doesn't normally occur in Europe, but a few have shown up there during the migration season; it has colonized the Canary Islands and Hawaii. The red admiral also colonized Hawaii a long time ago; today the Hawaiian settlers have evolved into a new species called Kamehameha butterfly. Gulf fritillaries show up in great numbers on the Gulf Coast every fall, but nobody knows where they go from there: possibly Cuba, or Central or South America.

Long-tailed skippers migrate in swarms along Florida coasts. American snouts possibly don't migrate every year, but when they do, it can be an outstanding spectacle: in 1921, an estimated six billion butterflies crossed from Texas into Mexico in just eighteen days.

But, of course, the most famous traveler among North American butterflies is the monarch. It is unknown why monarchs migrate; the closely related species called queen prefers to overwinter in its extensive summer range (although some queens migrate to eastern Mexico). Like other butterflies, individual monarchs don't complete the annual cycle of migration; instead, they breed on their wintering grounds and also along the way in spring, so the butterflies returning next year are the children or grandchildren of those that have left in the fall. Nothing at all is known about their navigational system; it is apparently prone to errors similar to those made by birds, so stray monarchs have reached Europe and Africa. In 1840 they invaded Hawaii and have since colonized much of Oceania, Australia, New Zealand, and Indonesia.

Monarchs follow a network of flyways remarkably similar to those used by birds. Some fly along the Atlantic coast to Florida, where they remain fully active all winter, or to Cuba. A few overwinter along the Gulf Coast or cross the Gulf of Mexico. But the majority of monarchs living east of the Rockies cross Texas (either along the coast or through the Hill Country) and fly all the way to the mountains of Central Mexico. The wintering sites of these millions of butterflies weren't discovered until 1975. All monarchs gather in a few old-growth patches of fir trees, and hang from branches in immense congregations. On warm, sunny days they fly around, feed and breed, but sometimes they have to hang in those trees for weeks, waiting out snowstorms and freezes.

It is still unknown where monarchs of the Southwest go; they might simply move a short distance across the Mexican border, or they might form wintering swarms in some yet undiscovered places. Some have been found to join eastern and western monarchs in their wintering sites. Monarchs living along the West Coast move to California (although a few have shown up at the wintering sites in central Mexico) and winter in tree groves in the coastal fog belt.

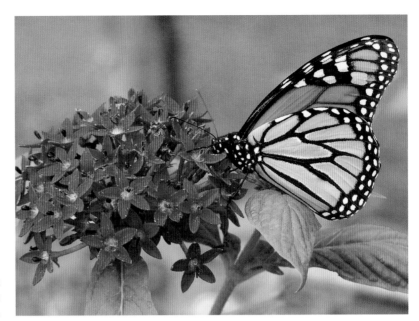

The majestic monarch butterfly, in contented feeding mode.

Red admiral, one of the very few butterflies to have reached Hawaii.

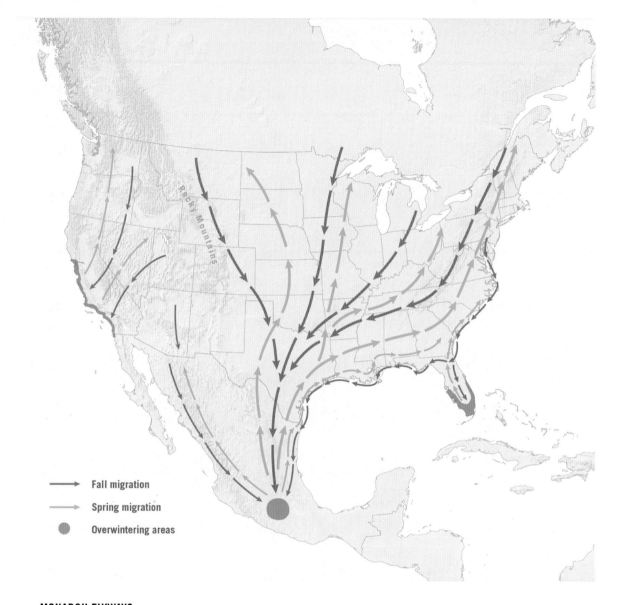

MONARCH FLYWAYS

Their wintering sites in California are well known, protected, and easy to visit—a must-see if you happen to be in California in late fall or early winter. The monarchs disperse as early as February and sometimes January.

Monarch populations are now declining throughout North America, but particularly in the Midwest. The main reason appears

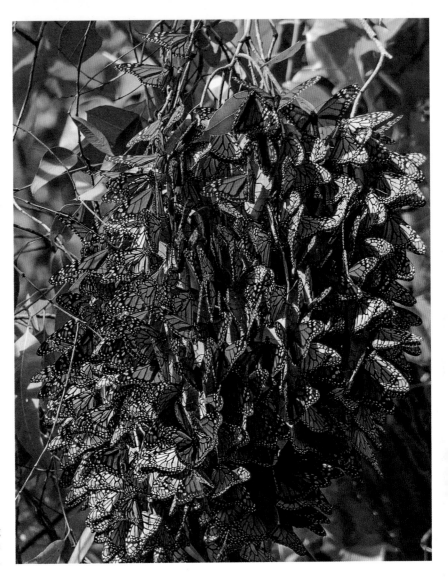

Wintering monarchs in California.

to be the increased use of herbicides that kill milkweed—the food plant of monarch caterpillars. In addition, the warming climate might allow the monarchs to overwinter throughout the South without migrating to specific sites.

Many other insects are known or suspected to be migratory. The list includes beetles, leafhoppers, a tiny insect called a greenbug, and many species of moths, including some hawk moths and a few huge tropical species that invade Texas following the beginning of summer rains in Mexico. One of these tropical visitors,

Convergent ladybugs
gather in a California
redwood forest.

The extremely camera-shy dwarf shrew, one of our smallest mammals. It lives in the Rockies and feeds on army cutworm moths in summer.

the mysterious black witch moth, disperses all the way to Canada and then flies back through the Gulf states, but in such low numbers that many people living there have never seen one. Migratory grasshoppers sometimes travel in huge swarms over the northern Great Plains.

Many dragonflies also migrate. They move in mixed-species swarms usually dominated by the green darner, a large, beautiful dragonfly. Green darners are particularly common in summer in the northeastern United States and southern Canada, and can migrate as far south as Honduras. It appears that most species have resident as well as migratory individuals; weather patterns determine which strategy will prove more successful in any particular year. Migrating swarms make long feeding stops along the way, and can take months to reach their destination. Some wetland areas along the Gulf Coast are particularly popular as stopover sites, and if a few swarms stop there at the same time, the commotion can be really spectacular: one wide-angle photo taken at White Lake in

Louisiana was later found to contain images of more than 16,000 dragonflies.

Black witch moth in Louisiana.

My most memorable encounter with migrating insects happened in Colorado. Every summer, huge numbers of army cutworm moths (commonly known as miller moths) migrate west from the Great Plains to feed on the nectar of alpine flowers in the Rockies. During the day they hide in talus slopes above the tree line. I was driving late at night to the summit of Mount Evans and suddenly entered a swarm so dense, it looked like a blizzard. Attracted by the headlights, thousands of moths began to land on the pavement, quickly covering it in a thick layer. A coyote showed up out of nowhere and began running like crazy in front of the car, gulping up mouthfuls of moths (I later learned that black and grizzly

bears have been observed doing the same—in parts of the Rockies the moths can become the main food source for grizzly bears for a few weeks). I had to turn the headlights off, and was lucky to have a near-full moon to light my way.

One species of ladybug, called convergent ladybug, is also known to migrate to the mountains. Millions of these beetles gather on certain mountaintops from Arizona to Montana in midsummer (supposedly to wait out the heat) and in ridgetop forest clearings of coastal California in winter (supposedly to wait out the cold). Why does this particular species engage in such behavior while others don't? It's still a mystery, just like almost everything else about insect migrations.

VIEWING TIPS

○ Every state and many counties have Audubon Society chapters where you can get detailed information about the best places to see migratory birds, as well as locations of hawk-watch and banding stations. There are also Internet forums where you can find up-to-date information about bird sightings in every state and ask for advice; they can all be seen together at http://birding.aba.org.

○ The most famous places to look for rare vagrants (birds outside their normal range) are the Aleutian Islands and other Bering Sea islands, AK, Point Reyes Lighthouse, CA, Farallon Islands, CA, far southern Texas, Dry Tortugas National Park, FL, Key West, FL, Bill Baggs Cape Florida State Park, FL, and Newfoundland.

○ **Snow geese** and other wintering **waterbirds** gather in huge numbers in the various wildlife refuges of California's Central Valley. Their distribution changes from year to year, but often the best places are Sacramento and Colusa National Wildlife Refuges and Gray Lodge Wildlife Area. Other good places, often with **tundra swans**, **trumpeter swans,** and **American white pelicans** in addition to other **waterfowl**, include Klamath National Wildlife Refuge, CA-OR, San Francisco Bay National Wildlife Refuge, CA, Mono Lake, CA, Stillwater National Wildlife Refuge, NV, Umatilla National Wildlife Refuge, OR, Skagit Wildlife Area, WA, Ridgefield National Wildlife Refuge, WA, Conboy Lake National Wildlife Refuge, WA, Reifel Migratory Bird Sanctuary, BC, Courtenay, BC, Lake Laberge, Yukon, Copper River Delta, AK, and Yukon Flats National Wildlife Refuge, AK. For large flocks of **black brant**, try Izembek National Wildlife Refuge, AK, in early fall, Willapa National Wildlife Refuge, WA, in late fall, Humboldt Bay National Wildlife Refuge, CA, in early spring, and Qualicum Beach, BC, in late spring. **Sandhill**

cranes winter on Staten Island, in Woodbridge Ecological Reserve, and in Gray Lodge Wildlife Area, all in California.

○ The best place to see wintering **snow geese** and **sandhill cranes** in the interior is Bosque del Apache National Wildlife Refuge, NM; smaller flocks winter in Willcox Playa Wildlife Area, AZ. Impressive concentrations of **waterfowl**, sometimes including **snow geese** and **swans**, can be seen in Fish Springs National Wildlife Refuge, UT, Great Salt Lake, UT, Maxwell National Wildlife Refuge, NM, Harriman State Park, ID, Camas National Wildlife Refuge, ID, Red Rock Lake National Wildlife Refuge, MT, Benton Lake National Wildlife Refuge, MT, Freezeout Lake, MT, Yellowtail Dam, MT, J. Clark De Soto National Wildlife Refuge, NE, Valentine National Wildlife Refuge, NE, Upper Mississippi River National Wildlife Refuge, WI, Horicon Marsh, WI, Rieck's Lake Park, WI, Brazoria National Wildlife Refuge, TX, Delta Marsh, MB, and Moosonee, ON. The world's greatest concentration of migrating cranes, mostly **sandhill cranes** but also **whooping cranes**, occurs on the Platte River, NE, in late March and early April; other stopover sites are Salt Plains National Wildlife Refuge, OK, and Last Mountain Lake, SK. **Sandhill cranes** also stop in large numbers in Monte Vista National Wildlife Refuge, CO, Jasper-Pulaski Fish and Wildlife Area, IN, and in Medicine Lake National Wildlife Refuge, MT, which is also good for seeing **American white pelicans**. One of the cranes' major wintering areas is Muleshow National Wildlife Refuge, TX. The best way to see wintering **whooping cranes** is to take a winter boat tour of Aransas National Wildlife Refuge, TX. Wood Buffalo National Park, AB and NT, where they nest, is now conducting crane walks in summer.

○ In the East, the largest concentrations of **waterbirds** are in southwestern Louisiana; try driving Creole Natural Trail. If you're lucky, you can see also **sandhill cranes** and even reintroduced **whooping cranes** there. Annual releases of juvenile **whooping cranes** take place in winter in White Lake Wetlands Conservation Area, LA. **Whooping cranes** from the newly created eastern population can often be seen in Necedah National Wildlife Refuge, WI. A great

place to see large flocks of **sandhill cranes** is Hiwassee Refuge, TN; the peak numbers there are in March. Massive flocks of **American white pelicans** and other uncommon **waterbirds** winter on the lakes in downtown Baton Rouge, LA. Migratory **waterfowl** also gather in large numbers in Merrit Island National Wildlife Refuge, FL, Parker River National Wildlife Refuge, MA, Back Bay National Wildlife Refuge, VA, Jamaica Bay Wildlife Refuge, NY, Iroquois National Wildlife Refuge, NY, Montezuma National Wildlife Refuge, NY, Delaware Water Gap National Recreation Area, NJ, Edwin B. Forsythe National Wildlife Refuge, NJ, Pea Island National Wildlife Refuge, NC, Mackai Island National Wildlife Refuge, NC, Lake Mattamuskeet National Wildlife Refuge, NC, Reelfoot Lake, TN, Bombay Hook National Wildlife Refuge, DE, and Cap Tourmente National Wildlife Area, QC; the Quebec site is famous for the largest concentrations of migrating **snow geese** in the East. Good places for **marine ducks** are Jones Beach State Park, NY, Seabrook Harbor, NH, and various New England ferry routes—for example, to Nantucket, MA. The small village of Whitesbog, NJ, is a great place to see hundreds of wintering **tundra swans** up close.

○ **Black** and **clapper rails** can be seen at Palo Alto Baylands Preserve, CA, during winter high tides. Yellow Rail Festival takes place every fall near Jennings, LA. For other species of **rails**, Anahuac National Wildlife Refuge, TX, is the best place.

○ **Sandpipers** and other **shorebirds** gather in large numbers at mudflats, particularly along coastlines, and around prairie potholes. The largest spring flocks can be seen at Bowerman Basin in Grays Harbor National Wildlife Refuge, WA, in Boundary Bay, BC, at Chaplin Lake, SK, at Carson Lake, NV, in Monomoy National Wildlife Refuge, MA, Wassaw National Wildlife Refuge, GA, at Beaverhill Lake, AB, Padre Island National Seashore, TX, and Matagorda Island, TX. One of the best places for the fall migration is Îles de la Madeleine, QC. Good places to see thousands of **eared grebes** feeding together with equally numerous **phalaropes** and other **shorebirds** are Mono Lake, CA, Great Salt Lake, UT, and Gooseberry Lake, AB.

To see hundreds of thousands of **sandpipers** feeding on horseshoe crab eggs, go to Saughter Beach or Prime Hook National Wildlife Refuge, both in Delaware, in the second half of May.

○ **Raptors**, **songbirds**, and other migrants, often including **bats** and **monarch butterflies**, gather in huge numbers in the fall at Cape May, NJ, and in Fisherman Island National Wildlife Refuge, VA. In the spring they converge in Point Pelee National Park, ON, and at Wisconsin Point, WI. The best places to see spring **songbird** fall-outs are the following tree grove sites in Texas: High Island, Candy Abshier Wildlife Management Area, Kempner Park in Galveston, and Matagorda Island. Large numbers of migrating **raptors** can be watched in the fall at Ashland Nature Center, DE, in Shenandoah National Park, VA, in Kiptopeke State Park, VA, at Owl's Head in Groton State Forest, VT, at Wachusett Mountain, MA, in Franklin Mountain Audubon Sanctuary, NY, at Mount Kearsarge, NH, at Hanging Rock Raptor Observatory, WV, in Cold Knob Scenic Area, WV, at Goshute Mountains, NV, and at Rogers Pass, MT. In the spring head for Dinosaur Ridge, CO, Braddock Bay Park, ON, Derby Hill Bird Observatory, NY, and Barker River National Wildlife Refuge, MA. Keep an eye out in both spring and fall around Riviera, TX, and in winter at Boundary Bay, BC. Up to 4000 **golden eagles** fly over Mount Lorette, AB, every September. One of the largest **vulture** roosts can be seen in winter in Versailles State Park, IN. A large communal roost of white-tailed kites can be seen from December to February at the intersection of Moddison Avenue and Carlson Drive in Sacramento, CA.

○ A colossal roost of **tree swallows** forms every winter in Lake Woodruff National Wildlife Refuge, FL, while hundreds of thousands of **purple martins** roost in winter under the Hwy 190 causeway over Lake Livingston, TX, and at the intersection of N 1st Street and Oldham Street in Nashville, TN. Lake Livingston is also famous for the country's largest evening flights of wintering **cormorants**. The world's largest roost of **American robins**, with over 1.5 million birds in some years, can be seen on winter evenings from the eastern

end of 74th Avenue NE in St. Petersburg, FL. The largest flocks of **red-shouldered blackbirds** form in winter along Creole Nature Trail, LA; for flocks of **tricolored blackbirds,** try Kern National Wildlife Refuge, CA. Huge **starling** flocks can be seen at Point Reyes Peninsula, CA, and in any agricultural area in the Midwest.

o Almost every city in the eastern United States has at least one large roost of **chimney swifts**, often in a tall chimney of a school building. The highest numbers of birds entering and leaving the chimney, sometimes over 100,000 can be seen from mid-August to mid-September. One of the largest roosts is at Clinch Avenue between Walnut Street and Market Street in Knoxville, TN. The largest known roost of **Vaux's swifts**, with up to 35,000 birds, forms from mid-August to mid-October in the chimney of Chapman Elementary School in Portland, OR.

o There are dozens of **crow** mega-roosts all over the country, particularly in California and the Northeast. Their sizes change every year; recently the largest one, with up to a million birds, was said to be located near Plaza Bonita shopping mall in National City, CA. Other very large roosts are at UW Bothell campus, WA, UC Davis campus, CA, Yuba City, CA, Wichita, KS, Auburn, NY, Danville, IL, Bethlehem, PA, and Zanesville, OH. You can find more locations at crows.net website.

o A large roost of **long-eared owls** can be seen in January and February at Grover Hot Springs, CA. In irruption years, **snowy owls** are often found in late fall and early winter at Logan International Airport in Boston, MA, in Jones Beach State Park, NY, Freezeout Lake, MT, Wisconsin Point, WI, and at Sachuest Point National Wildlife Refuge, RI. The largest numbers of **northern saw-wet owls** are banded every fall at Linnwood Springs Research Station, WI.

o Seeing bat migration is difficult but possible. On September evenings you can often see **red** and **hoary bats** flying south along the Mississippi River near Baton Rouge, LA, or southwest along the Gulf

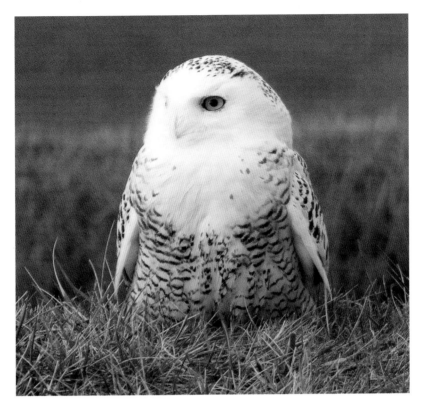

A snowy owl at a Rhode Island airfield.

Coast near Freeport, TX, or departing toward Cuba from Key Largo, FL. On moonlit nights in October, huge flocks of **Mexican freetail bats** can be seen flying over Falcon Reservoir, TX on their way to Mexico.

○ Wintering **monarch butterflies** can be best seen from November through January at the following locations in California: Natural Bridges State Beach near Santa Cruz, Monarch Grove Sanctuary in Pacific Grove, Pismo Beach in Oceano, and (the largest concentration, up to 100,000) at Goleta Butterfly Grove in Goleta. Migrating **monarchs** tend to be particularly numerous in Texas Hill Country in mid-October and along the Texas coast in late October; the coast of Louisiana is also followed by large numbers in some years (see monrchwatch.org for updates). **Painted lady** migration is most spectacular in April along the Mexican border, especially near El Paso, TX, Nogales, AZ, and Yuma, AZ. **American lady** and **red**

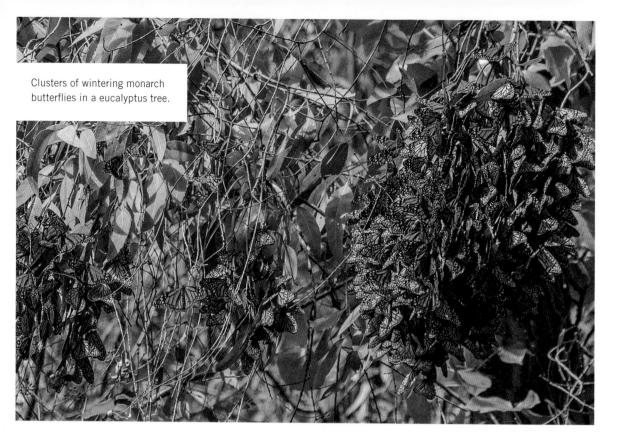

Clusters of wintering monarch butterflies in a eucalyptus tree.

admiral migrations can be equally spectacular both in April and in October; try Tijuana Border Field State Park, CA, or Lower Rio Grande National Wildlife Refuge, TX. Migrating **Gulf fritillaries** often gather in hundreds of thousands in St. Marks National Wildlife Refuge, FL, in late September and early October. **Long-tailed skippers** migrate in large numbers along both coasts of the Florida Peninsula from late September until November and again in April. **American snouts** migrate across the lower Rio Grande, TX, in late September, sometimes in millions or even billions; sporadic migrations have been observed in Arizona, Kansas, and even Ontario.

○ The best places to see the **army cutworm moth** migration are on the main road across Glacier National Park, MT, Guanella Pass Road, CO, and the road to the summit of Mount Evans, CO, but with the latter, you have to contact the road management staff well in advance to arrange nighttime access. **Black witch moths** can be

numerous in southeastern Texas in late spring and on oil platforms off Louisiana in late September. Migratory **dragonflies**, particularly **green darners**, can often be seen in huge swarms along the Gulf Coast in early fall and in Kohler-Andrae State Park, WI, in late summer; in both places the migrating insects attract hundreds of **gulls** and **nighthawks**. Millions of **ladybugs** gather in June and July at Ladybug Saddle on Mount Graham, AZ, at the summits of Signal Peak, AZ, Guadalupe Peak, TX, Gobbler's Knob, UT, Crane Mountain, OR, and other peaks. In winter you can sometimes find huge **ladybug** aggregations in the coastal mountains of California; one good location is Redwood Regional Park in Oakland (see ladybughotel.com for directions).

I am not providing exact dates because they change every year; it's a good idea to contact each location you are planning to visit well in advance. For coastal locations, ask also for tide schedules, as many birds (particularly shorebirds and rails) are often visible only at high or low tide.

SWIMMING BETWEEN WORLDS

M any long-distant migrants have to deal with extreme environmental differences between the starting and ending points of their journeys. The tiny phalarope, born on the tundra and raised in a rusty pond with a permafrost bottom, flies across mountains, forests, and cities to spend the winter bobbing on the swells of the open ocean under the tropical sun. But at least it is surrounded by pretty much the same air all the time. Some animals have to survive an even more drastic change: they move from one medium to another, and their bodies have to change the very essence of how they function.

A Complete Change

If you have ever licked an accidentally cut finger, you know that fresh blood tastes salty. Just like other liquids in our body, it is somewhere between freshwater and seawater in salt content. You can think about the same fact in a different way: the concentration of water in your blood is lower than in lake water (because there's more salt in the blood), but higher than in seawater (because in seawater there's even more salt). Our skin, like most biological membranes, is a bit more permeable for water than for salts. So when you swim in a lake, where the concentration of water is higher than inside your body, a small amount of water is constantly entering your system through your skin. If you swim in the ocean, the water again moves toward its lower concentration, and you'll be constantly losing fluid to the surrounding saltier water. This movement of water is called osmosis.

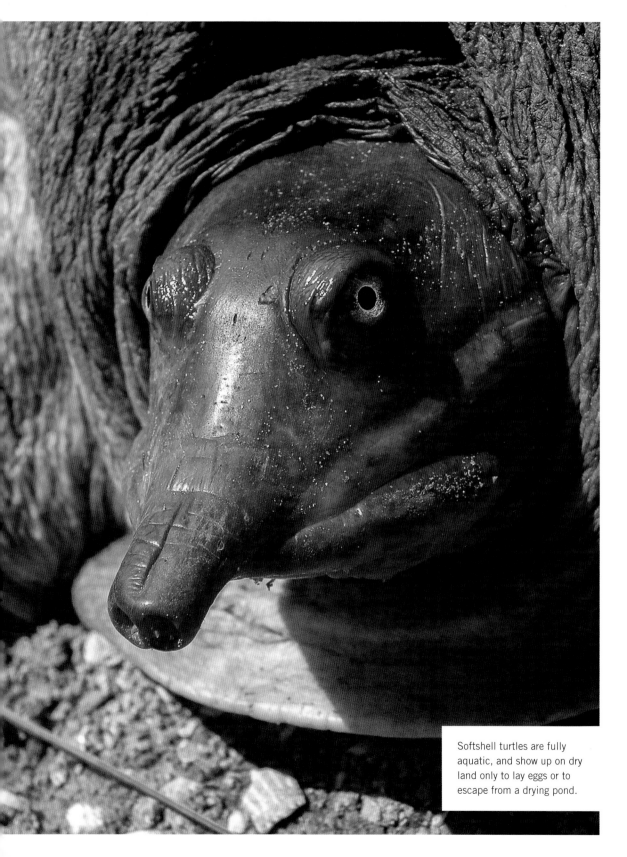

Softshell turtles are fully aquatic, and show up on dry land only to lay eggs or to escape from a drying pond.

A red-necked phalarope on a tundra lake.

Of course we don't live in the water, so for us it's not a big deal. As soon as we get back on land, we can sweat or void the excess water, or drink some freshwater to make up for the loss; the worst we risk is wrinkled fingertips after a long swim in a river. But if you are a fully aquatic organism, the problem of water constantly seeping in or out of your body is much more serious for you. You need major adaptations on cellular and systemic levels to deal with it.

If your school biology teacher was worth his salt (no pun intended), he should have introduced you to the genus *Paramecium*. It is a simple experiment: take a glass of water, put a bunch of dry grass in it, and leave it on a windowsill for a week. Dry grass becomes food to a bacterium called hay bacillus, which breeds in the millions and soon becomes prey to much larger, more complex, but still microscopic organisms such as amoebas, ciliates, and rotifers. The most abundant of these organisms are usually paramecia, incredibly fast-swimming ciliates shaped like a shoe sole. Although they are single-celled creatures, they have very complex anatomy and behavior; some studies have found that they are capable of learning and can be trained. Watching them even through a small

Paramecium, magnified a few thousand times. Note two star-shaped systems of bubbles in different phases of work.

microscope is a lot of fun, but if you manage to have a look with strong magnification, you'll see that each paramecium is equipped with two star-shaped systems of slowly pulsating bubbles. The bubbles constantly channel excessive water toward the center of each "star" and then eject it through a complex network of channels.

Marine animals lose water instead of gaining it. They can make up the loss by drinking the water that surrounds them, but that water is salty, so they have to get rid of excessive salt. Various animals have evolved different organs for doing so, such as particularly effective kidneys or specialized salt glands (these are located in the corners of the eyes in sea turtles, and on the surface of the tongue in crocodiles).

But if you move from seawater to freshwater, or vice versa, you have to deal with opposite problems: you need to expel either water or salt at different times. That's a really difficult physiological trick, and relatively few organisms have mastered it. Most of the fish, snails, and crabs you see in the ocean are not the same as the ones you see in rivers and lakes. There are entire groups of animals that have never managed to cross the divide: no freshwater sea stars nor freshwater octopuses exist, and there are virtually no marine insects. However, a few creatures have somehow learned to move between these two worlds, and built their entire evolutionary careers on that ability.

Running Upstream

The most famous of these between-worlds travelers is the salmon. Its closest relatives, fishes like ciscos and graylings, inhabit the cold, clean water of northern rivers and lakes. The salmon still uses such places for breeding, but feeds in the sea. This trick allows it to have the best of both worlds: cold streams contain lots of oxygen and few predators, so salmon eggs can develop quickly and safely; the sea offers large quantities of food for a predatory fish like the salmon.

But there is a price to pay. The main problems are not the hungry bears and bald eagles; these predators normally take only a small fraction of the population. But the cost to the salmon of switching its entire metabolism to go from living in seawater to the almost-distilled freshwater of streams, plus the strain of swimming against swift river currents, is very high. Females of the Atlantic salmon and its relatives sometimes manage to make the trip more than once, but the species collectively known as Pacific salmon (pink, sockeye, king, chum, coho, and masu) invariably die at the

Sockeye salmon usually spawn in rivers flowing into lakes that are connected to the ocean.

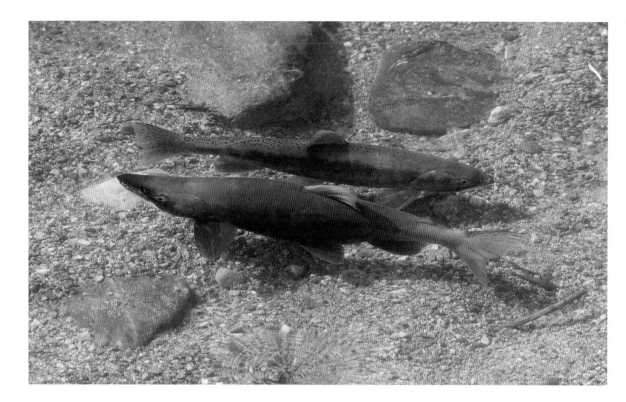

Kokanee salmon in a spawning dance. This photo was taken in a small creek flowing into Lake Tahoe; the male didn't have time to fully change into breeding colors during his short run upstream.

end of their journey. That allows them to put even more effort into it, converting much of their innards and then a lot of their muscle tissue into energy. Because of this, Pacific salmon can make longer trips than Atlantic salmon: some fish running up the Columbia River in the West spawn almost a thousand miles from the sea and climb seven thousand feet to get to their spawning grounds. Numerous populations of salmon have given up on migration and live in rivers all their lives; these are generally known as trout. Others feed in large lakes and move short distances to spawn in streams; these include cutthroat trout and the dwarf form of sockeye salmon known as kokanee.

The newly hatched salmon fry spend a long time (up to three years) in their streams, feeding on tiny plankton and slowly growing. By the time they float out of the river, they are still small. If the river is not polluted or dammed by humans, about ten percent of the eggs laid by females can make it to that stage; that's a much higher survival rate than in most marine fishes. The little salmon (called smelt at that age) spend a few months in the mouth of the

As the Pacific salmon moves upstream, its jaws change shape to become a formidable fighting weapon. Actual fights are rare, however.

river, gradually adjusting to seawater. Then they travel again, sometimes for thousands of miles, to the food-rich waters of the ocean, where they can grow much faster. Depending on the species, Pacific salmon spend one to five years in the ocean. Then they return, finding their native stream among countless others by smell. This time they have no time to adjust to the move from seawater to freshwater; they go straight in and don't care about the damage this change wreaks on their bodies. Their appearance changes, as well: they become brightly colored, and their jaws curve in preparation for possible fights.

A gauntlet of predators can interrupt the journey. Bears are the best known; the salmon-fishing brown bears of McNeill River in Alaska are probably the most photographed wild animals in the world. Some populations of black bears have evolved lighter coloration to become less visible to salmon looking at them from underwater: there are white "spirit" bears in one area of British Columbia and blue "glacier" bears around Yakutat in southern Alaska. When you see an adult brown bear in North America, you can immediately tell if it has access to a stream with lots of easy-to-catch salmon: those that do can be two to three times larger than those that don't

Most trout species either don't migrate at all or spawn in shallows and small creeks running into lakes. Only some individuals die after spawning. These Volcano Creek golden trout are endemic to a small area in the Sierra Nevada mountain range of California.

(the latter are usually called grizzlies). Bears are joined in the hunt for salmon by otters, bald eagles, ospreys, and sometimes wolves, foxes, and wolverines. But even before the salmon can make it into shallow rivers where all these predators await, it suffers heavy losses from dolphins, porpoises, killer whales, sea lions, seals, and various sharks (one of them aptly called salmon shark) that gather near the mouths of spawning rivers.

Still, just a few centuries ago salmon were among the most abundant fishes of the Northern Hemisphere. When medieval laborers in Britain signed up for a job with room and board, they asked in their contracts for salmon to be served no more than five times a week. Dams, pollution, and overfishing gradually took their toll, and today more Atlantic salmon breed in farms than in the wild. Even the inland populations that don't migrate anymore are often in trouble, particularly because anglers have transported numerous species and races of trout all around the continent, and now the introduced species outcompete native ones in many places.

Atlantic salmon now run in rather modest numbers, and the only places to get a good look at them are fish ladders at various dams. However, Pacific salmon runs are still amazing spectacles

Thanks to the abundance of salmon, the bald eagle is one of the most common birds of coastal Alaska.

in many places from California to Alaska. You can see the gatherings of seals, sea lions, and other large predators at the mouths of rivers, or watch the huge fish jump up waterfalls, or observe the mating dances in shallow spawning streams. Of the numerous predators, bald eagles are particularly interesting to watch as they have a unique system of sharing food: one bird catches a salmon, lands and take a few bites of it, then another eagle dives at the first one, forcing it to release the catch. This second eagle takes a few hurried bites and is then chased away by yet another eagle. If the prey is king salmon, the largest species, it can be fed upon by up to ten eagles in turn.

It's been known for centuries that salmon runs are critically important for the survival of many populations of predators, as well as the coastal Native American tribes of the Pacific Northwest. But another essential contribution of salmon became clear only recently. We now know that salmon runs transport a significant amount of nutrients from the ocean to the coastal forests. As bears, eagles, gulls, mink, and little water shrews feed on live or dead salmon, they pick up those nutrients and carry them to surrounding slopes. When you admire the colossal conifers of coastal

Oregon, enjoy the giant berries of southern Alaska, or buy furniture made of magnificent cedar wood from British Columbia, remember the countless salmon that sacrificed their lives to make all that possible.

Ancient Swimmers

Salmon are not the only fishes that live in the sea or in large lakes and migrate into rivers to spawn. Such fishes are called anadromous, and there are many of them. As you watch Atlantic salmon moving through fish ladders at New England dams, you might also spot various species of herring, particularly shad and blueback. Gatherings of shad in the mouths of rivers and canals attract their own suite of predators: gulls, cormorants, loons, and harbor seals.

Most anadromous fish are popular among fishermen and generally loved, but one is hated throughout the Northeast. Called the sea lamprey, this ancient creature is not even a fish in the zoological sense. Lampreys and their deep-sea relatives, hagfishes, are the oldest living vertebrates; they have no scales, no jaws, and no paired fins (from which the limbs of terrestrial vertebrates evolved). Lampreys breed in small streams; their larvae burrow into the sandy bottom and live there for a few years. After they change into adults, about half of the lamprey species don't eat at all; they stay in their streams, breed, and die. But larger species become predators. Instead of jaws, lampreys have huge suction disks armed with hooklike teeth. They use these disks to attach to various fishes, burrow through their skin, and feed on blood and soft tissues. Their victims usually die after a few days or weeks. The largest species, the sea lamprey, spends most of its life at sea, returning to rivers only to spawn.

The sea lamprey is normally uncommon. Romans, who prized it as a delicacy, bred it in pools, and would occasionally punish slaves by throwing them into the pool (if a lamprey is very hungry it will sometimes attach to a human; it soon realizes the mistake and releases, but can leave a nasty wound). But as canals were built around rapids and waterfalls of northeastern rivers, the sea lamprey

The mouth of the sea lamprey is equipped with a suction disk which attaches to fish for feeding purposes.

A marvel of evolution, sturgeon are slowly losing their ground in the modern world. This is a huge lake sturgeon spawning in Wisconsin.

used them to invade the Great Lakes, where it had no predators and decimated the native fish populations. Unlike salmon, lampreys don't remember the smell of the water of their native stream; instead they are attracted to pheromones produced by lamprey larvae living in the sand. These pheromones are now used in traps that are set in rivers flowing into the Great Lakes to control lamprey numbers.

Sea lamprey's smaller relative, the Pacific lamprey, spawns in the rivers of the Pacific Northwest. It used to be an important source of food for a few local tribes until the construction of dams on the Columbia River destroyed its most important spawning grounds.

There are just two places where Native Americans still practice traditional lamprey fishing, and in both places it's very dangerous. One site is the mouth of the Klamath River, in Northern California, where fishermen spear lampreys at night in the surf. The other is Willamette Falls, Oregon, where thousands of lampreys crawl up the rocks using their suction disks; tribal members hand-catch them in ice-cold waterfalls while balancing on slippery rock ledges.

The largest anadromous fishes, also very ancient, are the sturgeon: some of them can grow over twenty feet long. North America is the last part of the world where at least some species of sturgeon and their relatives the paddlefish are relatively common; elsewhere they are either extinct or endangered. Sturgeon are mostly bottom feeders living in turbid waters, so seeing them in the wild is difficult; there are only a handful of places where you can watch them underwater. Despite being so ancient and slowly evolving (their appearance has changed little in the last hundred million years), these are intelligent fish with complex but poorly understood behavior. Some live in rivers all their lives; others migrate to feed in the ocean or in large lakes, then come back to spawn. Paddlefish

Swimming with giant paddlefish is an unforgettable experience.

are strictly freshwater, and feed on plankton they catch by filtering water through their gills. They also prefer turbid waters, but there are now a few quarries and lakes where you can snorkel or dive with these amazing fish in clear water.

Gars are another ancient group of fishes; today they survive only in North and Central America. The largest species, the alligator gar, has evolved a remarkable ability to move freely between freshwater and saltwater. It usually lives in turbid bayous and lakes of the Deep South, but occasionally can be encountered offshore. When I lived in Louisiana, I spent a lot of time trying to see the giant predators of these waters: the alligator gar and the blue catfish. It took me almost a year, but eventually I caught a moment when the water in one of the channels leading into White Lake cleared up somewhat for a few hours, and I could enjoy snorkeling with some of the largest freshwater fishes in the world.

The Craziest Migration

Some fish, known as catadromous, travel in the opposite way: they spend much of their lives in freshwater and go to the ocean to breed. These are usually fish of marine origin that have recently colonized freshwater habitats, but couldn't adjust their breeding biology. The only truly catadromous fish in North America is the American eel. Female eels live in brackish water and in short coastal streams, while males can move far upstream. Eels are nocturnal, and on cool nights with heavy dew or drizzle they will sometimes travel overland, slithering like snakes. Sometimes this habit results in them being stuck in isolated pools or water wells, where they grow to huge size, occasionally surviving for over a century. But normally after five to twenty years in freshwater, eels migrate to the Atlantic Ocean and swim to the Sargasso Sea, where they breed at great depths (their eyes grow much bigger as they move to the sea). There they meet with their close relatives, European eels, which have to migrate much farther.

The details of eel breeding behavior are still poorly known. Large females can produce over eight million eggs. The hatchlings are

The alligator gar, a giant predator of southern rivers.

weird, fully transparent leaf-shaped larvae called leptocephali, with tiny heads and long, thin teeth. Nobody knows what these teeth are for, since leptocephali never have anything in their stomachs. One theory is that they suck "juices" from jellyfish, while another is that they somehow absorb nutrients from seawater through their skin. The most recent opinion is that they feed on tiny clumps of dead plankton floating in the ocean, which are called marine snow.

The leptocephali are carried by the Gulf Stream to the shores of North America; this takes up to a year (European eels take up to three years to reach Europe). By the time they approach the coast, they turn into "glass eels" which resemble small adults but are still fully transparent. Glass eels remain in brackish water until they turn into small, fully pigmented eels called elvers, which enter the freshwater and feed on insect larvae.

Just a few decades ago it was sometimes possible to see thousands of elvers as they formed ropelike bundles and crawled over small waterfalls along the eastern coast of Canada and New England. Now the American eel is becoming increasingly rare due to dam

Cormorants can be deadly predators of migratory fish.

construction, pollution, and competition with introduced species. Unlike the European eel, it is not yet endangered, but most fisheries have closed and some of the largest populations have collapsed.

Out of Water

Some animals leave the water altogether to breed. Surprisingly, in addition to eels, the list includes a few more species of fish. The best known is the California grunion, a small fish that spawns on the sandy beaches of Southern California and northwestern Mexico. The run usually happens on spring nights, two days after the full or the new moon. The fishes use a large wave to get carried high up onto the beach, where a male wraps himself around the female and fertilizes her eggs as she lays them into the sand. A few seconds later the next wave returns them to the sea. The eggs are ready to hatch in ten days, during the next high tide, but if the tide is not high enough, they can wait in the sand for up to two months.

Much more spectacular spawning takes place on the East Coast, also in spring. On the nights of a full moon, huge horseshoe crabs

Horseshoe crabs are the largest living members of the lineage that also includes spiders and scorpions.

crawl out of the ocean to lay their eggs in the sand, males riding on the backs of females. You can often see a few pairs anywhere along the coast, but in the Mid-Atlantic states some beaches are overrun by hundreds of thousands of these ancient creatures (horseshoe crabs are not really crabs, but the surviving relatives of extinct sea scorpions, and have been around for at least 450 million years). They lay masses of eggs. Many eggs get eaten by sandpipers—who time their spring migration so that they arrive at those beaches just as the horseshoe crabs spawn—but most hatch in two weeks, during the next high tide.

As the water warms up in summer, beaches of the Atlantic and Gulf Coasts get their largest marine visitors, the sea turtles. They mostly breed on the coast of the Florida Peninsula, but a few can be seen as far up the coast as North Carolina. Sea turtles have undergone a catastrophic decline in the early twentieth century, but thanks to protective measures, their North American populations are now recovering.

The most common sea turtle species in North America is the loggerhead; its massive head is an adaptation for feeding on bottom

Loggerhead sea turtle.

invertebrates, many of which have hard skeletons. Its hatchlings swim to the Sargasso Sea, where they spend a few years feeding on various inhabitants of sargasso weed before returning to coastal waters. Seventy to eighty thousand females lay eggs on North American beaches every year.

The green turtle is now rapidly increasing in numbers, from two hundred fifty females counted in 1989 to twenty-five thousand in 2013 (this species mostly breeds in odd-numbered years). This is still far from the numbers observed by Columbus, who reported that in parts of the Caribbean, the sea seemed to be covered with floating turtles. Green turtles inhabit shallow waters and feed on eelgrass.

The largest and rarest of the sea turtles is the leatherback. It can exceed seven feet in length and weigh over fifteen hundred pounds.

A baby loggerhead sea turtle resting on a patch of sargasso weed.

Loggerhead hatchlings making their frantic run for the ocean.

These creatures are wanderers of the open ocean, and the only sea turtles regularly occurring in cold water (they are sometimes seen during late summer whale-watching trips off California and New England). Leatherback turtles feed on jellyfish, and suffer severe losses because they often swallow floating plastic bags and party balloons. Leatherback numbers are growing in Florida, but you still have to be very lucky to see one, as only a few hundred females nest there every year.

A face only a mother snapping turtle could love?

This brave snapping turtle seems to have chosen a risky route.

Baby turtles can be strikingly colorful.

Not all young turtles are colorful, but they can still be cute.

Sea turtles usually come out at night. There are now organized turtle walks on some of the best beaches in Florida. If you'd like to try looking for them yourself, better do it on a night of a full moon and don't turn on your flashlight. A female about to come out of the sea can be easily scared off. But once she digs the nest and begins to lay eggs, she can be approached and quietly watched from a few feet away.

Adult sea turtles are generally too large to be killed by native land animals, except for jaguars and bears. But there are smaller sea turtles called ridleys, and they can be killed by a coyote or even a raccoon. To minimize the chances of that happening, they come ashore in large numbers on certain days in August and September. These mass nesting events are called *arribadas* ("arrivals" in Spanish), and can involve tens of thousands of females. Historically very few ridleys nested north of Mexico. However, one of the two species, the Kemp's ridley, is now threatened in Mexico, so there is an attempt to create a second breeding population on Padre Island in Texas. For now, there are just a few hundred animals, but in a few decades you might be able to watch impressive arribadas there.

Many turtle nests get dug up by feral dogs, coyotes, and raccoons (only leatherback nests are usually too deep for wild animals to reach). But if the eggs survive and hatch, another spectacle takes place, and it's one of nature's most touching sights. Tiny hatchlings work together to break out of their underground prisons and frantically scamper to the sea, while seabirds, large crabs, and other predators try to capture as many as they can.

Freshwater turtles also lay eggs on land. If you walk around lakes and ponds of the South on summer nights, you might spot a few females coming out to dig nests, including some species that are usually almost fully aquatic: agile softshells, huge snapping turtles, and exquisitely beautiful map turtles. They also have to move overland if their ponds dry up, or their feeding and wintering sites are in different lakes. The vicinity of Reelfoot Lake in Tennessee is particularly famous for turtle migrations.

Different turtles breed at different times, so from April until October drivers have to be careful along lakeshores and riverbanks: watch for tiny hatchlings! Their shells are still soft and don't provide much protection, and they are a favorite meal of almost every predator.

Into the Water

Many adaptable animals do the opposite of turtles: they breed and grow up in the water, but spend most of their adult lives on land. Doing so requires deep rebuilding of the entire body, as anyone who has seen both a tadpole and a frog knows.

Frogs, toads, newts, and salamanders of the mole salamander family are all water-born creatures that move to land as adults. They often breed in small temporal ponds (known to biologists as vernal pools) because in such places there are no fish and few predatory insects. In warmer places with lots of winter rains or spring snowmelt, many species breed in winter or early spring to escape predatory insects altogether.

There are a few places in the United States where stretches of roads are temporarily closed to protect migrating newts or salamanders,

Eastern newt, making its
way across fallen leaves.

The eggs of a California tiger
salamander in a vernal pool.

but elsewhere migrating amphibians suffer horrendous losses on highways.

You can find good places to view migrating salamanders by contacting local herpetological clubs; many states have such clubs, often with Facebook pages. Some frogs and toads, however, prefer to breed in summer. After a particularly strong rain, millions can be encountered crossing roads; the best places to see such amazing migrations are in the swamps of the Deep South.

Amphibians living in more arid places might get a chance to breed only once every few years. Rare California tiger salamanders can disappear underground for up to a decade, waiting for a particularly rainy winter to fill the vernal pools. Once the rains come, the eggs and then tadpoles have to develop as fast as they can before the pools dry up.

Toadlike amphibians called spadefoots that live in southwestern deserts have evolved an unusual way of dealing with this problem. These nocturnal creatures got their name from hard calluses on their feet, used to burrow underground every morning. When

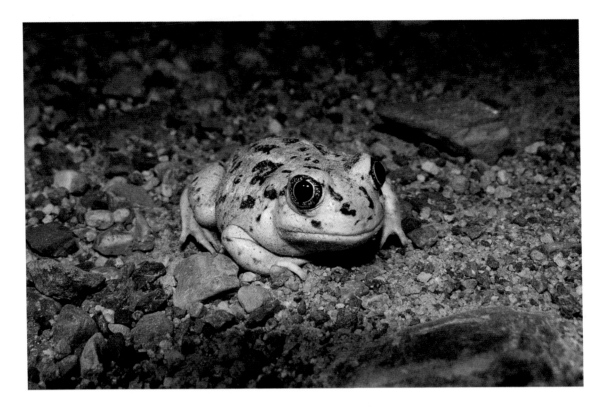

rains come and fill the pools, spadefoots immediately lay their eggs there. Soon after the tadpoles emerge, some of them begin to look different from others. Most are peaceful herbivores and feed on algae that rapidly grow on the muddy bottoms of the pools, but a few develop hook-shaped jaws, begin to feed on their brothers and sisters, and grow very fast on protein-rich food. If the pool survives long enough, both types of tadpoles turn into little spadefoots, but if it dries up too soon, only the carnivorous tadpoles make it.

Couch's spadefoot develops as either an herbivore or a carnivore.

Many insects have aquatic larvae, while adults take to the air to breed. The best known are dragonflies; if you walk with a flash-light around a grassy pond on a summer night, you might see a dragonfly emerging from a larva (properly called a nymph if the insect doesn't go through a pupa stage in its development) that has crawled out of the water onto a grass blade or sedge stem. The champions among the moving-between-worlds creatures are diving beetles: they can swim, run on land, fly, and burrow underground, where they hibernate.

Tiny toadlets learning to hide underground on the bottom of a dried-up pool.

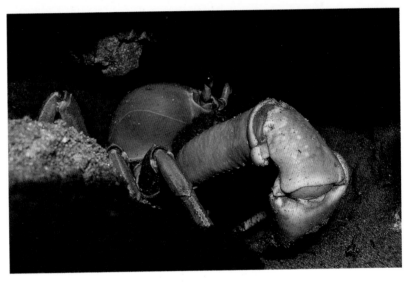

Land crab in its burrow.

Large land crabs and hermit crabs of southern Florida breed in the sea. They usually go there on rainy nights, and lay eggs in the surf. Tiny baby crabs come back many months later, after surviving the dangerous life of planktonic larvae.

But perhaps the most unusual travelers between realms are horsehair worms. They look like a long, thin—you guessed it—hair from a horse's tail, up to six feet in length. They are parasites that infect large predatory insects, such as katydids, beetles, and praying

mantises. Adult worms live in freshwater; they can form huge balls known as Gordian knots during mating. A female lays up to ten million eggs. The tiny larvae that hatch from the eggs drop to the bottom of the pond and wait there, each hoping to be eaten by an aquatic larva of some small flying insect, such as a damselfly or a mayfly. If this happens, the insect eventually transports the worm larva to the air and then (if the larva is lucky) to dry land. Then, if the worm larva gets *really* lucky, the small insect either gets caught and eaten by a larger one, or dies and is scavenged by something like a cricket. Only in this case can the larva develop into an adult worm, which lies tightly curled in the host's body cavity and feeds by absorbing the host's blood. Once the worm becomes fully grown, it somehow changes the host's behavior, causing it to find a pond and drown itself, allowing the worm to escape into its natural environment. Moreover, this is not the horsehair worm's only trick. If the host gets eaten by a bird or a mammal, the worm can escape by wiggling its way out of the predator's digestive tract . . . but perhaps we'd best stop there.

Baby Travelers

Many marine animals are completely sedentary, like sponges and corals, or move slowly, like sea stars and small crabs. They still need to travel to find new places to live, but instead of risking their lives as adults, they entrust this duty to their offspring. Virtually all marine invertebrates have tiny, transparent larvae that feed on even smaller plankton and drift with the currents. A lucky few happen to find a good place to settle down just when they are large enough to do so. These larvae are often bizarre-looking; if you ever visit a marine research station, don't miss a chance to see them through the microscope.

One outstanding natural spectacle that few people know about is the mass spawning of coral. Many species of coral spawn at the same time on particular nights, so much so that the ocean is filled with their eggs and predators can't eat them all, no matter how hard they try. Marine scientists have recently learned to predict

this spectacle more or less reliably, and local dive operators usually run a few trips per year to witness the event.

A trip to watch coral spawning begins like the most boring scuba dive ever. As night falls, you dive to about ten feet and lie on the sandy ocean bottom, looking at large heads of brain coral around you. You wait for hours, trying to not move (to conserve air) or fall asleep. Then you notice that the corals around you look different: tiny whitish bubbles have emerged from every pore. Suddenly, all these bubbles float up toward the surface, like raindrops falling upside down. This living blizzard causes a lot of commotion: schools of fish, reef squid, and large prawns come from nowhere and start gobbling up the eggs. Within a few minutes the show is over; the current carries the eggs away from the reef, into the open ocean, where they have to play the life-or-death lottery—with dismal odds of winning.

VIEWING TIPS

○ There are numerous places in the West where you can see **spawning salmon**: Taylor Creek at Lake Tahoe, CA (**kokanee** in October); Willamette Falls, OR (**Pacific lamprey** in June, **king salmon** in September—but you must be accompanied by a tribal fisherman); Master's Bridge and Soda Springs Overlook, OR (**salmon** and **trout**, September); Flaming Geyser State Park, WA (**king salmon**, October through December); Mission Creek Regional Park, Stamp Falls, and Peachland Creek, all in BC (**king salmon**, September through October), Gerrard, BC (**salmon** and **trout** in May and September); and pretty much any small river without waterfalls that flows directly into the sea in northern BC or AK north to Nome. You can also watch **salmon**, **steelhead**, and occasionally **white sturgeon** in June at the fish ladder at Bonneville Dam, OR.

○ In the East, **Atlantic salmon** and **shad** can be seen at Amoskeag Fishways, NH (May); Vernon and Wilder Dams, VT (June); Turner Falls and Holyoke Dams, MA (May and June; **sea lamprey** and **blueback herring** also present). **Pacific salmon** has been introduced to the Great Lakes and can be seen at Grand Rapids, Mishawaka, and Berrien Springs Fish Ladders, all in Michigan (May and October). **Rainbow trout** jumping waterfalls can be seen in late summer at Willoughby Falls, VT. One of the best places to see **trout mating dances** is High Lake in the John Muir Wilderness, CA, where the most beautiful species, the **golden trout**, spawns in late June.

○ River mouths of the Pacific coast are good places to see various predators gathered to hunt for salmon. **Harbor seals** gather at the mouths of the Russian and Klamath Rivers, CA, while **Steller's sea lions** gather at the mouth of the Columbia River, which divides Oregon and Washington. **Spotted** and **harbor seals** gather at river

mouths around Nome, AK. **Salmon sharks** and **killer whales** gather in the fjords of the Alaska Panhandle. Salmon sharks feeding on salmon can be seen in late June and early July by taking a live-aboard tour organized by Dive Alaska (divealaska.com). **Bald eagles** gather at many Alaskan rivers; the largest concentration (around four thousand) is in Alaska Chilkat Bald Eagle Preserve (October through December).

○ Fishing **brown bears** in Alaska can be seen by taking an expensive bear-viewing tour from Anchorage or Kodiak, or by flying to McNeil River State Game Sanctuary or Katmai National Park, but it's easier to take a tour of Glacier Bay National Park or explore small rivers near Yakutat (try Nine-Mile Bridge), where you also have a chance of spotting **black** and **glacier bears**. There are **brown bear**-viewing platforms at Pack Creek on Admiralty Island, AK. Fishing **black bears** can be seen at Anan Creek in Tongass National Forest, AK, and around Klemtu, BC (white **spirit bears** are also possible at the latter location).

○ May **herring** runs at the southern entrance to Cape Cod Canal, MA, attract lots of **seagulls**, **bald eagles**, **harbor** and **gray seals**, **loons**, and **cormorants**. **Eulachon** (a small fish) runs in the Pacific Northwest and the Alaska Panhandle in March and April; it also attracts lots of predators to river mouths—the best viewing place is Lower Skeena River, BC.

○ You can snorkel or dive with large **paddlefish** in France Park in Cass County, IN, Gilboa Quarry and North Point Dive Quarry, both in Ohio, Loch Low-Minn near Athens, TN, and Mermet Springs, IL. **Gulf sturgeon** jumping out of the water can be seen in early spring at Suwannee River, FL. The only viable area where you can still see mass migrations of young **eels** into small rivers is along the eastern coast of Nova Scotia.

○ Spawning **Arctic grayling** can be seen in Beaver Lake near Sitka, AK; spawning **walleye** in southern McMillan Creek at Conesus

A red-spotted toad brought out of hiding by summer monsoon rains in Animas Valley, NM.

Lake, NY; spawning **lake sturgeon** (sometimes huge) can be seen in the town of New London, WI, in March or early April (contact the city's chamber of commerce for timing predictions). Spawning **California grunion** can be seen in April and May on a few beaches around Los Angeles and San Diego, CA; see forecasts at http://www.seecalifornia.com/sports/fishing/california-grunion-schedule.html. The best beaches to see spawning **horseshoe crabs** are in Delaware; my personal favorites are Fowler Beach in Prime Hook National Wildlife Refuge and Pickering Beach in Little Creek Wildlife Area. You have to be there during evening high tides on the nights of a new or full moon.

○ **Sea turtle** walks are conducted in late summer at Bald Head Island, NC, in Wassaw National Wildlife Refuge, GA, in Little Talbot Island State Park, FL, in John D. MacArthur Beach State Park, FL, and at Marine Life Center of Juno Beach, FL. Most of the time you see only

loggerheads, although **green** and **leatherback turtles** are also possible in Florida. **Hawksbill turtles** occasionally nest on the Florida Keys. For information about nesting **Kemp's ridleys**, contact Padre Island National Seashore, TX. The world's largest **freshwater turtle** migration can be seen in May around Reelfoot Lake, TN, which is also a good site to see **bald eagles** in winter.

o Spectacular **frog** migrations take place on rainy nights on backcountry roads in or near Everglades National Park, FL, in Bon Secour National Wildlife Refuge, AL, along the access road to White Lake Wetlands Conservation Area, LA, and in Okefenokee Swamp, GA. The latter is also a great location to see **"winter" frogs** on warm, rainy nights in February and March. A good spot to observe **spadefoots** after summer monsoon rains is Lordsburg Playas, NM.

o **Land crab** migration can be seen on rainy nights in Mattheson Hammock Park in Coral Gables, FL, and in the northeastern part of Key Largo in the Florida Keys. **Horsehair worms** are often easy to find in Las Huertas Creek in Bernalillo County, NM.

o Diving trips to see **spawning coral** are organized in late August and early September by a few dive operators in the Florida Keys; they usually go to John Pennekamp Coral Reef State Park.

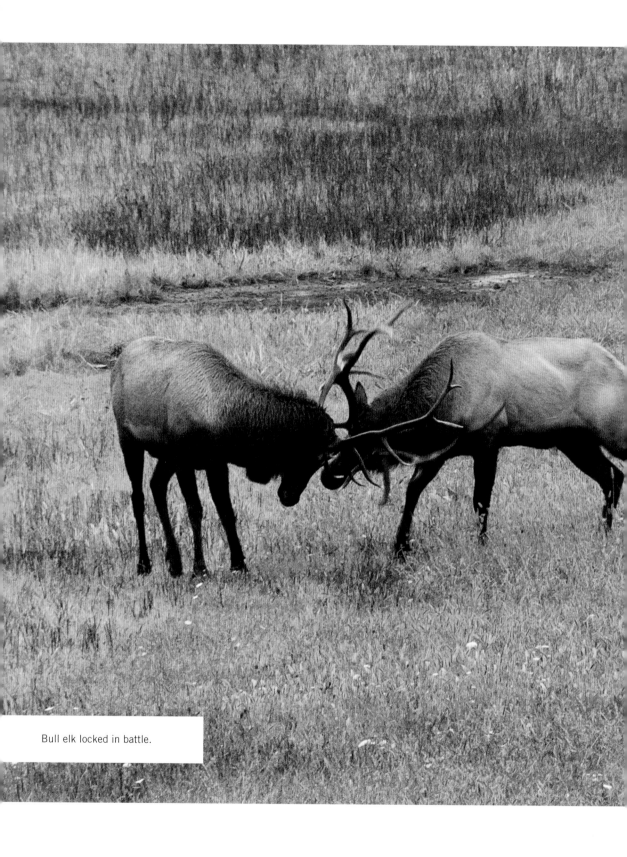

Bull elk locked in battle.

SPECTACLES OF LOVE

Older textbooks on zoology used to divide animals into the categories of "social" or "solitary." Today it's becoming clear that truly solitary animals are rare exceptions. Unless you are a sedentary sea sponge or a parasitic worm forever imprisoned in your host's gut, you need some form of socializing. Animals meet for many reasons, but, of course, the most common one is to procreate. And procreation is one area where evolution's ability to create beauty reaches its peak.

People usually think of spring as the time of love, but in reality every season in North America is breeding season. Wolves, ravens, and great horned owls begin courtship in February; a few bat species mate in wintering caves; deer, caribou and mountain goat rut can stretch until January; elephant seals mate in midwinter; there are winter-breeding frogs and salmon; and many rodents and a few other mammals happily breed year-round, sometimes raising tiny naked babies in burrows dug in the snow. The ultimate winter breeder is the burbot, the only truly freshwater member of the cod family. A relative of deepwater marine fishes, it spawns in midwinter in the dark, ice-cold depths of northern lakes, and uses its ability to tolerate the cold to prey on other fishes that become a bit lethargic at low temperatures.

Some animals conduct their love affairs in businesslike style, but most incorporate some kind of ritual: songs, dances, fights, nuptial gifts. A list of them all would easily fill a bookshelf, but we'll focus on the most spectacular.

FUN IN NUMBERS
BREEDING AGGREGATIONS

Modern humans are taught from an early age that the act of love requires privacy. Our ancestors who lived in communal caves and huts would laugh at the idea, and very few animals share it. Gathering in large numbers to mate is not only about making it more fun; it is also very practical. It gives you the opportunity to compare potential partners and choose the one (or ones) you like. Besides, for many animals mating is quickly followed or preceded by laying eggs, so doing all this in large groups offers other advantages, such as the safety that comes in numbers.

Heat in the Cold

For seals and sea lions, the sequence and proximity of mating and birth is noteworthy. Childbirth (or, in this case, pupping) is immediately followed by mating. Male fur seals, elephant seals, gray seals, and sea lions stake out territories at breeding rookeries a few weeks in advance, eagerly waiting for females to arrive and give birth. Then, in a practice few human females would likely endorse, the males mate with the new mothers within a few days of the birth—sometimes within hours. Pregnancy lasts exactly one year. It sounds simple enough, but in reality this is a grueling affair for both sides. Males endure weeks of bloody fighting—so exhausting that some of them can't recover and die soon after. Only very few bulls actually get to breed: among elephant seals, just a few males out of a hundred sire ninety percent of the offspring. Such extreme selection has made them highly adapted for battle. Females unfortunately pay the price, as they are mounted by gigantic, rather brutish males.

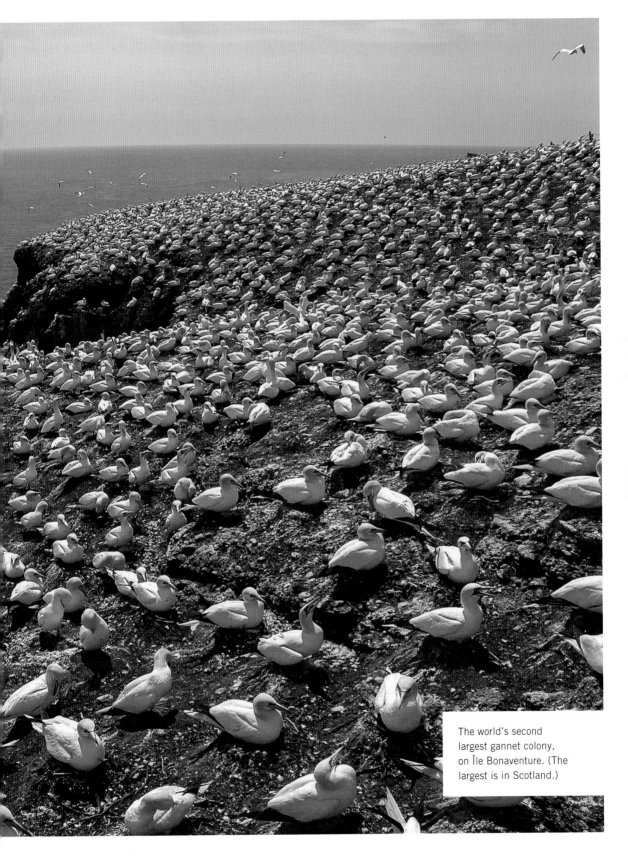

The world's second largest gannet colony, on Île Bonaventure. (The largest is in Scotland.)

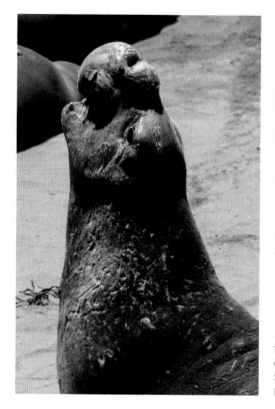

California sea lions sometimes give birth at Pier 39 in San Francisco.

More often than not, fights between male elephant seals end quickly. Still, they soon become heavily scarred.

Few of the world's natural spectacles can rival the sight of a large seal or sea lion rookery. There is usually a lot of overlap in events, so if you are lucky, you can simultaneously see males fighting, females giving birth, and older pups hanging around in unruly gangs, waiting for their mothers to return from the sea and feed them. Walrus rookeries are a lot more peaceful, but still make an unforgettable sight. There are also interesting differences between species. For example, male California sea lions mostly defend their territories from intruders coming out of the sea, while northern fur seals and Steller's sea lions are more aggressive toward terrestrial trespassers.

Females of other types of seals don't congregate at rookeries, but give birth in dispersed pupping areas. This means the males have to either patrol the pupping areas looking for females that have just given birth, or find pregnant females and guard them until delivery, seizing their window of opportunity soon thereafter. There is much less fighting involved, and most males get to mate at least some of

the time, so the selection pressure on them is weaker and they don't look that different from females. The only exception is the hooded seal: males have huge swollen "noses" and can blow a weird-looking pink balloon out of one of the nostrils. Mating in these species usually occurs underwater and is seldom seen. The primary reason to visit pupping areas is to view the famously cute baby seals. In species and populations breeding on ice, pups are born white (or blue-gray in the case of hooded seals). Baby ringed, bearded, and spotted seals are born in places frequented by polar bears, so they are skittish and shouldn't be approached (they would try to dive, and that's dangerous for them when they are little). However, harp, ribbon, and hooded seals make long migrations specifically to reach the few areas that have ice floes but are south of the polar bear's range; their pups have no anti-predator defenses and remain calm if you come close or even pet them.

Male northern fur seal with his harem.

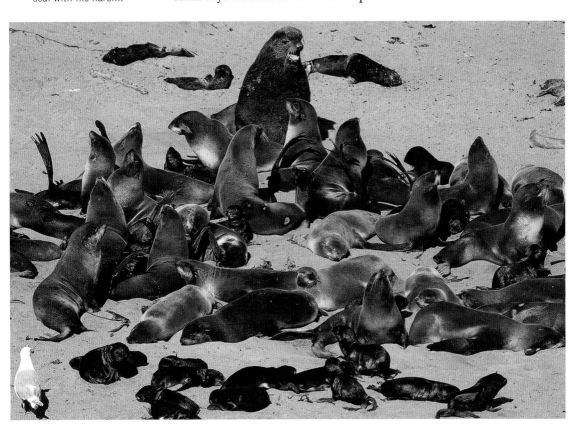

A small island in the Chukchi Sea is home to a thriving seabird colony.

Planning a trip to see those pups is tricky because they remain in their baby fur only a short time. As soon as they stop nursing, they molt into spotted coats and disappear in the sea to hunt by themselves. Lactation is short: female hooded seals stop feeding their pups after just four days, faster than any other mammals. A trip to see them isn't cheap, either—you need a helicopter to get to the right ice floes. Still, for many, the adventure is worth the cost. Very few people actually travel to see the pups, mostly because of the

horrific images of the senseless slaughter of hundreds of thousands of baby seals. These killings are still sponsored by the Canadian government in order to please local fishermen, who blame the animals for collapsing fish stocks (as do many fishermen in places where seals live; in places with no seals, fishermen blame killer whales, or marine scientists, or cormorants—this is a contentious issue). However, tourism is the only alternative for small coastal communities that have become dependent on seal hunting, and many tour guides are former hunters, so going on such a trip can actually help reduce the slaughter.

The tendency of seals and sea lions to form huge breeding aggregations is shared by most species of seabirds. There is a good reason: seabirds concentrate on small, predator-free islands conveniently located within reach of particularly productive parts of the ocean. As mentioned earlier, such places are likely to exist in cold seas or in areas where warm and cold currents mix. Not surprisingly, marine mammals and seabirds often prefer the same islands. The Pribilof Islands and the Aleutians off Alaska, the Farallon and Channel Islands off California, small outlying islands off Maine and eastern Canada, and Sable Island (far off the eastern coast of Nova Scotia) attract huge numbers of both birds and mammals.

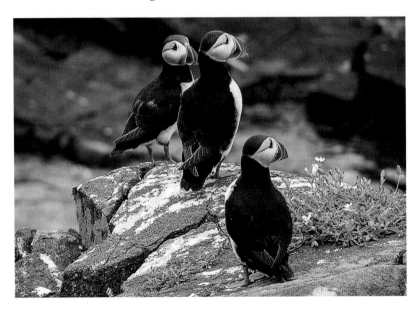

Atlantic puffins prefer to colonize predator-free islands.

Different species of seabirds prefer different places for nesting, so every such island becomes a complex community; the exact composition depends on the ocean and the latitude. Murres, auks, guillemots, cormorants, kittiwakes, and sometimes fulmars form huge colonies on vertical cliffs (although sometimes they nest on flat surfaces and, in the case of kittiwakes, on building walls). Murres are particularly well adapted to nesting on narrow rock ledges; their eggs are cone-shaped so they don't roll off. If you look closely, you can see horned puffins and guillemots hiding in protected niches and cracks in the cliffs.

If you climb onto the flat top of an island, you might see large gulls, a few raptors such as peregrine falcons, and sometimes huge colonies of northern gannets. Talus slopes and areas of soft ground where burrows are easy to dig can be inhabited by Atlantic or crested puffins, shearwaters, storm-petrels, dovekies, and various auklets; these birds are too small and vulnerable to predation by seagulls to nest in the open. Some of them visit their nests only at night to escape predators. The highest species diversity can be found on remote islands of the Bering Sea. The largest mixed colonies have millions of nests. Streams of birds constantly fly in and out of the colonies, bringing food to chicks or heading out to sea to feed.

Each species has its favorite food—fish, squid, or large plankton—and foraging distance. When the chicks of murres and puffins get too big for their narrow ledges, they parachute to the sea on their tiny wings, escorted by anxious parents who then continue to feed them for months. Storm-petrels, fulmars, and shearwaters use a tougher approach to parenting: they simply leave their chicks. The offspring then use their fat stores to survive while down is replaced by feathers and their wings grow long enough to allow takeoff.

If you fly over the vast, emerald-green expanses of summer tundra in the North, you might suddenly see what looks like a touch of fresh snow in a broad valley. Getting closer, though, it becomes clear that what appeared to be snow is actually scores of geese. Ross's and snow geese nest in huge colonies, sometimes with tens of thousands of nests. In recent years, protection at wintering sites has led to rapid

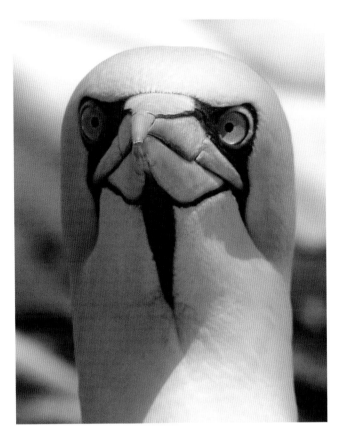

Gannet head markings are quite dramatic.

Murre eggs.

growth of these colonies; in some places, the tundra now looks like it's been trimmed with a lawn mower. It is not known why these two species nest in colonies, while other species of tundra geese prefer to nest solitarily, sometimes side by side with large raptors or snowy owls (to obtain protection from marauding Arctic foxes).

The Land of Depravity and Debauchery

Nowhere is sex in numbers more popular than in the Deep South. It begins in January with massive choruses of winter frogs (a few frog species preferring to breed on warm, rainy winter nights) and continues throughout spring and summer, as immense swarms of insects hatch in wetlands and forests, and mate in the air. There are countless swarm-forming species, each with its own schedule.

Chicks of shearwaters (pictured), fulmars, and storm-petrels are abandoned by parents before the young birds molt from fluff to feathers.

Love bugs are blackish flies that got their name for their tendency to remain connected for a few days or even weeks after mating. They swarm in late spring and again in late summer. Their larvae feed on rotting grass and other dead vegetation. Natives of the Gulf Coast, love bugs have recently spread up to the Carolinas due to the warming climate. Their numbers are controlled by parasitic fungi, but these fungi spread a bit more slowly, so the swarms at the advancing northern edge of the range tend to be the largest. A popular myth in the South is that love bugs were accidentally created by mad scientists from the University of Florida, but the oldest North American record of this species is actually from Texas.

Not all swarmers are as benign as love bugs. As early as March, biting insects come out in masses throughout the South, and don't disappear until November. The worst, depending on the area, are blackflies, horseflies, saltwater mosquitoes, or tiny sandflies. Snake Bight Trail in Everglades National Park holds the world record for insect biting intensity: twenty-two bites per minute per square inch of exposed skin. These swarms of biting insects can be so impressive that I was going to describe them in detail, but I found myself itching just from remembering them.

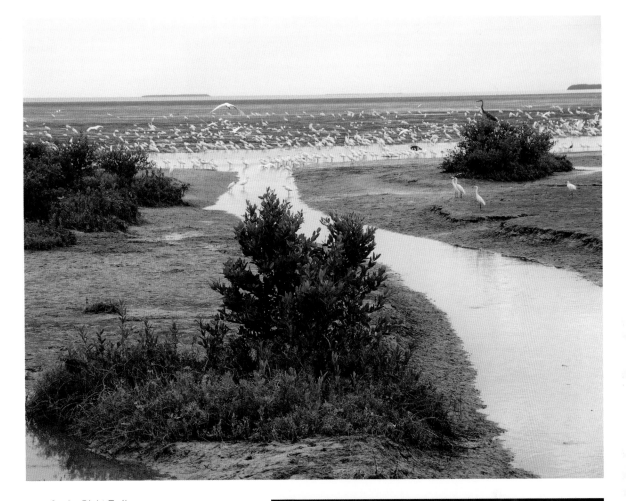

Snake Bight Trail
in the Everglades holds
the world record for the
number of insect bites
per minute.

The Florida peeper, a
common winter frog.

Tennessee fireflies perform
in the darkening sky.

Winged termites and ants swarm after rains. They emerge from the colonies that raised them, mate in the air, shed their wings, and crawl into protected places to found new colonies. Nowadays the most common ant in the South is the introduced Argentine fire ant ("the South's most hated invader since General Sherman" according to one local newspaper), but in many places it is being replaced by yet another introduced species, the so-called crazy ant.

And, of course, there are fireflies (a somewhat misleading name for a family of beetles). The southern states have the world's highest diversity of fireflies. Each species uses its own color and blinking code. In some species the females are flightless and look like larvae,

Green treefrog is one of the most abundant summer frogs of the Deep South.

but both they and the larvae also produce light (they are commonly known as glowworms). The larvae are toxic and use the light to warn potential predators. A female hidden in the grass will blink the code if a good-blinking male of the same species flies above her, inviting him to land. But males have to be very careful: females of some larger firefly species can use the codes of smaller species to attract their males and eat them.

When a large number of fireflies of the same species are gathered, they sometimes begin to blink in unison; the reason for this behavior is poorly understood, but some locations where this happens have become popular tourist attractions.

The name glowworm can be misleading, because not all glowworms are flightless beetles or beetle larvae. There are a few tiny worms that live on the forest floor and produce weak greenish light for unknown reasons, and a few fly larvae that use light to attract prey (tiny midges and mites). There is one such fly species in North America, commonly known as dismalite. Its larvae live in moss-covered rock crevices and small caves of the southern Appalachians and the Cumberland Plateau, and can be best seen on moonless summer nights. Look for tiny blue dots of light in moist, shady places.

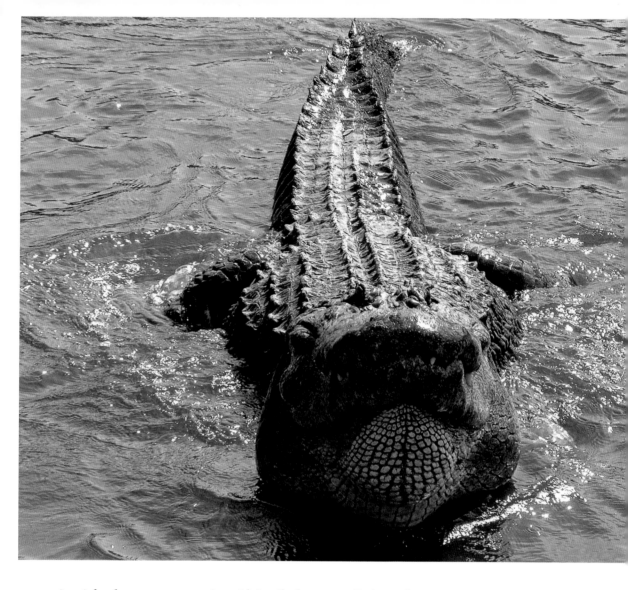

A bellowing alligator. Males produce infrasound (sound too low for humans to hear) between bellows; these powerful vibrations shake the water on their backs, making it "dance."

As nights become warmer in mid-April, choruses of winter frogs give way to those of summer-singing species. Meanwhile, American alligators gather to dance at night and bellow in the morning. Their bellowing choruses were described by naturalists as early as the eighteenth century, but, amazingly, the dances remained unknown to science until I was fortunate enough to discover them in 2006.

The reason I call them dances is that the dynamics of these nighttime gatherings remind me of village dance parties, where people come alone or with their loved ones to mingle, flirt, generally have

a good time, and occasionally to fight. The largest alligator dancing groups I saw in the Everglades had dozens of participants swimming in circles, splashing, chasing each other, sometimes hissing or snapping at an unwanted suitor or getting cozy with a wanted one. You can often see pairs or even trios joining the melee or leaving, but I don't know how often alligators leave with a partner that is not the one they came with. Recent studies have shown that despite being somewhat promiscuous, alligators often have preferred partners they mate with year after year. As pairs form, you can watch alligator courtship—a steamy affair full of delicate sensuality and warm tenderness. It can be initiated by either sex, but females tend to be a bit more straightforward in their advances.

By dawn, the dances are usually over, but sunrise brings the after-party bonus: a bellowing chorus. Here's a description of the first such chorus I saw, from my book *Dragon Songs*:

The lake was barely visible in pink fog. The forest was eerily quiet after the crickets-filled night. The purple sky was crisscrossed with golden jet contrails and lines of high cirrus clouds. The sun was just about to come up. The alligators were all in the water, floating like black rotten logs. Suddenly the largest one, a beast almost as long as my car, lifted its massive head and heavy rudderlike tail high above the water surface. He (such huge individuals are usually males) froze in this awkward position for at least a minute, while others around him were also raising their heads and tails one by one, until there were twenty odd-looking arched silhouettes floating in the mist.

Then the giant male began vibrating. His back shook so violently that the water covering it seemed to boil in a bizarre, regular pattern, with jets of droplets thrown about a foot into the air. He was emitting infrasound, acoustic vibrations too low for human ears to hear. I was standing on the shore at least fifty feet away, but I could feel the waves of infrasound within every bone in my body. A second later, he rolled a bit backwards and bellowed—a deep roar, terrifying and beautiful at the same time. His voice was immensely powerful. It was hard to believe that a living creature could produce what sounded more like a heavy tank accelerating up a steep rampart. He kept rocking back

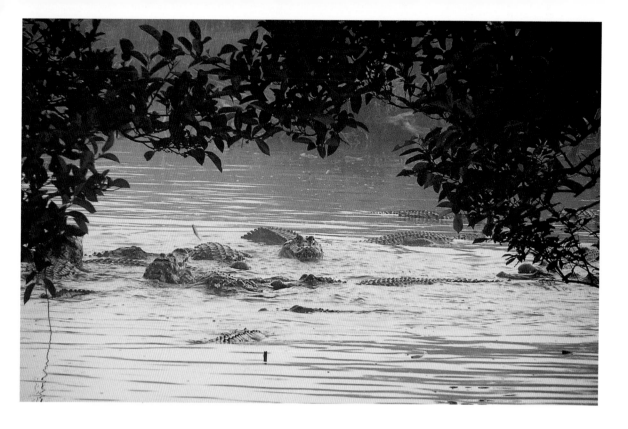

and forth, emitting a bellow every time his head was at the highest point and a pulse of infrasound every time it was at the lowest. All around the lake, others joined him. They were all smaller, so their voices were higher-pitched and less powerful, but still impressive. Clouds of steam shot up from their nostrils (weren't they supposed to be cold-blooded?) Trees around the lake—huge bald-cypresses—were shaking, dropping twigs and dry leaves on churning waters. I stood there, frozen, fascinated, hearing alligators in other lakes, near and far, as they joined this unbelievable show of strength and endurance. For about an hour, waves of bellows and infrasound rolled through forests and swamps all across southern Florida.

Then, gradually, they stopped. It was quiet again. The alligators were floating silently in the black water of the lake as if nothing had happened. I waited for two hours, and not a single one of them moved. Nothing moved there, except the rising sun and flocks of snowy egrets that sailed across the sky on their way from their night roosts to some fish-filled ponds.

On very rare occasions, alligator dances last into daylight.

Since the seas around the South's shores are not as productive as those up north, and there are few predator-free islands here, large seabird colonies are rare. Gulls, terns, and skimmers nest on large sandbars, while noddies, frigatebirds, and boobies form colonies on the remotest islands of the Florida Keys. But on the inland waterways, it's a different story.

When the first Spanish explorers arrived in what is now Florida and the Gulf Coast, they found mixed colonies of egrets, herons, cormorants, pelicans, wood storks, ibises, and spoonbills that stretched for many miles and had hundreds of thousands of nests. This bounty was almost destroyed when feather-decorated ladies' hats came into fashion, triggering a few decades of barbaric plume hunting. Egrets were hunted for the plumes they grow for mating dances, while spoonbills and flamingoes were shot for beautiful pink feathers. Almost all wading birds of the Southeast were killed off; it took perseverance and self-sacrifice by America's first environmentalists to stop the slaughter at the last moment.

Sadly, bird numbers never fully recovered, and a few species remain rare; today the chief problem is habitat loss due to draining

Double-crested cormorants often nest in egret rookeries.

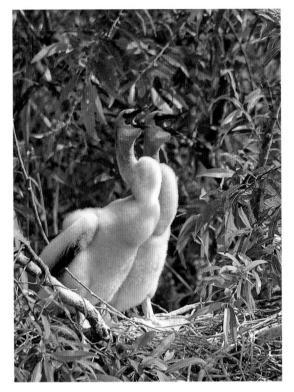

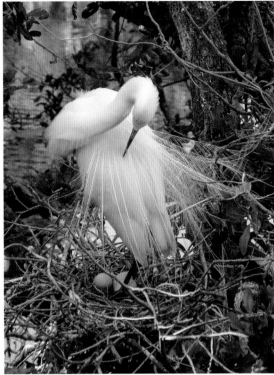

Anhingas are closely
related to cormorants,
but prefer to form their
own colonies.

Great white egrets
grow the longest plumes.
This one guards its nest.

of wetlands for agriculture. Still, there are a few places where you can see large mixed colonies, with many species performing their splendid springtime mating dances.

My favorite egret colony in North America is located near the city of St. Augustine, Florida, on the grounds of a large zoo specializing in alligators, caimans, and crocodiles. When I was working on my PhD study of the language of these animals, I had to spend a lot of time there. The unique opportunity to watch so many birds of different species up close, as they nested within a few feet of an accessible boardwalk, was always a pleasure that helped me endure long days of observations.

Hot and humid, with proliferating fire ants and bloodthirsty swarms of biting insects, the Southeast is a tough place to be a

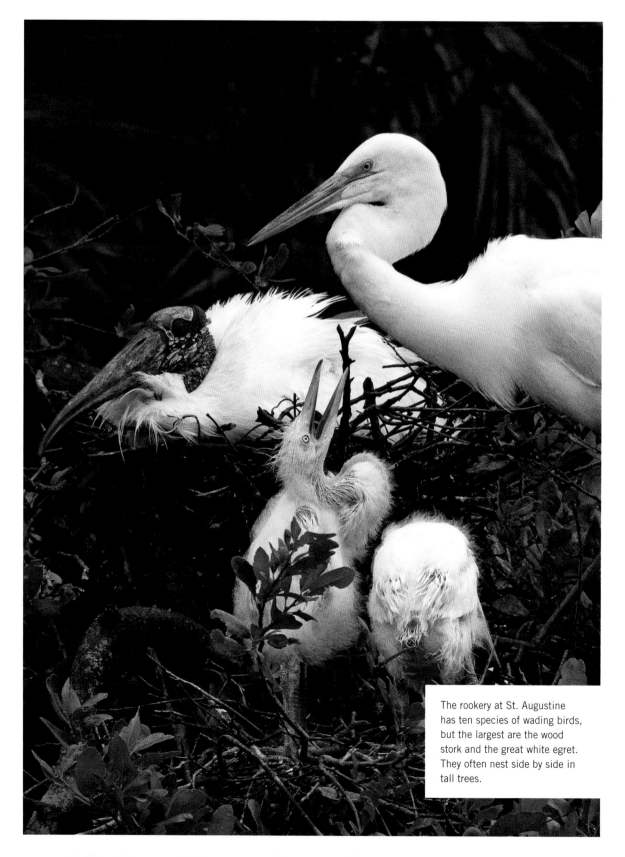

The rookery at St. Augustine has ten species of wading birds, but the largest are the wood stork and the great white egret. They often nest side by side in tall trees.

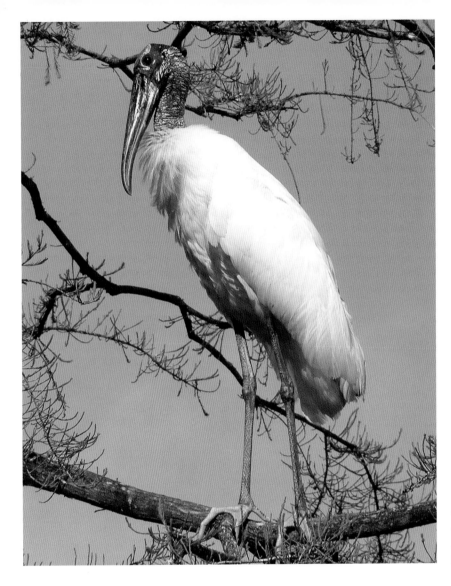

Wood storks were once virtually extinct in North America, but are now slowly recovering.

mammal, so most local mammals occur at rather low densities. But there is one species that forms the largest breeding gatherings of any warm-blooded animal on Earth. It is the Mexican freetail bat. Freetails are bats with long, narrow wings and fast flight, making them look a bit like swallows. They chase insects high in the air, and can fly far from their roosts in search of large swarms. They range over much of the Americas and usually live in colonies ranging in size from a few individuals to a few thousand (I once found six Mexican freetails squeezed into a cigarette pack–sized metal

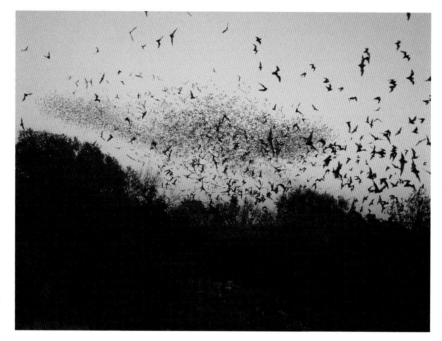

A small seam on the underside of a highway bridge is just big enough for a group of Mexican freetail bats.

Mexican freetail bats emerge from Bracken Cave, Texas.

slot in a basketball stand). But in some parts of the southwestern United States, Mexican freetails form enormous colonies in caves and sometimes in concrete structures, such as highway bridges. The largest colony, located in Bracken Cave near San Antonio, is estimated to contain twenty million bats.

Some Mexican freetail colonies have recently become tourist attractions. People come at sunset to watch a living tornado as the bats rise to the sky in a black stream. Falcons, hawks, and owls can often be seen snatching a few, but most bats escape the predators and, after gaining altitude, disperse to feed on insects. Radar data show that flocks of bats can fly up to 300 miles a night; larger

Townsend's big-eared bat often forms small colonies in caves and abandoned mines of the West.

colonies are said to consume a few tons of prey per night. Almost all that food is made up of agricultural pests—they are the only insects sufficiently abundant to feed so many hungry bats.

The bats' return at dawn is even more spectacular, because they approach the colony flying about a mile high, then dive straight into the cave entrance, making whistling sounds like a hail of bullets.

During the day, freetail bats hang from the ceiling of the cave or squeeze into cracks in concrete. They pack themselves unbelievably tight, particularly naked babies that stay warm by forming crèches: up to five hundred can roost in one square foot. Births are highly synchronized, and entire crèches often take flight at the same time, dropping from the ceiling all together. Young bats that don't manage to learn to fly in the split second before falling often don't get a second chance. Adult freetails can't take off from a horizontal surface because their wings are too long, so if a juvenile falls to the cave floor and survives, it has to crawl to a wall, then climb up to take off again. The cave floor underneath the colony is covered with a thick layer of guano (bat manure), crawling with beetles, cockroaches, and other insects—a fallen bat, dead or alive, is quickly consumed.

When tiny tricolored bats hibernate in cold caves, they often become covered with dewdrops.

An endangered northern myotis bat. By the time you read this, the species may already be extinct.

Mega-colonies of Mexican freetails disappear in winter, as the bats migrate to Mexico. Many bats living east of the Great Plains do the opposite: they live in small groups in hollow trees, abandoned buildings, or other shelters in summer, but gather in large colonies in caves to hibernate during the winter. Many species also mate in these caves. Unfortunately, these winter colonies are rapidly disappearing. A few years ago a deadly fungus from Europe was accidentally introduced to caves in New York State, and began spreading. The fungus causes a disease called white-nose syndrome, which can wipe out entire colonies of bats in just one winter. Within a few years it killed eighty percent of bats in the Northeast (causing billions of dollars of damage to agriculture) and spread as far as Mississippi and Washington State. It is still unknown whether it will be as destructive in the South as in the Northeast, and if it affects all species or only some. Scientists are particularly concerned about one species, the gray myotis bat, which lives in just a few large colonies where bats are tightly clustered. So far, no major die-outs of gray myotis bats have been reported, and you can

still see their mass emergences from caves in some southern states, but things could change very quickly, possibly even by the time you are reading this.

The Not-So-Temperate Latitudes

You don't have to travel to remote Arctic islands or the steamy swamps of Florida to see some mass action of the sensual kind. The midlatitudes of North America have their own share of love-related spectacles. Spring choruses of frogs and toads can be as impressive as in the South, particularly if you stumble upon a large gathering of spring peepers with their ear-piercing calls, amazingly loud for such tiny creatures.

Scientists studying frogs spend a lot of time learning to identify them by ear. On warm spring nights, you can drive around back-country roads with your windows down, listening for frog choruses. In recent years two new frog species were discovered this way, one of them in the suburbs of New York City.

Frog choruses have their own kind of beauty, but, of course, what makes spring in temperate forests so special is the dawn chorus,

On the West Coast, the largest frog choirs are usually formed by Pacific chorus frogs.

A 13-year cicada, just emerged from the nymph.

Spring peeper in a Missouri floodplain forest.

produced by numerous bird species. Birds tend to sing more actively at dawn almost everywhere in the world (the forests of Chile are one mysterious exception), but for unknown reasons the temperate forests of North America and Eurasia have the richest, most beautiful bird choruses. In June, when nighttime darkness is almost nonexistent at high latitudes, many birds sing all night long; one mockingbird was recorded singing for twenty-two hours in one twenty-four-hour period, producing over two thousand songs.

Unlike songbirds, cicadas prefer to sing in the heat of the day. Usually you hear the huge, beautiful ones called dog-day cicadas; they can be seen every year, with different species emerging in spring, summer, and autumn. Their nymphs live underground for two to three years.

But it is the so-called periodical cicadas that are truly special and produce unforgettable spectacles. They are unique to the eastern United States. There are seven species: three with a seventeen-year cycle of development and four with a thirteen-year cycle. The

former mostly live to the north of the latter, but there is some overlap. All species with the same cycle length living in the same area are synchronized, and show up on the surface at the same time after spending thirteen or seventeen years underground as nymphs. In addition to species, these cicadas are divided into broods, each having its own geographical range and emerging in different years. Theoretically there could be seventeen broods of 17-year cicadas and thirteen broods of 13-year cicadas. But in reality there are only twelve broods of 17-year cicadas (plus one recently extinct brood) and only three broods of 13-year cicadas (the fourth one is also recently extinct), which means that in some years you can't see them anywhere. But there are also years when you can see both 17- and 13-year cicadas, sometimes even in the same area.

Such long gaps between synchronized emergences are unique among animals (although some Asian plants have synchronized blooms with even longer gaps), so periodical cicadas have been the focus of much research. There are a number of ongoing studies using sophisticated computer modeling, and citizen science projects aimed at mapping the distribution of species and broods more accurately. One remarkable fact is that thirteen and seventeen are both prime numbers. A long-standing theory claims that having such long development and synchronized emergences separated by a prime number of years is a mechanism for dealing with predators and parasites. It is difficult for a predator or a parasite to evolve such a long life cycle, so it has to go into decline during the gap years and can't build up its numbers fast enough during an emergence (which only lasts a few weeks) to make a dent in the cicada population. If the gap time was not a prime number, a predator could catch the emergence at least sometimes (for example, if it was sixteen years, a predator could have a four-year cycle and catch the cicadas one time out of four). However, this theory is now less popular. It appears that predator and parasite avoidance is only a secondary benefit, while the original reason for evolving long cycles lasting prime numbers of years was a necessity to minimize hybridization between 17- and 13-year cicada species (the full explanation is a lot more complex, and is well supported by computer

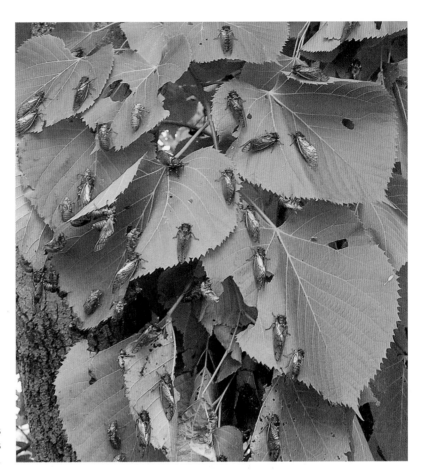

Periodical cicadas sometimes reach densities of one million per acre.

models). Their unique life cycles don't completely save the cicadas from parasites—there is one species of fungus that infects them. Of course, numerous predators feed on them (populations of moles, mice, and some birds surge around the time of emergence), but periodical cicadas emerge in such numbers that predation is negligible; indeed, they are noticeably tamer and easier to catch than other large cicadas, apparently because they simply don't care.

Locals often hate periodical cicadas because of the noise and the alleged damage to plants. In reality, the cicadas aren't serious pests, although in the last year before emergence their nymphs suck so much sap from tree roots that many trees stop growing. And their impressive choruses last for less than a month—a small price for witnessing such a unique natural event.

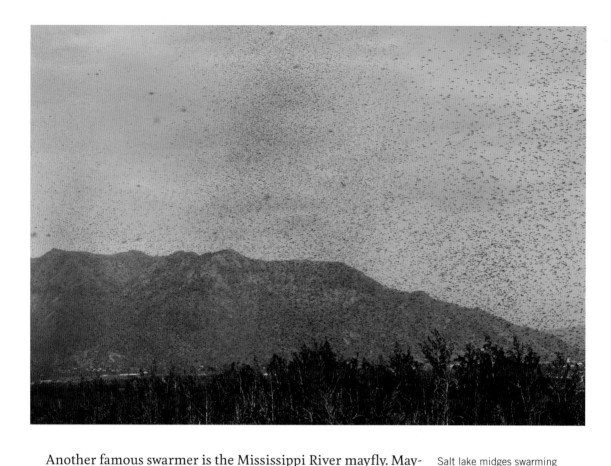

Salt lake midges swarming near the Great Salt Lake in Utah.

Another famous swarmer is the Mississippi River mayfly. Mayflies are the oldest flying insects, and the only ones that molt not only as nymphs or larvae, but also as adults (the technical term for a mayfly that already has wings, but still has to molt one last time is pre-adult). If you come to the insect's namesake river on a midsummer night to watch them swarm, you can see pale, recently emerged pre-adult mayflies land for a couple minutes to shed their exoskeletons. Their nymphs spend up to three years on the bottom of the river feeding on muck, slowly accumulating energy for the mating flight that lasts only a few days or even hours. Mayfly swarms are so huge that they look like big thunderstorms on weather radars, and insects killed by cars form dangerous slicks on riverside roads.

Caddisflies also form huge swarms sometimes. These swarms can be particularly impressive on the Arctic coasts, where there are few other insects. Without them, the tundra would have a lot fewer

Common garter snake. Thousands can be seen in May emerging from wintering dens in Manitoba.

birds. Songbirds and shorebirds of the tundra are particularly fond of adult caddisflies, while ducks eat a lot of caddisfly larvae.

The greatest swarmers in the West are tiny midges whose larvae live in salt lakes. Their swarms look like pillars of black smoke and keep growing throughout the summer. By October, they become so large that sometimes you can see them from an airliner flying at twenty thousand feet.

Some animals can't fly but can still swarm. Every year in early May, tourists flock to the small Canadian town of Narcisse, Manitoba, to watch thousands upon thousands of common garter snakes emerge from their wintering dens. It is the largest concentration of snakes in the world. Males are smaller than females; soon every female is chased by a bunch of males. Finally the lucky champion manages to get on top of the female, and you can see waves of muscle contractions running along his body from tail to head. It's always been thought that these waves are a form of foreplay, sexually stimulating the female, but a more recent (and disputed) theory suggests that the waves squeeze the air out of the female's lung (snakes have only one), forcing her to stop moving and submit. In September, the snakes return to the dens and can again be seen in huge numbers on warm sunny days before disappearing underground. At that time, there are usually fewer tourists, because the snakes just soak up the last rays of the sun and don't do anything interesting.

VIEWING TIPS

○ The best place to see fighting and mating **elephant seals** is the viewpoint on Hwy 1 north of San Simeon, CA, where fighting reaches its peak in December and pups are born in January. Año Nuevo State Park, CA, is also popular. The largest rookeries of **northern fur seals** are on Pribilof Island, AK. **California sea lions** mostly breed on the Channel Islands, but there is now a rookery near Fisherman's Wharf in Monterey, CA. **Steller's sea lions** mostly breed in Alaska. At Point Bennett in Channel Islands National Park, CA, you can see breeding **California** and **Steller's sea lions**, **northern** and sometimes **Guadalupe fur seals**.

○ **Harbor seals** breed on many rocky beaches along the Pacific coast; one is in Carmel, CA. On the Atlantic coast, the main pupping area of **harbor** and **gray seals** is on the extremely remote Sable Island, NS; smaller and more accessible areas are at Seal and Green Islands, ME, and Muskeget Island, MA (the latter accessible only by seaworthy kayak). Helicopter tours from Îles de la Madeleine, QC, to **harp** and **hooded seal** pupping grounds can be organized through Château Madelinot, http://www.hotelsaccents.com/chateau/seal-watching/. The main attraction there is the harp seal, so if you are also interested in hooded seals, you have to mention it at every stage of organizing the trip.

○ Unlike in Europe, large seabird colonies in North America are usually off-limits, and you can only watch them from a boat. A spectacular exception is the huge **northern gannet** colony at Île Bonaventure near Percé, QC, where you can almost touch the birds (in June and July). **Atlantic puffins** and other nesting seabirds can

be seen up close at Petit Manan Island, ME. A much larger colony is located in Witless Bay Ecological Reserve, NL. Cape St. Mary, NL, has **puffins**, **murres**, **razorbills**, **guillemots**, **kittiwakes**, **great cormorants**, and **fulmars**. Another good place to see **Atlantic puffins**, **razorbills**, **guillemots**, and **great cormorants** is Bird Island, off Cape Breton, accessible by boat tour from the town of North Sydney, NS. See http://www.neseabirds.com/ for more details. Seeing **dovekies** is more difficult; they nest in a few places in Greenland and in Home Bay on Baffin Island, NU. Bylot Island, accessible from Pond Inlet, NU, has a colony of over a million **seabirds**, plus one of the largest colonies of **snow geese**. Another place with huge **geese** colonies is Dewey Soper Migratory Bird Sanctuary, NU.

○ On the Pacific coast, **seabird** colonies can be seen with binoculars from many coastal lookouts such as Point Reyes Lighthouse, CA, in Mitlenatch Island Provincial Park, BC, and from boat tours to Kenai Fjords National Park, AK, and other rocky shores. But to see really huge colonies, you need to travel to the Aleutians, the Pribilofs, or other Bering Sea islands. The largest colony in North America is on St. George Island, AK.

○ An excellent place to see and hear **winter frogs** is Okefenokee Swamp, GA. Unfortunately, the most beautiful winter frog of North America, called the **ornate chorus frog**, doesn't occur there and has generally become very rare. The most impressive **summer frog** choruses take place in Atchafalaya National Wildlife Refuge, LA, although they are also very impressive in Okefenokee Swamp and many other large wetlands.

○ Swarms of **love bugs** are easy to see in summer around Lake Okeechobee, FL. Synchronized blinking of countless **fireflies** can be seen near Elkmont, TN, in early June. Visiting this place requires an advance reservation through Great Smoky Mountains National Park. Alternative locations include Congaree National Park, SC, and Three Rivers Wildlife Management Area near Knoxville, TN.

Another good place is Kellettville, PA, where an annual **firefly** festival takes place in late June; see http://pafireflyfestival.blogspot.com/. The best place to see **glowworms** is Dismals Canyon, AL; they also occur in Pickett State Park, TN, where glowworm-viewing tours are conducted in summer.

○ The best place to see **alligator** dances and bellowing choruses is at the end of Anhinga Trail in Everglades National Park, FL (it is also the best place to see nesting **anhingas**). St. Augustine Alligator Farm Zoological Park, FL, has ponds with lots of huge old alligators, so bellowing choruses there are even more impressive. The same ponds also have the most accessible wading birds rookery in North America, with numerous species of **egrets** and **herons, wood storks**, and sometimes a few **roseate spoonbills** (contact the park for viewing times). It is also the best location to observe **alligators** trying to lure birds by carrying little sticks on their snouts. A better place to see nesting **roseate spoonbills** is near the entrance to Rip Van Winkle Gardens, LA. In the West, a small, easily accessible **egret rookery** is located at 950 W 9th Street, Santa Rosa, CA. A larger one can be seen up close on Alcatraz Island in the San Francisco Bay.

○ Dry Tortugas National Park, FL, has the only **noddie, booby,** and **frigatebird** colonies in North America. Huge **gull** and **tern** colonies exist in Monomoy National Wildlife Refuge, MA, Captree State Park, NY, Grays Lake National Wildlife Refuge, ID, Medicine Lake National Wildlife Refuge, MT, Boundary Bay, BC, and at Isles of Shoals, NH. One of the largest **gull** colonies is on an island in Mono Lake, CA, but it can only be viewed from afar. A small colony of **least** and **roseate terns** exists on the roof of the government building in Marathon, FL; climbing to the only place where you can see the roof requires some physical ability, and although it is not explicitly prohibited, I don't know how the police would react if they see you. The largest colony of **American white pelicans** (ten to twelve thousand) forms from May through July in Chase Lake National Wildlife Refuge, ND. Another large colony is at Pyramid Lake, NV.

The largest colonies of **white-faced ibis** are at Carson Lake, NV, and in Bear Lake National Wildlife Refuge, ID.

o Tours to see **freetail bat** emergences from Bracken Cave, TX, are organized in summer by Bat Conservation International. In Carlsbad Caverns National Park, NM, at Congress Avenue Bridge in Austin, TX, and at Vaugh Drive Bridge in Houston, TX, you can see both the emergence and the return. To get close-up views of the freetails, try the large colony under both ends of the I-80 bridge over Yolo Bypass between Sacramento and Davis, CA. Emergences of **gray myotis bats** can be seen on summer evenings at Nickajack Cave, TN, Judges Cave near Marianna, FL, and Sauta Cave, AL—but the caves themselves are off-limits.

o For detailed information on the times and places of emergence of various broods of **periodical cicadas**, visit http://magicicada.org. **Mississippi River mayflies** can be seen in June and July along the Mississippi River from LaCross, WI, to Memphis, TN. Another good place is the Route 462 bridge over the Susquehanna River, between Columbia and Wrightsville, PA. At Red Deer River in Dry Island Buffalo Jump Provincial Park, AB, you can see dozens of **goldeneyes** feeding on **mayflies** in late July and early August. **Caddisflies** swarm in many locations; the most impressive swarms form in mid-June around Barrow, AK; in late June and late September at Parker Dam, AZ, and along the Colorado River in Grand Junction, CO; in late May along the Yellowstone River between Bozeman and Livingston, MT; and at various times along the Mississippi River and the Great Lakes shorelines. Swarms of **salt lake midges** can best be seen in October along the causeway to Antelope Island and at other locations around Great Salt Lake, UT; you can also see them at Mono Lake, CA.

o The trail to Narcisse Snake Dens, where the mass emergences of **garter snakes** occur, is signposted on Hwy 17, 3.6 miles (6 km) north of Narcisse, MB.

EARNING SOME
RITUAL FIGHTS AND
COURTSHIP STRATEGIES

Many animals have to face fierce competition in trying to find a mate. Their trials might be as simple as racing to find a newly hatched female (some male moths can smell a female from ten miles away), or as complex as finding a good site for a nest, establishing and defending a territory, and singing almost nonstop for weeks so that a female flying overhead might notice. Usually it's the males that are trying most overtly, with various ornaments and dancing skills to improve their chances of drawing attention. But females are also competing, just in more subtle ways. In some cases, the roles are reversed: for example, male phalaropes are less brightly colored than females, and do most of the work incubating the eggs and raising the chicks, while females fight over males and guard them. As soon as the male gets busy sitting on the eggs, the female leaves him to look for new adventures.

Love Games

Why are males showier than females in most species? One theory is that females have to be choosier because they invest more in producing eggs and raising the offspring, so they can't waste time and effort on mating with low-quality partners. Another opinion suggests that males are generally more expendable, and so can be burdened with heavy antlers or camouflage-breaking bright colors. I think both theories can be correct in different cases.

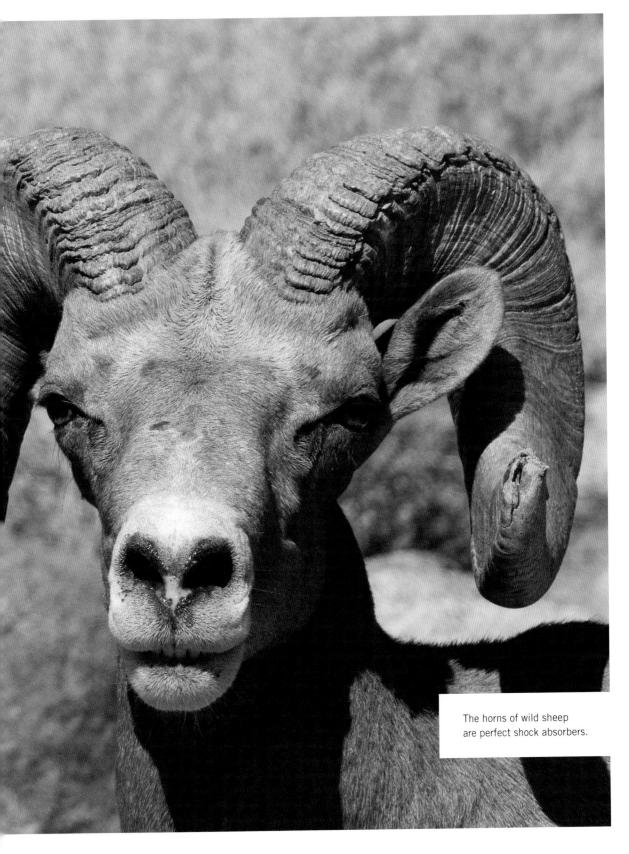

The horns of wild sheep
are perfect shock absorbers.

As a result of males constantly trying to impress females, and females trying to pick the best mate, an arms race of sorts often unfolds: males try to cheat, and females try to see through the cheating. The textbook example is the male elk: as it matures, it develops a loop in its trachea that makes its voice deeper, as if it were larger. Interestingly, the only other species known to use the same trick is humans: men's larynxes descend during puberty, making their voices sound more masculine. Studies have found that most women find deep male voices sexier. Human females, of course, use a whole arsenal of tricks to look younger, healthier, and generally more attractive.

Some species have escaped such tricks by relying on what are called honest signals, features that can't be faked. For example, female birds often judge males by their ability to perform very fast

Female (top) and male red phalaropes.

Male elk use an anatomical trick to sound big and strong.

songs with rapid changes in pitch. But females of many other species simply let the males test their strength and endurance directly by engaging in battle.

Ramming for Success

Most male mammals have to fight for females, territory, or dominance at some point. If the animals are lucky, these fights are ritualized and seldom result in serious injuries, but in some cases fights are to the death. The most vicious fight I've ever seen was between two yellow-bellied marmots in the mountains of the Sierra Nevada: I'll spare the gory details, but one opponent suffered terrible wounds and the other was almost torn to pieces.

Male ruminants are among the feistiest combatants. Since they lack the deadly fangs and claws of carnivores and the steel-strong

incisors of rodents, they had to evolve weapons designed specifically for male-to-male combat: horns and antlers. These weapons are usually, but not always, shaped in such a way as to allow the competitors to test their strength without causing too much damage. The deadliest ones are the short, sharp horns of mountain goats: they have disemboweled many a wolf and at least one unfortunate hiker. The massive horns of wild sheep and muskoxen serve as weapons and protective helmets at the same time; muskoxen horns are so impervious that before the invention of rifles, hunters' bullets couldn't penetrate them.

All native ruminants of North America fight during the rutting season, and it's always a treat to watch fighting deer, bison, muskoxen and bighorn—but moose and elk ruts are particularly dramatic. All the elements combine to create a perfect natural spectacle: the fall colors, the far-carrying calls of the males, the powerful clashes. As

Mountain goats look cute and cuddly, but they are deadly fighters.

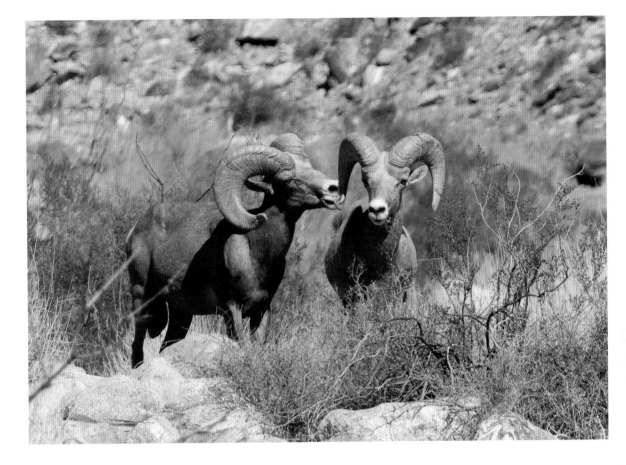

Outside the brief rutting season, male bighorns get along surprisingly well.

if trying to make the show even more impressive, both species call and fight most actively on cool, brilliantly sunny mornings. It's a sight no one can forget.

In places where hunters use elk calls to hunt the animals, the elk eventually learn to call much less often, or not at all. So for a real show, try places where they haven't been hunted for a long time, such as large national parks.

There is a lot more to see during rut than just fighting. Males do a lot of interesting things: they pick up clumps of dry grass to hang from their antlers and make them look bigger, they play-fight with shrubs, and they chase females around. Just don't get too close—you don't want to be chosen as a training dummy.

Whales are descendants of terrestrial ungulates, and some of them have retained their love of a good fight, or maybe they developed it anew. Their tournaments are much more difficult to

observe, and for some deepwater species (such as the mysterious beaked whales) the tendency of males to fight can be only inferred from the shape of their teeth and the heavy scars covering their bodies. It was long suspected that the extended, weird tusks of male narwhals were used in fights, but these fencing matches have only recently been observed and filmed.

Scientists have always been amused by the similarity in weapons possessed by male elk and their namesakes, the stag beetles. Males of one North American species, the giant stag beetle, have jaws shaped almost exactly like elk antlers. These, too, are tournament weapons: they are much weaker than the short, claw-shaped jaws of females, and their purpose is not to maim the opponent, but to lift him up and throw him. Stag beetles usually fight on old stumps and logs, good places for females to lay eggs; their larvae can feed on rotting wood. If a male gets thrown off the log or stump, by the time he climbs back to the arena it's too late to fight again—his adversary is already mating with the female. After mating, the male will install a plug in the female's genitalia to make sure she remains faithful.

Among the most ritualized battles are those between male rattlesnakes. The adversaries rise vertically, trying to press each other to the ground. They always fight fair: there are no known cases of bites during fighting. These fights are usually over within a few minutes, but on rare occasions when the males are evenly matched, they can fight for more than an hour. Cottonmouths and copperheads also fight in this manner.

Song Wars

While brutish mammals often brawl physically, birds and insects seldom do, generally preferring to sort things out by singing or dancing. Of course, some mammals have also learned the trick. Tiny canyon bats and harvest mice sing to their loved ones (their songs are sometimes too high-pitched for us to hear). Baleen whales sing a lot; their songs are at the opposite end of the sound spectrum and are sometimes too low for our ears. The most accomplished singers

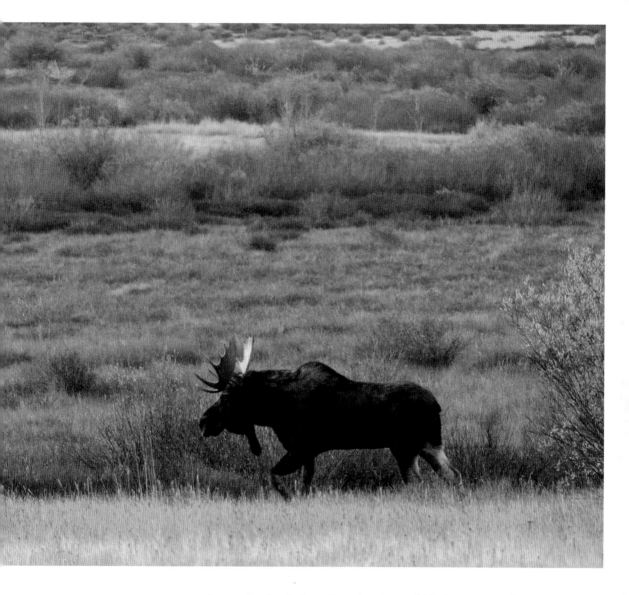

Bull moose play-fighting with shrubs.

are humpback whales: they sing incredibly long, complex songs in order to . . . well, nobody really knows why they do it.

Humpbacks have been studied by generations of scientists and watched by millions of tourists; their songs have been incorporated in human music and are often played in yoga and meditation classes—but we still have no idea what purpose the songs serve. The usual suspects are mate attraction and territorial marking, but they don't seem to explain the patterns of whale behavior. We know

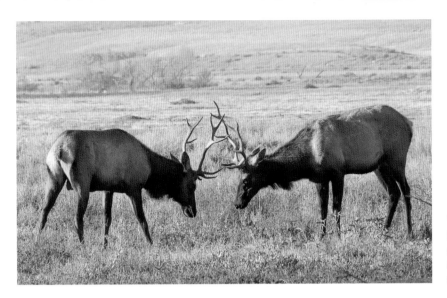

Tule elk of California fight during rut, but since they are a smaller subspecies of elk, it's a bit less impressive.

that humpbacks in each geographical area usually sing songs of the same type, but change them every few years; a whale accidentally moving from one area to another can so impress the locals with a new song that all of them switch to the new style. We also know that whales can sing for more than twenty-four hours nonstop, even when there's no indication that other whales are listening. I suspect that the true explanation is not strictly utilitarian, but I will not use the word "fun," to avoid being ostracized by my colleagues.

Humpbacks also engage in a variety of displays such as lob-tailing, tail-slapping, fin-slapping, and particularly breaching (jumping out of the water). They can breach up to a hundred times in a row, and sometimes many whales will do it together at the same time (no wonder humpbacks are so popular among whale watchers). Again, nobody knows why they do it. It seems that unlike singing, breaching is much more frequent in places where humpbacks breed. Other aquatic animals, such as sturgeon, mako sharks, and large skates also breach (giant mobula rays can "fly" fifteen feet high). In all those cases, as with so many animal behaviors, the reasons are a mystery, although there are many theories.

When you think about singing animals, you probably first think about birds, particularly songbirds. Few people know exactly what the term songbird means. Songbirds are a subgroup of passerines (the largest group of modern birds) that have a particularly complex

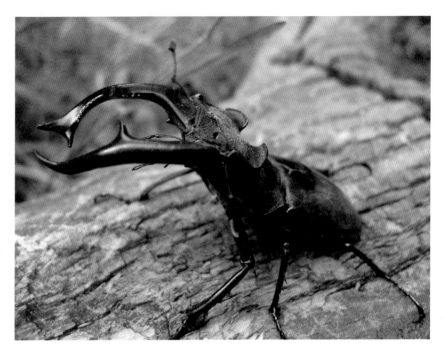

The giant stag beetle, whose antlerlike jaws are used to throw challengers off prized real estate: the rotting logs where females can lay eggs.

syrinx (sound-producing organ in the trachea). The musical qualities of their songs are irrelevant for this classification. American flycatchers, pewees, and phoebes are not songbirds, but ravens and crows are. Many nonsongbirds produce very complex songs, such as hummingbird warbles, or simple but beautiful sounds, such as loon calls. There are about four thousand species of songbirds, but only a few hundred sing particularly beautiful songs. The main function of songs is generally believed to be to attract mates and mark territory; males of some species continue to sing after the chicks have fledged, in order to teach their sons how to sing properly.

Europeans traditionally consider nightingales the world's best singers. The Japanese tend to agree, without realizing that their beloved bird (whose name usually translates as "nightingale") is actually a bush-robin. My personal favorite is another Eurasian bird called a blackcap. North America doesn't have such a clear winner; city folks usually prefer the northern mockingbird, while naturalists (starting with David Thoreau) tend to be fond of the hermit thrush. You can easily make your own choice by listening to a CD with the songs of all North American birds—but to fully appreciate the depth and variations, you have to hear these birds on a

Pacific loons arrive at their breeding lakes as soon as there's open water among the ice.

quiet spring morning in their natural habitat. Be sure to listen to the Carolina, Bewick's, and house wrens; the wood thrush; and the vesper sparrow. In the Southwest, listen for various thrashers; in western mountains, for Cassin's finch; in grasslands, for meadowlarks; in Alaska, for bluethroat. Even if you don't want to learn the songs of individual species, you can still enjoy the chorus—usually best in April and May in deciduous and mixed woods from the Appalachians to the Great Lakes region. Many species of songbirds are declining in numbers for a variety of reasons (loss of habitat—particularly in wintering areas in the tropics, brood parasitism by cowbirds, pesticide poisoning, and climate change, just to name a few), so it's better to enjoy them while they are still around.

Interestingly, some birds "sing" without using their syrinx, or even their voice in general. Most woodpeckers drum: they find a dry snag or sometimes a metal pole and produce a rapid series of knocks that sound like a trill; that trill differs between species. Wilson's snipe has narrow tail feathers that produce quavering sounds when the bird goes into a steep dive.

Singing in flight is quite common among birds, particularly those that live in open landscapes where finding a high perch is

A golden-crowned sparrow sings at midnight at Hatcher Pass, Alaska. In the Arctic, birds can often sing without a night break, thanks to twenty-four-hour daylight.

Lapland longspur. The male's bright plumage is a backup signal for windy days when his song doesn't carry far.

difficult. Those flights often follow a particular pattern and are called display flights. Longspurs, horned larks, and lark buntings usually sing while hovering high above ground. Woodcocks fly horizontally over woodland-bordered fields and forest roads, making insectlike roding sounds. Pectoral sandpipers fly in circles over their Arctic breeding grounds, making loud bubbling sounds and inflating their chests so that they look like winged balloons.

Many hummingbirds have spectacular display flights. For example, male Anna's hummingbirds, common residents of California gardens, will hover in front of females, then climb straight up for about a hundred feet and go into dives that end near the starting point of the flight; as a male comes abruptly out of a dive, he gives out a sharp, popping cork-like sound and begins to climb again. On sunny days, a male will orient his elliptical display flight in such a way that the sun reflects off his iridescent red throat feathers.

Nesting female hummingbird.

Interestingly, some butterflies with iridescent wings have display flights very similar to those of hummingbirds. A male grapevine swallowtail will make an arc in front of a female in such a way that the sunlight reflects off his wings into her eyes.

There are also birds that sing during display flights at night. The most familiar are nighthawks; barn owls also fly in circles and make clicking sounds. Other owls usually call from perches. The most beautiful owl song in North America is that of the barred owl, a common sound of summer nights in eastern woods.

Baby barred owl in the Everglades.

An American crocodile singing in the Florida mangroves.

Although crocodiles and alligators are commonly called reptiles, their closest living relatives are birds (birds are just one lineage of dinosaurs, and dinosaurs are crocodiles' relatives). Not surprisingly, both alligators and crocodiles sing pretty much like birds do. Many people who spend a lot of time outdoors in the South are familiar with alligator bellows, but few have heard the song of the American crocodile: a low, rumbling roar. Crocodiles sing much earlier than alligators (in the first days of spring) and never form choruses. The male's roar is often preceded by a powerful infrasound pulse and followed by one or two head slaps, signals of dominance.

Other native North American reptiles don't sing, but some introduced species do. If you spend a night in a cheap hotel or private home in southern Florida, you might hear the song of a gecko. A few species have been introduced to the area; the most common is the Mediterranean house gecko, a small lizard that inhabits buildings and feeds on insects. Its call is a sharp birdlike chirp. As with many animal sounds, nobody knows its purpose; the most common theory is that it's a territorial call, but it might be an attempt to attract lizards of the opposite sex, or perhaps crickets.

Anole lizards are mute, but they have found a replacement for singing. Adult males have a triangular fold of bright-colored

skin under their throats. This is called dewlap, and the anole lizard flashes it frequently during the day. The only native species in North America, the green Carolina anole, has red dewlap, but in southern Florida, where half a dozen Caribbean species have been introduced, you can see anoles with white or yellow skin folds. Despite numerous studies, it is still unknown why anoles flash their dewlaps.

As lakes and rivers of the East warm up in June, male freshwater drums start singing their songs. These large fish are the only fully freshwater members of a large family called sciaenids. Most of its members live in the sea and also use their swim bladders to produce drumming sounds, as you can tell from their names, such as "croaker" and "striped drum."

With a few exceptions such as woodpeckers and humans playing string instruments, vertebrates produce sound by compressing air-filled cavities, be it swim bladders, lungs, or frog resonators. Cicadas also do that (they make sound by moving membranes called tymbals that you can see on the underside of the male's abdomen), but most insects use a completely different mechanism called stridulation. To understand stridulation, try running a fingernail along a comb. The most familiar singers of this kind are crickets, katydids, and grasshoppers. Crickets and katydids make sounds by rapidly

Puerto Rican brown anole flashing his dewlap.

(left) A large grasshopper from New Mexico.

(right) One of the grasshopper species that sing in flight. Note the bright rear wings that are normally visible only in flight, and stridulation grooves on the inside of the hind thigh.

rubbing together their wings. Usually there is a sharp scraper on one wing and a washboardlike surface on the other. Grasshoppers rub their hind legs against their wings, but otherwise the mechanism is the same. The most advanced stridulators are bessbugs: large black beetles that are often found under logs in eastern woods. These beetles take care of their offspring and use at least fourteen different sound signals to communicate between themselves and their larvae, but very little is known about their language.

Late summer is the best time to listen to katydid and grasshopper choruses because many species have an annual breeding cycle: they overwinter as eggs and take a few months to become adults. In some places you can hear thousands of individuals belonging to dozens of species. Most of the time you hear males; females of some species also sing, but only briefly and in response to a particular male. Male katydids and grasshoppers usually have just one song, but male crickets can have up to four. In addition to the "loud song," used most of the time, they also have the "aggressive song," used when another male is nearby; the sentimental-sounding, quiet and intimate "courtship song," used when a female begins to approach them; and the short, very loud "triumphant song," emitted just

after a successful mating. What purpose, if any, the latter type has is unknown. The current theory is that it somehow stimulates the female to lay eggs. A few species of parasitic flies find male crickets by their songs; the risk of lethal parasitic infestation has forced some cricket populations to give up singing altogether.

It's interesting that grasshopper and cricket songs (as well as the songs of many frogs and toads) become faster in tempo as the temperature rises. That difference can be heard in places where the air warms up very fast, such as narrow canyons that stay in shade until the sun is nearly overhead, or in high-elevation meadows where the temperature drops fast after sunset.

Some grasshoppers that live in grasslands and meadows have evolved display flights very similar to those of longspurs and other prairie birds. They sing while flying in circles and flash their red or yellow rear wings.

If you walk along the shore of a quiet grassy pond, you can sometimes hear what sounds like distant, low-pitched metallic humming. This is the song of a small water bug called the water boatman. You can often see these creatures as they float on the surface; they

Some Florida cockroaches are also capable of producing sounds.

are about the size of a grain of rice. Consider yourself lucky: their songs lose about ninety-nine percent of their volume as they travel from the water to the air. Underwater they are as loud as a passing freight train; a pond with large numbers of water boatmen could burst a human eardrum. A male water boatman produces the loudest sound of any animal relative to its size, by rubbing the tip of his penis against his abdomen.

Lacewings, small green insects common in gardens, also produce sounds, but these sounds are very soft. They sometimes resemble a little electric motor or a distant helicopter. The sounds serve to attract the attention of the opposite sex, but while we know they are produced when the insect shakes its abdomen, we don't know exactly how the sounds are made. To hear them, you need to put your ear very close to courting lacewings, preferably in a quiet room. Scientists with trained ears can tell identical-looking lacewing species apart just by their songs.

Some invertebrates produce sound by tapping on the ground. Jerusalem crickets drum with their abdomens, while jumping spiders tap with their legs. However, some species of jumping spiders only drum if they are on a solid surface. If they are on soft soil or sand, where tapping wouldn't work, they switch to dancing.

Drakes sometimes court females as a team.

Dances at Dawn

Unless you count funny leaps performed by courting hares, jack-rabbits, Arctic foxes, and some humans, North American mammals don't dance during courtship. Neither do reptiles (except alligators) or amphibians. But there are lots of dancers among our birds, fish, butterflies, and arachnids (spiders and their relatives). Fish dances are usually simple: the male, bright-colored during the mating season, circles the female, showing off his colors. You can see such behavior in darters, trout, grayling, pupfish, and many other species. Bird dances are incredibly diverse, and are used by numerous species, ranging from tiny sandpipers to five-foot-tall whooping cranes. In many cases you can clearly see how these dances have evolved, because they look like exaggerated versions of everyday movements, such as bathing or preening (performances by drakes of various species in front of female ducks are good examples). Other dances have become so complex and weird, they don't look like anything a normal bird would do. Among North American birds, some of the most accomplished dancers are grebes and grouse.

It is thought that grebe dances have evolved from aggressive displays. In smaller species they are brief and consist of simple moves

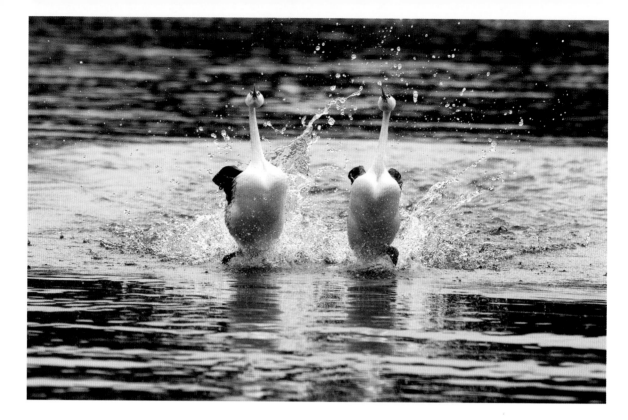

and calling in turn, but in larger species they can include up to seven different moves, performed by both partners in splendid synchronization. Dances of western and Clark's grebes often begin with the male approaching the female with a bunch of weeds in his bill; these weeds are probably a replacement for what was once a fish brought as a nuptial gift (discussed later). The birds then rise vertically in the water face-to-face, nod to each other, swim side by side while performing a complex series of rapid head movements, and finally run over the surface of the lake, standing up, flapping their wings and stretching their necks forward at a right angle to their bodies. Some western lakes are literally covered with the grebes' floating nests in summer, and you can watch this spectacle more than a hundred times per day.

There are eleven species of grouse in North America, and they provide a perfect illustration of the evolution of courting dances, from very simple to more complex. The three species of ptarmigan don't even have real dances; their males just give loud calls in

Clark's grebes in the final stage of their mating dance, running in unison over the water's surface.

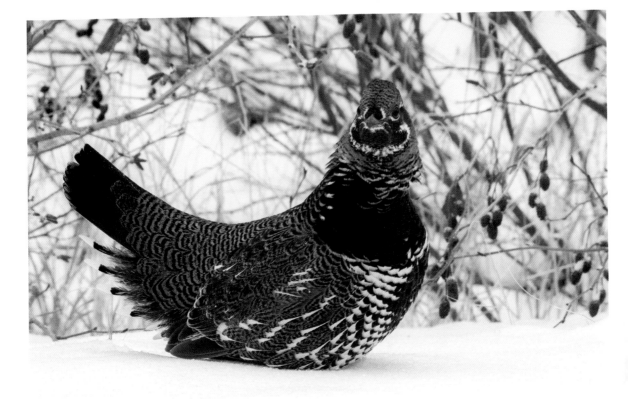

Male spruce grouse.

display flights and pose on rocks or tall shrubs. They also use a neat trick to make themselves highly visible during the mating season. Ptarmigans are unique among birds in that they have white winter plumage, which they acquire in the fall by gradually molting from their cryptic summer feathers. In spring the process is reversed, but it is timed in such a way that during the mating season, males have very striking coloration, with reddish or brown bodies and white heads, necks, wings, legs, and bellies.

Like ptarmigans, ruffed grouse are monogamous. They have an unusual dance, or rather display, currently thought to be mostly for marking territory. The male perches on a log, fans his tail, ruffles his neck feathers, and flaps his wings, producing an unbelievably loud drumming sound. For centuries it was believed that he simply drummed on the log with his wings, but high-speed videos have shown that the wings never touch the log; the sound is produced by rapid movement of the wings through the air. Displays by the spruce, blue, and dusky grouse are a bit similar, but in the latter two

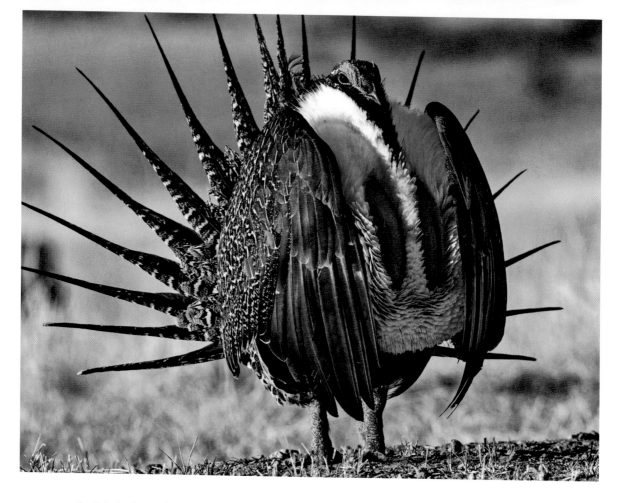

The male greater sage grouse puts on an impressive strut during mating.

cases the birds don't flap their wings—instead, they inflate two huge balloonlike resonators on the sides of their necks and make deep booming sounds. The "hoots" of blue grouse are audible to a human for over a mile, but those of another species, the sooty grouse, are so low in pitch that most humans can only hear them up close.

Things get much more interesting for the remaining five species of North American grouse: these are all polygamous and gather in large numbers at communal dancing grounds called leks. These are amazing sights, and many people make long trips west in the spring to see the leks of all five species: the greater and lesser prairie chicken, the sharp-tailed grouse, and the greater and Gunnison sage grouse. This trip is known among birders as "the grouse grand slam."

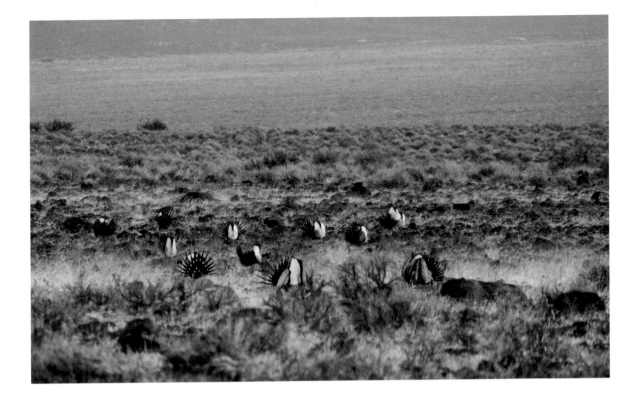

Lekking greater sage grouse.

The locations of leks often remain constant for decades or even centuries, and some are now equipped with observation blinds. It is better to arrive at the blind the evening before (bring a warm sleeping bag and a scope). If there is no blind, park your car at least a hundred yards from the lek in the evening and quietly wait for dawn. Never exit the blind or the car until the dances are over: disturbance makes the birds abandon the lek. It is important to contact the landowner in advance (the areas are often national grasslands or owned by the BLM; contact the local office), because sometimes the leks are no longer active, or you need to pick up keys to enter the blind. Precise directions are also important, as it's easy to get lost in the grasslands.

There was a time when you didn't have to travel to the West to see grouse leks. The greater prairie chicken could once be found on the East Coast and also in eastern Texas. Today the eastern subspecies is extinct and the one in Texas is critically endangered. The only leks you can see east of the Mississippi are those of sharp-tailed grouse, located in remote northern Canada. The remaining prairie chicken

In the East, the most spectacular bird dances are those of wild turkeys.

Some bird displays are purely territorial. Here, two avocet couples face off.

populations are highly fragmented and threatened by a long list of bad things, from massive loss of habitat to herbicide poisoning to females of introduced pheasants laying eggs in prairie chicken nests. The Gunnison sage grouse, amazingly discovered only a few years ago, has a tiny range and is highly vulnerable. The greater sage grouse is still widespread, but is also in trouble. It is highly sensitive to sounds and doesn't tolerate the presence of tall structures such as power lines and oil rigs (they are often used as perches by birds

of prey), so as the West is being turned into a playground for energy companies and their trappings, the grouse numbers are shrinking. In the mid-1970s, you could see up to 400 males at one lek; now seeing 50 is almost impossible.

The dynamics of grouse leks are complex and, despite many years of research, not completely understood. Although there is a lot of running around, every male has a territory. The territories at the center are the smallest and the most valuable; fights over these territories are common. Females don't dance or make sounds; they quietly watch the males and reject or accept their advances. The male prairie chicken and sharp-tailed grouse inflate brightly colored air sacks on the sides of their necks and make booming sounds. In sage grouse, the inflated air sacs form huge bags on the chest, and the sounds are more complex. It is interesting that the female doesn't seem to care at all about the male's territory: her choice is based only on the male's dancing performance.

Among the small birds, some of the weirdest performances are given by blackbirds and their relatives, grackles and cowbirds. They assume bizarre postures and produce strange metallic sounds. They

Red-winged blackbird, displaying.

A desert scorpion in a threatening posture.

also fluff their feathers to make their iridescence more visible: a dull-colored cowbird suddenly begins to shine with splashes of green and blue. Two species, the red-winged and the tricolored blackbirds, have bright-colored shoulder patches that are extended and look really beautiful during displays. The patches of tricolored blackbirds are scarlet red edged with white. Those of red-winged blackbirds are usually red edged with yellow, but in areas where tricolored blackbirds also occur, the patches of red-wings are simply red (such birds are sometimes called bicolored blackbirds). This change is called character displacement, and supposedly serves to avoid hybridization by making two closely related species look more different in places where they occur together. Unfortunately, this beautiful example of evolution in action might soon disappear, as tricolored blackbirds are rapidly vanishing due to habitat loss.

Perhaps the most unlikely dancers are slugs. Slugs are hermaphrodites, and when they have sex the process goes both ways. It is a complex affair: many species generate calcareous projectiles, called love arrows, and pierce each other, apparently for sexual stimulation. Others hang themselves head down on a thread of slime, intertwining their bodies and penises. The penises are sometimes much longer than their owners, so untangling them after sex is very

Slugs in a mating dance.

difficult. Banana slugs of the Pacific coast don't even bother with extricating themselves: after having sex for the first time they bite off their penis or let their partner do it, and live the rest of their lives as females. In some slugs, the foreplay can last up to three days, but the act itself can be over in about two seconds. There are hundreds of slug species and each one has sex in its own unique way.

The longest mating dances are performed by scorpions. They usually last a few hours, but some couples spend a few days holding hands (I mean, pincers) and walking forward and backward or sometimes in circles. The dance ends with the female accepting a package of the male's sperm.

Nuptial Gifts

Some birds such as terns and shrikes have a charming ritual: the male has to bring the female a fish or some other snack to gain her favors. This has nothing to do with paying for sex: the gift shows

Alligator snapping turtles are probably the worst lovers among North American animals. Mating of these giants is always an extremely violent affair.

the female that the male is a capable provider of food. In spiders it helps distract the female so she doesn't eat the male. Male katydids can't bring food, so when they inject their sperm they accompany it with a package of highly nutritious proteins. If the package is big enough, the female uses the sperm to fertilize the eggs; if it's not, she might choose to block the sperm and mate with another male.

Male birds of prey don't bring nuptial gifts, but they are tested in a different way. During incubation and while the chicks are being raised, the females don't hunt—the male is entirely responsible for feeding her and the brood. He brings the food and gives it to the female during a dangerous aerial maneuver: the female has to turn upside down in midair to accept the prey from his talons. So during courtship, females test the males' aerobatic skills by imitating the food transfer. This aerial ballet is particularly fascinating to watch in the largest species, bald and golden eagles. Bald eagles will often lock talons and plummet to the ground, only to

This black widow couple settled in my bedroom corner. The male black widow does not bring nuptial gifts to the female, and often does not survive mating. In this case, the female chose not to eat the male, and they lived happily ever after.

separate and fly apart at the last possible moment; this is probably a test of commitment, and even established pairs repeat it every spring. Golden eagles pick up rocks or tree branches, drop them in midair and catch them again, showing off their proficiency in vertical dives. But the most acrobatic raptor in North America is the swallow-tailed kite; its mating flights often resemble butterfly dances.

VIEWING TIPS

○ Fighting **mountain goats** can sometimes be seen up close in late November and early December at Disaster Point in Jasper National Park, AB, in Lost Creek State Park, MT, and in Clarks Fork Canyon, WY. Fighting **bison** are more difficult to see because their rutting season stretches from June to September and is less intense; try Yellowstone National Park, WY, or Wind Cave National Park, SD. **Bighorn sheep** fights take place in late fall and early winter; good places to see them include the vicinity of Jasper, AB, Radium Hot Springs, BC, and Sun River Canyon, MT. **Dall sheep** rut in late fall; try Atigun Pass on Dalton Hwy, AK, and (for the dark race called stone sheep) Stone Mountain and Muncho Lake Provincial Parks, BC.

○ Among the best places to see **moose** rut (mid-September to late October) are Captain Cook State Park, AK, Prince Albert National Park, SK, Riding Mountain National Park, MB, and particularly Red Rocks Lake National Wildlife Refuge, MT. **Elk** rut usually peaks in October; the best places to see it are Banff and Elk Island National Parks, AB, Charles M. Russell National Wildlife Refuge, MT, Valles Caldera National Park, NM, Grand Teton National Park, WY, Rocky Mountains National Park, CO, Redwood National Park, CA, Hatfield Knob in North Cumberland Wildlife Management Area, TN, and Elk Country Visitor Center near Benezette, PA. **Deer** rut in November in the North but as late as February in Florida; see the first chapter for good places to see them in large numbers.

○ Male **canyon bats** in courtship flights can often be seen late at night along forest roads in Yosemite National Park, CA. The "songs" of **harvest mice** can be heard on moonless nights in Duralde Prairie, LA, and in Whites Mill Refuge, TN.

- The best place to see **humpback whales** breaching is Monterey Bay, CA. Many local whale-watching operators have hydrophones, giving you a chance to hear humpback songs.

- The majestic **loon** calls can be heard on many lakes in the North, but usually there's only one species, the **common loon.** You have to travel to Nome or Barrow, AK, or to Inuvik, NT, to hear three or four additional species. Nome and Barrow have road systems where you can also see and hear other Arctic birds; Barrow is particularly good for **pectoral sandpipers** (display flights in mid-June), **eiders**, and **Lapland longspurs**, while Nome has an outstanding diversity of **shorebirds.** The **hermit thrush**, **wood thrush** and many other good singers are common in eastern woods; try Great Smoky Mountains National Park, TN-NC, or Shenandoah National Park, VA. **Bluethroat** is much more difficult to hear; try upland portions of Dalton Hwy, AK, or Dempster Hwy, YT.

- **Wilson's snipes** are common in swamps and marshes over much of the northern United States and Canada; listen for their tail songs on spring nights. **Woodcocks** are common throughout much of the East; contact the local Audubon Society branch to find the best places for watching them in spring. **Barred owls** are also common throughout the East, but they are much easier to see and hear in the South: try Everglades National Park, FL, Highland Hammock State Park, FL, or Congaree National Park, SC.

- Display flights of the **lark bunting**, as well as the **chestnut-collared** and **McCown's longspurs** and other prairie birds can be seen in many national grasslands—for example, Thunder Basin National Grassland, WY. The best places to see weird display flights of **Anna's** and other western **hummingbirds** are various botanical gardens in California and Arizona. Many species of **woodpeckers** can be seen in large numbers in forests that burned three to ten years ago, such as those in Yosemite National Park, CA.

- The best place to watch roaring **crocodiles** is the Flamingo area in Everglades National Park, FL: look for them in the morning in late February through early March, on the far side of the lock at the entrance to the harbor. A good place to see and hear **freshwater drums** underwater is Nickajack Lake, TN.

- Some of the best, most diverse choruses of **grasshoppers, katydids,** and **crickets** can be heard in early September in Ramsey Canyon, AZ, Laguna Atascosa and Lower Rio Grande National Wildlife Refuges, TX, Okefenokee Swamp, GA, and at the edges of hammocks (islands of tropical forest) in Everglades National Park, FL.

- **Red-necked grebe** dances are difficult to see in North America (try Quill Lakes, SK), but **western** and **Clark's grebes** are still abundant on many western lakes. To see their dances in early May, try Shuswap Lake, BC, Grassy Point, MB, Dog Lake, OR, Des Lacs National Wildlife Refuge, ND, Medicine Lake National Wildlife Refuge, MT, Clear Lake State Park, CA, or Lower Klamath Lake, OR.

- **Ptarmigan** can be seen almost anywhere in the tundra, but farther south they occur in large bogs or in the mountains above the timberline. Most good places in the lower forty-eight states are inaccessible during the mating season due to winter road closures. Try Dalton Hwy and Hatcher Pass, AK, and Dempster Hwy, YT.

- **Ruffed grouse** is a common bird in the North, but approaching it close enough to see a display is tricky. Relatively tame individuals can be found in many protected areas of Minnesota, in Riding Mountain National Park, MB, and North Cascades National Park, WA. **Spruce**, **sooty**, and **dusky grouse** are much more approachable. The former is very common, among other places, along the Trans-Labrador Hwy, NL, and many roads in northern BC and Alberta. The best place to see the latter is Black Canyon in Gunnison National Monument, CO. Displaying **sooty grouse** can often be seen in lowland portions of Olympic National Park, WA, and in Pacific Rim National Park, BC.

Lacewings produce very soft buzzing sounds, but nobody knows how they do it.

○ **Sharp-tailed grouse** leks can be seen throughout North Dakota, in the Upper Souris and Arrowwood National Wildlife Refuges and in the Wildlife Management Areas of Morton County. In Montana, visit Bowdon and Charles M. Russell National Wildlife Refuges, Blackleaf Wildlife Management Area, and Pine Butte Swamp Preserve. Namekagon Barrens Wilderness Area, WI, is also a good spot. For **greater prairie chicken** leks, try Pawnee Prairie Wildlife Management Area, NE, Tallgrass Prairie Preserve, OK, Sheyenne National Grassland, ND, Wray area, CO, or Buena Vista Grasslands Wildlife Area, WI. **Lesser prairie chicken** leks exist in Beaver River Wildlife Management Area, OK, Comanche National Grassland, CO, Cimarron National Grassland, KS, Gene Howe Wildlife Management Area, TX, and in Black Hills Lesser Prairie Chicken Area, signposted off Hwy 206 about 32 miles south of Portales, NM. The town of Woodward, OK, has a **prairie chicken** festival every April, with tours to see both species (check lektreks.org).

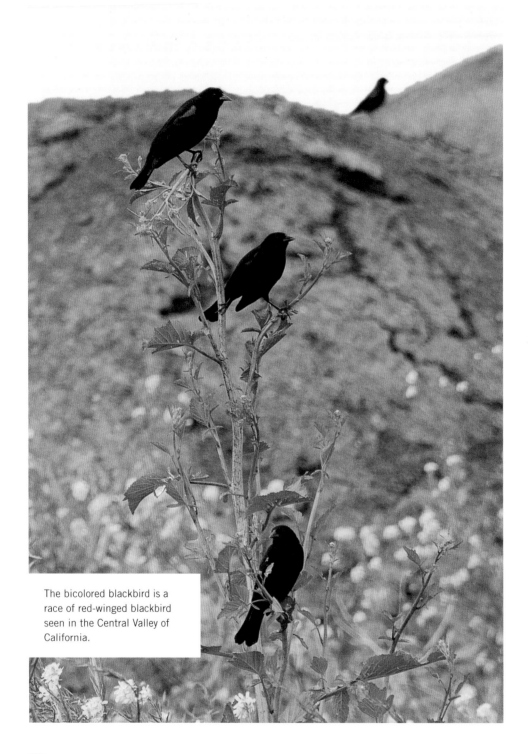

The bicolored blackbird is a race of red-winged blackbird seen in the Central Valley of California.

- The only **Gunnison sage grouse** lek open to the public (April 1 through May 15) is on County Road 887 near Doyleville, CO, 0.6 miles north of Hwy 50. **Greater sage grouse** leks are disappearing so fast that it's difficult to provide reliable information; try Sand Creek Wildlife Management Area, ID, Coalmont area, CO, Albany area, WY, or take an organized tour. Such tours are offered in early April out of Craig, CO, and on variable dates out of Dubois, ID (see grousedays.org). One of the last leks in California is at Lake Crowley (contact Eastern Sierra Audubon Society, esaudubon.org).

- **Red-winged blackbird** is one of the easiest birds to see in marshes and swamps. **Tricolored blackbird** is rapidly vanishing, but it's still possible to find it by exploring National Wildlife Refuges of the Central Valley in CA, such as Merced National Wildlife Refuge.

- **Bald eagles** are now increasingly common over much of the country, and even nest in some cities such as Anchorage, AK, and Baton Rouge, LA. The best place to see their mating flights is AK, where about a half of the global population nests. BC, Minnesota, and Florida also have large populations. Mating flights of **golden eagles** are more difficult to see, in part because pairs don't repeat them every spring. Try Altamont Pass, CA, or Snake River Canyon along the Idaho-Washington state line. Mating flights of **swallow-tailed kites** can be seen in May in Highland Hammock State Park, FL (near the campground), and occasionally in Atchafalaya National Wildlife Refuge, LA.

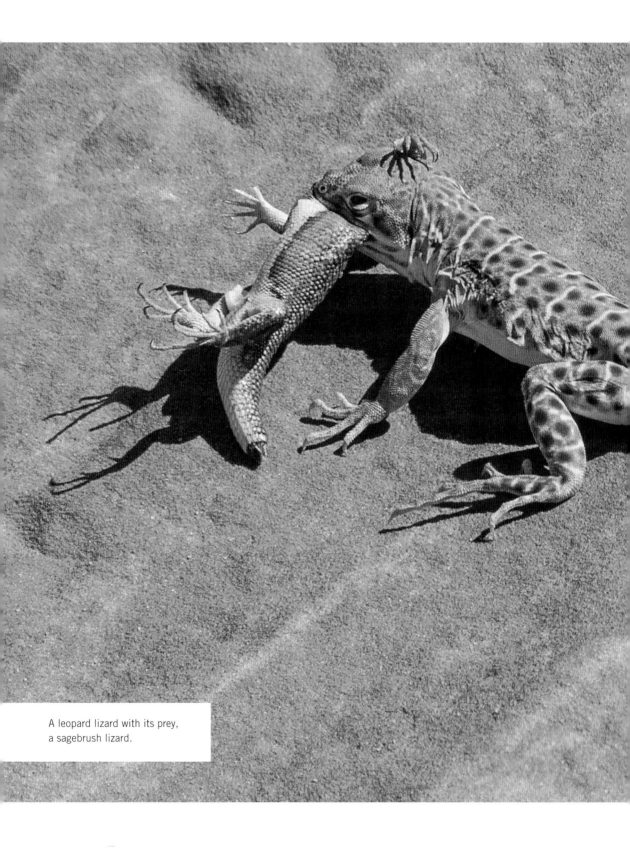

A leopard lizard with its prey,
a sagebrush lizard.

EVERYDAY SPECTACLES

Life on Earth is way too complex for any human to fully comprehend, so for thousands of years people have been trying to make sense of it by creating simplistic models. In some ancient models the ecosystems are run by spirits or deities, in others all animals have humanlike minds. Later the models became more useful in that they described at least some aspects of life accurately. The relationships between predators and prey were particularly popular among the few biologists who were also good at math, and the result is that we now know a bit more about natural selection, population dynamics, and cooperative behavior. Some extremely simplistic terms have even made it into the mainstream culture, none more so than the concept of the food chain.

Let's look at various links of that chain. But don't be surprised if the chain itself proves to have plenty of branches, loops, and knots.

CLEVER PREDATORS AND SMART PREY

Last April two climbing roses in our backyard were attacked by aphids. We don't use chemical pesticides, so I applied horticultural oil to a few buds that were most densely covered by the insects, then just waited. Within a few days the cavalry came to the rescue. First arrived ladybugs, then lacewings, and finally hoverflies. If I looked at the roses closely, I could see where they laid their eggs: ladybug eggs looked like tiny cantaloupes, hoverfly eggs like little cucumbers packed in white silk, and lacewing eggs were minuscule white ovals on long, hairlike stalks.

The aphids kept multiplying. They are good at it: females can reproduce asexually, giving birth to small copies of themselves at an impressive rate. They seemed unstoppable. Then the predators' larvae emerged from the eggs: tiny, slow-moving monsters covered in protective spikes. They were compulsive eaters. Everywhere I looked, they were plowing through the aphid ranks, leaving death and destruction in their wake. By the time the larvae grew up and began to turn into pupae, I couldn't find a single aphid anywhere. It didn't mean that every single one of them was eaten—some managed to fly away in time. But I didn't have to worry about my roses anymore.

Garden Wars

Of course, it doesn't always work so perfectly. A garden is an artificial ecosystem where species from different parts of the world are thrown together; it is not fully self-regulating and requires human attention. But you can still see a few interesting features of the so-called food chain in your garden.

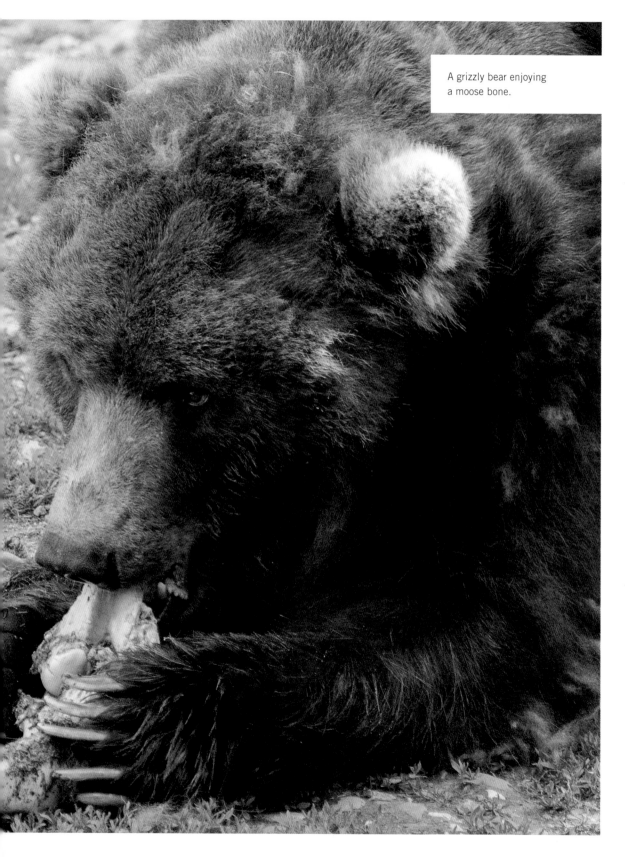

A grizzly bear enjoying a moose bone.

It may be hard to tell, but this ladybug is on a murderous rampage, consuming aphids.

One thing they didn't tell you in school is that many species can jump up and down the chain depending on the circumstances. One spring I noticed that the scrub-jays that lived in our garden began to eat other birds' eggs and chicks. I started adding eggshells to the mix in our bird feeder, and the jays returned to their normal diet of seeds, complemented with an occasional moth or snail. Apparently they used larger prey only as a source of calcium.

Such jumps happen most often when a species is introduced to a novel environment where nothing like it has been present before. Chinese mantises were accidentally introduced to North America from Asia, where they fed only on insects. But here they found a new prey: hummingbirds. Every fall I have to watch my

Chinese mantises can kill and eat hummingbirds, and will lie in wait on the bottom of hummingbird feeders.

hummingbird feeders to make sure there are no mantises hanging head-down under the bottom. They can sit there for days or even weeks waiting for their chance; if you shake them off, they climb the tree and somehow find their way back to the feeder. Sooner or later they score, catching a hummingbird, killing it by piercing its chest with the long spikes on their front legs, and eating it. These mantises are females (males are smaller), and they need good protein meals to produce their egg sacks. The sacks are made of foam that hardens when exposed to the air; the foam protects the eggs so well that they survive the winter. There are lots of interesting questions here. How did the mantises learn to hunt hummingbirds? How do they know to wait at the feeders? How do they find their way back to the feeder from the ground through the maze of tree branches? I don't know the answers to any of these mysteries; if you have a lot of free time, you can try to come up with some experiments to figure them out.

In addition to jumping up and down the food chain, many animals don't mind hunting those that are supposed to be on the same level. Many years ago I participated in a study of lynx and wolverine biology in the taiga forests near the Arctic Circle. It was before radio

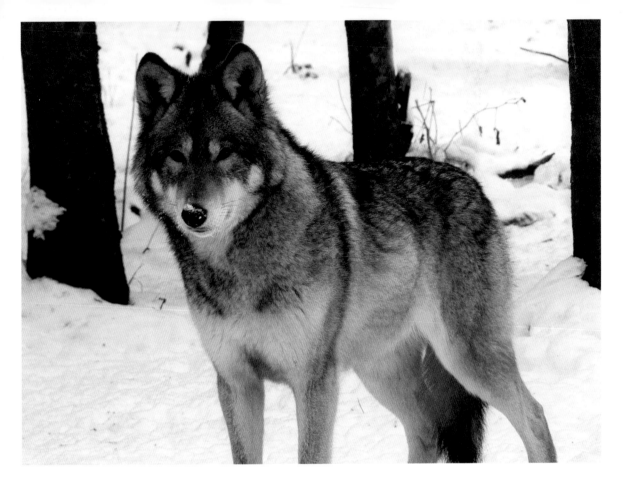

collars and GPS data loggers became widely available, so our main method of study was snow tracking. Wolverines routinely walk more than forty miles per day, so we had to ski for sixteen hours a day and sleep on the snow (a tent would have been too heavy to carry). It was fascinating, because we could see the entire daily life of the animal written out on the snow. But imagine our disappointment and sadness when the lynx we had been following for a week suddenly ran into a pack of wolves in a frozen, treeless bog, with no place to hide. The unfortunate lynx was torn to pieces.

Another interesting feature of the food chain is that every species has an effect on those above and below it, and this effect spreads up and down in alternate ways, resulting in what is referred to as trophic cascades. The best-known example is the extermination of wolves in the United States. One effect was a population

The gray wolf plays one of the most important roles in the complex machinery of North American ecology.

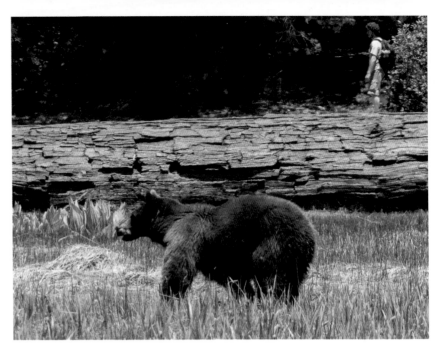

When grizzly bears were exterminated in California, black bears moved in. They are now extremely abundant in much of the state, and exist in surprising proximity to human populations.

explosion of deer and later elk (as well as introduced feral pigs). Those increased populations resulted in the local extinction of some forest plants and ground-nesting birds, not to mention rising car insurance premiums (another mystery is why they are called premiums—but I digress). Another effect of the wolves' disappearance was the proliferation of coyotes, which became extremely abundant in the West and colonized the entire East. Coyotes made life difficult for marmots and prairie dogs, but particularly for smaller predators such as bobcats and foxes, and that lead to population explosions among mice, voles, and rats. Mice are now destroying not just crops, but also lots of bumblebee nests, so farmers have to call in trucks loaded with beehives to have their crops pollinated. Next time you pay some ridiculous price for a bag of almonds in a supermarket, blame the war on wolves that was waged all over the country by the federal government and private cattle owners for more than a century.

You can easily see a trophic cascade in your garden if you don't keep your cat indoors: it will effectively kill off small birds, and without birds, insects will proliferate. You might not like the effects of that spectacle on your roses.

Snowshoe hares look very different in various parts of their range. This is an unusual brown form, from the drier parts of the Olympic Peninsula in Washington State.

Right now, humans are causing what is probably the greatest trophic cascade (a better description is trophic avalanche) since the extinction of dinosaurs—by removing all large and medium-sized fish from the ocean. As fish stocks collapse one by one, the marine ecosystems spectacularly unravel, resulting in dead coral reefs, jellyfish "plagues," and toxic algal blooms. A few centuries ago the water in Chesapeake Bay was so clear that people could see shipwrecks lying at a depth of a hundred feet—now you can barely see your toes if you wade knee deep.

A real-life food chain usually looks like a tangled net, with each species being a predator of numerous others, and a prey for many other predators and parasites. But some animals feed on just one kind of prey or host plant, and a few are so well protected that almost nothing can feed on them. In such cases the chain becomes more linear and prone to wild swings; this happens most often in relatively simple ecosystems of salt lakes, extreme deserts, or the Far North.

The textbook example is the Canadian lynx. Unlike its more versatile relatives the Eurasian lynx and the bobcat, the Canadian lynx feeds almost entirely on one species, the snowshoe hare. The hare numbers fluctuate widely, with peaks observed every ten years in boreal forests covering about half of the continent, from Alaska to Labrador (there are, however, a few large areas that are one to two years ahead of the general pattern or behind it). The lynx numbers follow, changing in the same way, but with a one- to two-year delay. The last hare year was 2009, and 2010 was a great year for lynx watching: I saw eight during a four-week trip to Alaska that summer. Now the hare numbers are rising again, so plan a trip to the northern woods in 2020 if you'd like to see a lynx.

What causes the hare numbers to fluctuate? Over the years people have come up with all kinds of explanations: maybe the hares were running out of food, or running out of just one particular kind of essential food, or their increased density was causing disease or parasite outbreaks. The theories were many. Testing these hypotheses proved difficult, as few scientists could afford to wait ten years for each experimental trial, but eventually it became clear that none of these explanations worked. The only one that did work was that the periodic declines were caused by increased predation as predators built up their numbers in response to the proliferation of

Moth caterpillars have all kinds of weird defense mechanisms. Unfortunately, many large moths are now rare because of light pollution, pesticides, and introduced parasitic wasps.

hares. But we still don't know why after each peak the hare numbers stay low for a few years before beginning to rise again, or why hare peaks often coincide with high sunspot numbers. Some evidence suggests that much more complex mechanisms are at work, including those that involve lifetime response to stress, and changes in predators' hunting success depending on snowpack thickness.

Of course, a garden is also a simplified ecosystem, so sometimes you can see such periodic phenomena there. I know that the coming winter will kill many ladybugs, lacewings, and hoverflies in my garden, so next April there will be another aphid outbreak. But as long as I don't use pesticides, my little friends should be able to deal with it. Unless, of course, the aphids hire bodyguards—and that's not a joke.

Hired Help

Aphids belong to a large group of insects that also includes cicadas, leafhoppers, shield bugs, and lots of other creatures, many of which are really weird-looking. All of them feed by sucking plant sap, so they have to remain in place for a long time and are very vulnerable to predators. They have developed many ways of protecting themselves: some, like periodical cicadas, emerge in huge swarms; others, like garden aphids, multiply at astonishing speed by essentially cloning themselves; yet others cover themselves with spitlike foam (you've probably seen those on your rosemary), or a layer of wax, or a pile of excrement. But many are provided protection by ants, and that has resulted in some of the most spectacular symbiotic relationships in nature.

The sap that these insects feed on is mostly just water with sugar. To obtain essential proteins and other nutrients from such food, they have to pump a lot of it through their systems. If you watch a feeding aphid, you'll see tiny droplets of liquid emerge from its rear end every couple minutes.

Ants love sugary water. They can eat only liquid food, so they can't eat any of the stuff they carry to their colonies, such as insects they have killed, grass seeds, or bread crumbs from your kitchen.

This worker ant tends her flock of aphids.

They have to feed these items to their larvae, and then the larvae regurgitate some of it in liquid form to feed the adults. The droplets of sugary water produced by aphids and leafhoppers are often the only thing worker ants can use as snacks away from home. Some ant species have become fully dependent on these insects: they herd them like cows, defend them from predators, and sometimes even build little barnlike structures to protect them from the elements. When a young winged female ant leaves her home to mate and become queen of a new colony, she takes a little aphid larva with her, and this larva becomes the founder of the ants' domestic herds (remember, aphids can reproduce asexually).

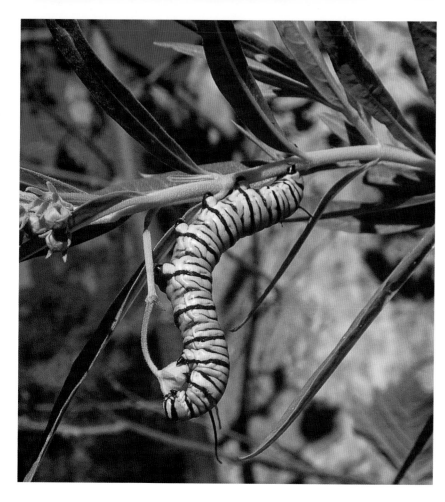

Milkweed is the favorite food of monarch caterpillars.

Aphids and grasshoppers are not the only animals to hire, borrow, or steal other species' protection. Caterpillars of little blue butterflies release mysterious chemicals that seduce ants into carrying the caterpillars into their nests and feeding them until they grow up. Hummingbirds often nest under the nests of hawks; the hawks don't care about their tiny neighbors, but provide protection from jays, squirrels, and other nest robbers. Monarch butterfly caterpillars accumulate toxins from the milkweed plants they feed on, and these toxins persist in adult butterflies, making them unpalatable for most birds.

If you are a scuba diver, you should be familiar with nudibranchs, shell-less mollusks that are often so flamboyantly bright-colored that they stand out even on coral reefs. They have pushed the toxic

defense method a bit further: many of them feed on stinging polyps and somehow manage to move stinging cells from their stomach to their skin; the cells survive the ordeal and keep working as a sort of shield for the mollusk. Other nudibranchs feed on harmless algae and either are well camouflaged or mimic the stinging ones.

Ants have essentially domesticated their former prey to guarantee themselves a steady supply of food. Many aquatic creatures use a different approach: they grow their vegetables inside themselves. Sea slugs, giant clams, and most species of reef-building corals have symbiotic single-cell algae living inside their tissues. Coral polyps still have to catch plankton sometimes to obtain building materials for their bodies, but their energy needs are taken care of by the algae. That's why almost all reef-building corals can only live at shallow depths and need a steady stream of plankton-carrying seawater. The reefs they build tend to become ring-shaped as the central part doesn't grow anymore. Such rings are called atolls; they are very common in the tropics, but the only one in North America is Marquesas Key, near Key West.

If you'd like to see an animal with symbiotic algae, there's no need to travel to the seashore. A large ciliate called a green stentor, which is common in ponds and can be easily seen with a small microscope, is full of algal symbionts. If you watch it long enough,

This little hermit crab is using the defenses of two other species: it lives in a snail's shell and has planted two stinging sea anemones on top of it.

you can see how it swallows little algae, digests some of them and lets others live and multiply.

Domesticating your prey is only one way of using other species to help you obtain food. If you live in the South, you have probably seen cattle egrets walking around grazing cows: the cows flush grasshoppers and other insects from the grass, allowing the egrets to catch them. In drier areas, cowbirds use the same method. Coyotes often hunt prairie dogs together with badgers: as the badger tries to dig up the prairie dogs' burrows, the coyote catches the rodents that try to run away. For a long time, some zoologists thought that the coyote was the only one benefiting from this partnership, but recent studies have shown that the badger's hunting success also increases if a coyote is present.

Some nudibranchs are toxic and brightly colored, while others are harmless and well camouflaged.

A cattle egret on its favorite perch.

The most spectacular example of many species feeding together is group feeding of humpback whales. They use two methods. Lunge feeding is when they simply rush into a school of fish, open their mouths and gulp as much as they can. Bubble feeding is more complex: a humpback or two make circles below a school of fish, blowing streams of bubbles. The rising streams form a wall around the fish, scaring them into forming a tight ball. Then the whales make smaller and smaller circles, until the fish ball becomes so small that a whale can suddenly rise with an open mouth and swallow all or most of it. Either way, feeding humpbacks are usually joined by hundreds of other predators: dolphins, sea lions, seagulls, shearwaters, sometimes even pelicans. Occasionally a bird gets swallowed with the fish if it isn't careful.

Some predators have become experts at robbing others of their prey. In cold seas, jaegers do it most often. They chase seagulls, gannets, and particularly terns, hitting them until they drop their hard-earned catch. In the tropics, frigatebirds play the same game; their attacks can be so persistent that some tropical seabirds have learned to bring food to their chicks only at night to avoid having it

stolen. Wolverines can follow otters or lynxes to forcibly steal their catch, while California condors will often follow turkey vultures to carrion and then take over.

A humpback whale bubble feeding in the center of the created spiral.

Talon, Tooth, and Claw

When I mentioned predators, the first thing that came to your mind probably wasn't the lacewing. Large mammals such as wolves are more iconic beasts of prey. People have always been fascinated by such imposing, powerful animals. It's probably a combination of fear, admiration, and envy—the envy that a naturally defense-less, weak, tools-dependent primate feels towards swift, powerful, well-armed creatures.

Unfortunately, most of us now live in places where large carni-vores are rare or extinct, and seeing them make a kill is extremely difficult. Even wildlife biologists who study wolves, mountain lions,

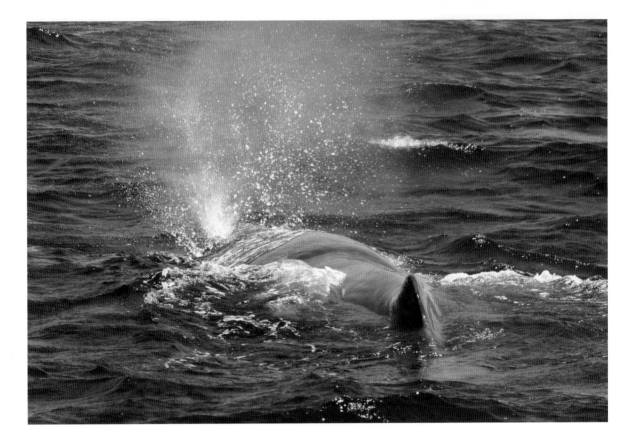

or grizzly bears often spend decades in the wilderness and never see an act of predation.

But the largest and most versatile predator of the North American continent, the American alligator, has now largely recovered from years of overhunting, and can be easily observed. The problem is, alligators seldom hunt. Being cold-blooded, they need almost ten times less food than mammals of the same size, so you have to spend a lot of time in their habitat to see them make a kill. They are also largely nocturnal, and often hunt in turbid waters. I spent many years watching them, and saw only a handful of attacks on birds or mammals, just three of them successful. Of course I saw them catch fish many times, but that usually wasn't particularly noteworthy—although sometimes it was quite spectacular.

It is now known that alligators and crocodiles use at least a dozen different methods of hunting and fishing (I pride myself on having discovered a few of these). They can slowly stalk their prey, or

A crocodile (left) and an alligator (right) in trailside ambushes.

crawl out of the water and lie in ambush near forest trails, or float on the surface with outstretched arms waiting for a fish to touch their toes. They can also fish cooperatively—forming a line across a shallow, fast-flowing channel and waiting for the current to carry fish into their open mouths, or descending by the dozens into a drying-out pond and digging all the catfish from the bottom mud. Sometimes alligators or crocodiles will divide into two groups, the larger animals forming a line and forcing fish toward the shallows, where smaller reptiles can easily catch the prey driven to them. Such cooperative fishing can last for hours, and definitely qualifies as a spectacle.

They also use tools for hunting. Ponds and lakes with lots of alligators are often chosen by egrets and other wading birds for their colonies. Alligators protect the birds from predators such as raccoons and large snakes, but this protection is expensive: any chick that falls into the water is unlikely to survive. During the nest-building season, when hundreds of egrets, herons, ibises, wood storks, spoonbills, and cormorants all look for building material, the vicinity of the colony is often swiped clean of any sticks and twigs. Desperate birds resort to stealing from neighboring pairs, and fights frequently erupt. Alligators take advantage of this shortage; they float around the colony with little sticks lying across their snouts, waiting for a hapless bird to try to pick it up.

If you live too far north to have alligators around, you can watch smaller predators: coyotes and foxes. Despite persecution, they are

now increasingly common over much of the continent, and live in many cities. In winter, when the soil is frozen and small rodents leave their summer burrows to move under the snow, foxes and coyotes spend a lot of time hunting for mice; sometimes they dig through two feet of snow to get to their prey. The mechanism of mousing is not really understood; a surprising and still controversial study a few years ago revealed that the predators orient themselves along the lines of the planetary magnetic field before pouncing at their prey, but nobody has the slightest idea why. Mousing is a rigorous activity demanding full concentration (it's really difficult to hear a mouse through two feet of soft, fluffy snow), so the hunters are often oblivious to their surroundings and can be watched for hours at a time.

Cooperative feeding by alligators. Here they are hunting for catfish.

Red foxes looking for stunned fish at the base of Niagara Falls.

Smaller carnivores often chase rodents into their burrows, and the most specialized of them have their body size perfectly adjusted to the burrow diameter of their favorite prey. Black-footed ferrets are built to chase prairie dogs; long-tailed weasels go after large voles and ground squirrels; short-tailed weasels mostly hunt voles, mice, and lemmings; the tiny least weasels kill small rodents such as bog lemmings and red-backed voles.

One predator you can observe very easily is the sea otter. They dive for their food, but bring the catch to the surface to dismantle and consume. Sea otters live all around the North Pacific, from the Kuril Islands off Japan to California, but only the Californian otters are known to use tools: they often bring stones from the bottom to hammer at various clams, crabs, and sea urchins.

Egrets and herons might sometimes fall for alligator trickery, but they are cunning hunters themselves. Each of the twelve North American species has its own preferred tactics. It's a bit difficult to

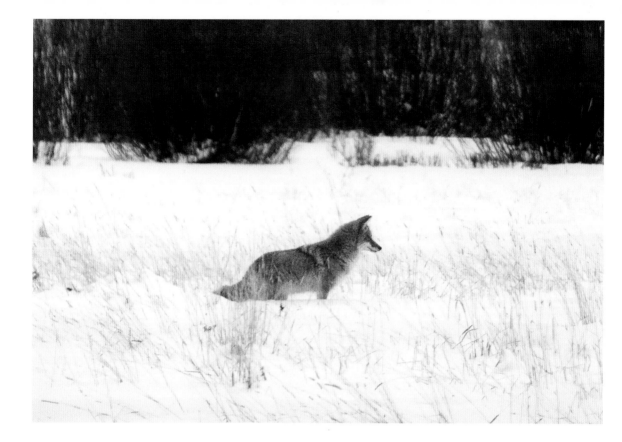

A mousing coyote. Note the ears turned downward.

see bitterns or night-herons hunt, but others can be easy to observe. Great white egrets and great blue herons are ambush hunters: they can stay still for hours, waiting for a fish, frog, or baby alligator to move within their strike radius. For some reason, you often see a great white egret hunting in the company of a great blue heron, but I've never heard any explanation of it. Snowy egrets have bright yellow toes and use them as fish bait: they walk into the shallows and move their toes to make them look like wiggling worms. They also follow feeding ibises and even manatees, catching small animals that try to escape from their paths. Reddish egrets run along the shore, trying to flush fish from their hiding places. Sometimes the birds' leaps and spurts look almost like dancing. Tricolored egrets and little blue herons are more moderate in their tactics: they walk slower, with frequent stops. Little blue herons will open their wings to create a shady area; on hot days it attracts fish seeking a cool shelter. Cattle egrets follow cows and other large herbivores. And green

A black-footed ferret, carrying her cub to a new den.

A sea otter will often find a nice pebble and use it for hours, breaking mussel shells and holding the stone under an armpit during dives.

herons have a baiting trick of their own: they sometimes throw little pieces of soil or vegetation in the water to attract fish.

Raptors can be even easier to observe than egrets and herons, as most North American species prefer to hunt in the open. Only a few, like northern goshawks and Cooper's and sharp-shinned hawks, are forest dwellers with broad wings and tails adapted for unbelievably maneuverable flight through the trees. They hunt

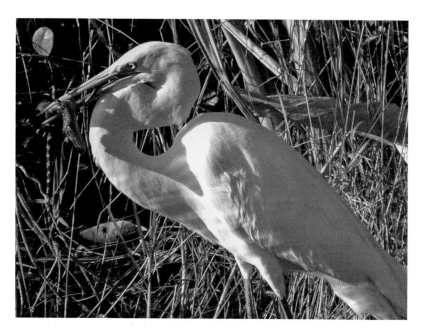

Baby alligators are a favorite prey of great white egrets.

birds and sometimes small mammals from an ambush. Many species, like red-tailed hawks and golden eagles, are generalists, hunting pretty much everything that moves. But some are very specialized: Mississippi kites feed mostly on cicadas; Swainson's hawks and white-tailed kites on mice and voles; swallow-tailed kites on anole lizards and paper wasps; ferruginous hawks on hares, rabbits, and ground squirrels; and snail kites on apple snails. Our only raptor completely specialized to hunt fish is the osprey. In addition to talons, ospreys have little spikelike structures on their toes to aid in catching fish.

Bald eagles are generalists, but they prefer fish and other prey they can catch in or near water. The population that lived on Channel Islands off California became extinct in the 1940s because of DDT poisoning (many large birds were dying out at that time, as DDT accumulated in their bodies and caused them to lay eggs with abnormally thin shells). The islands were then colonized by golden eagles. That created a serious problem. The islands are inhabited by North America's smallest and cutest wild canine, the endemic island fox—each of the larger islands has its own subspecies. Golden eagles began hunting the foxes, and soon some of

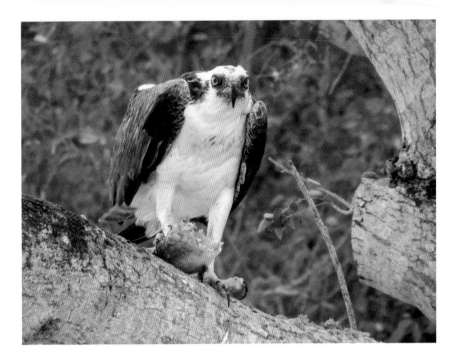

An osprey with its catch.

the fox subspecies were so diminished that they existed only in captivity. San Miguel Island lost all its wild foxes except for one particularly cunning female. The National Park Service couldn't kill the golden eagles, because they were also a threatened species at the time; catching them proved extremely difficult. The situation looked hopeless, but then a few bald eagles were reintroduced to the islands. What happened next was totally unexpected. The bald eagles tirelessly and methodically searched the islands on which they were released, chasing and killing every single golden eagle. Fox populations are now recovering. They are very tame and have become the main attraction of island campgrounds.

Each raptor has its own arsenal of hunting methods. Harriers fly low and fast, holding their wings in a V-shape. This gives them extra stability in the turbulent air near the ground: if the bird lists to one side, the wing on that side becomes more horizontal and provides more lift, automatically correcting the roll (small training planes have similarly raised wings for the same reason). American kestrels hover in one place, looking for dragonflies and grasshoppers. The most spectacular method is used by the peregrine falcon: it dives at its prey at great speed, sometimes exceeding two hundred miles

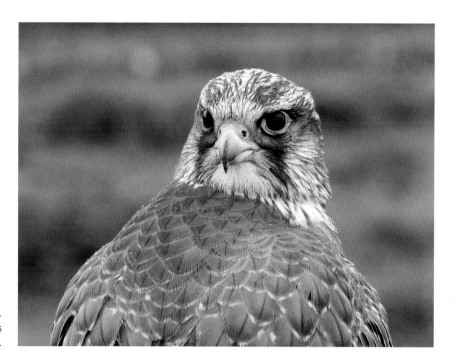

A female adult gyrfalcon. Some raptors' eyesight is ten times better than ours.

per hour, hitting it in midair with a clenched foot. The force of the impact is so great that it allows peregrines to kill much larger birds; they will hunt geese and cranes, and have been known to kill golden and bald eagles while defending their nests. Nowadays many peregrines nest on tall buildings in big cities, where you can watch them hunt pigeons.

Owls hunt mostly at night (although a few species also regularly hunt in daylight). They have rows of tiny dents on the leading edges of their flight feathers, and that gives them the ability to fly without making any audible sound. A great horned owl could fly right behind your head and you wouldn't hear a thing.

Moths use a similar method to avoid detection by small owls and bats. They also jam bat sonars, both actively (some male moths can make a noise with their genitalia that is on the same frequency) and passively (by emitting tiny clouds of ultrasound-absorbing hairs when hit by a bat's sonar beam). To witness these acoustic duels you need special ultrasound-converting equipment (at the minimum, a bat detector), but one simple evasive maneuver used by some moths is much easier to observe by watching bats that chase moths around street lights. Upon hearing the bat's ultrasound pulse, the moth will

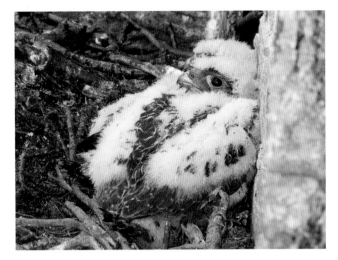

Two fluffy gyrfalcon chicks.

The Florida Everglades is a favorite place for barred owls to hunt small snakes.

simply close its wings and drop to the ground. A few moths, such as the beautiful luna moth, have long streamers on their hind wings. In flight, these streamers produce a sound that makes them irresistible to bats, but if a bat seizes a streamer, it breaks off. Moths are so good at avoiding bats that most North American bat species prefer to hunt smaller insects such as gnats and mosquitoes, and form huge swarms to feed on these insects during mass emergences.

Hunting a flying prey in midair is a difficult skill that requires the ability to process a lot of information very quickly. Many small birds and almost all bats have mastered it, but, although insects have been flying for much longer, few of them can hunt on the wing. The only ones in North America are robber flies, damselflies, and dragonflies. Dragonflies are particularly interesting because they defy the laws of technological evolution.

Just like human-built airplanes, insects have evolved from biplanes into monoplanes. Primitive, poor-flying insects such as mayflies have two pairs of wings working independently. All insects that fly well, such as butterflies, moths, wasps, bees, and flies, either have one pair of wings or their front and rear wings lock together in flight to work as one. Dragonflies are an exception: they use their front and rear wings independently, but are still so agile that hardly

Male luna moths can be identified by their feathery antennae, which are sufficiently sensitive to smell a newly hatched female from up to twenty miles away.

any flying insect can escape them. Watch them hunt when you have a chance—they are really good at it.

Dangerous Waters

To see one of North America's smartest predators, you have to be able to scuba dive. Octopuses use an amazing variety of hunting tricks. When I was a kid, I volunteered at a local zoo. The zoo had only one little octopus, but it was more interesting to watch than most other animals. One evening we forgot to put a brick on the glass cover of its tank. That night the octopus lifted the cover, got

out of the tank and down on the floor, crossed the room, climbed into a different tank, and killed all six huge king crabs living there.

Octopuses are nocturnal hunters and are generally shy, so even if you know where one lives, it might take many hours of diving to see it hunt. But it's worth the effort. A small octopus will sometimes fearlessly leap on the back of a large crab and ride it for a few minutes before wrapping its arms around the crabs's legs to immobilize it, then killing the prey with a well-placed bite of the octopus's venomous beak.

Of course, octopuses are not the only reason to learn scuba diving. You see all kinds of fascinating interactions underwater: flying fish and squid escaping predators by taking to the air, pistol shrimp killing their prey with an unbelievably powerful pressure wave created by clicking their claw, mantis shrimp breaking clam shells with a blow of their knucklelike front foot (the fastest movement by any known animal), remoras riding sharks and feeding on their leftovers, and anglerfishes using a fishing rod–like structure

A giant Pacific octopus hiding under a sunken ship.

Small remoras like this one can often be found attached to nurse sharks.

on their foreheads to lure in smaller fish. But the most amazing of all are the cleaners.

There are two kinds of cleaners: cleaner fish and cleaner shrimp. They have similar coloration, with bright stripes indicating their status. They set up so-called cleaning stations in particular places, usually at sticking-out parts of the reef. Larger fishes, from the harmless butterflyfish to huge sharks and manta rays, visit these stations to let the cleaners remove parasites and flakes of dead skin. They usually behave very well and queue patiently. You can actually join the line and have your teeth cleaned if you open your mouth. The problem is, there are other small fishes, called false cleaners, which mimic the real ones. Instead of providing a useful public service, they approach the trusting customers and suddenly bite them, getting away with a mouthful of flesh. They are generally rare, and can only strike occasionally; otherwise the clientele would leave that part of the reef to look for cleaners elsewhere.

Fighting Back

I could fill another entire book with descriptions of various methods used by prey species to escape their predators—from huge bubbles inside the skulls of kangaroo rats that enable them to hear

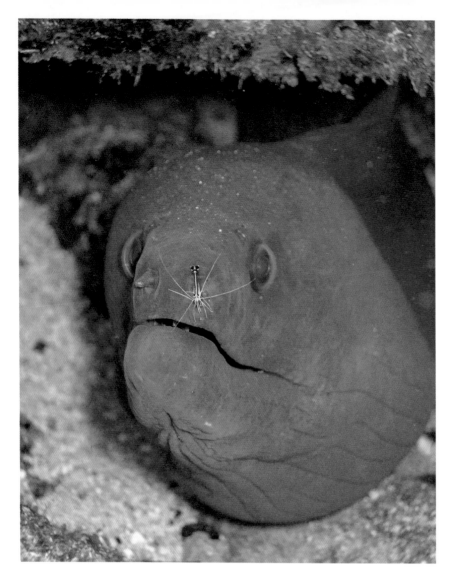

A cleaner shrimp and its "client"—a moray eel.

infrasound produced by owl wings, to the complex code that prairie dogs use to give a description of an approaching predator in their alarm calls. But you can easily see many such tricks yourself. If you spend an hour in the summer exploring your backyard (or any small garden or overgrown vacant lot), you will see at least a few insects using camouflage; a few sporting bright colors to tell the world they are bad-tasting, poisonous, or can sting; and yet others that are harmless but mimic the dangerous ones. Wasps are mimicked particularly often; you can see flies, beetles, and even moths

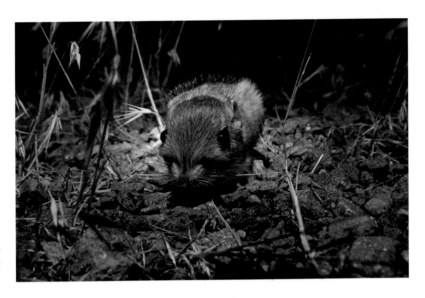

Even baby kangaroo rats are experts at listening for predators.

mimicking them. If you get really good at spotting and observing insects, you'll also see predators using similar tricks, like jumping spiders that mimic ants to get closer to them.

My favorite example of aposematic coloration (bright colors serving as a warning to predators) is the eft. It is a stage in the life of some species of newts (for some reason, only the ones living in the eastern states), between the aquatic larva and the camouflaged adult. Efts are ridiculously bright and highly toxic. My wife is so allergic to their toxin that her nose begins to run every time we pass within twenty feet of an eft while walking in the forest; we sometimes use her unique ability to find efts for photography. She doesn't have such a reaction to adult newts or to any other salamanders (I am really fond of salamanders, so she has seen dozens of species up close).

The species of newts that live on the West Coast don't go through the eft stage in their development, but as adults they are even more toxic than East Coast efts. However, for some reason they are brownish above, and have aposematic coloration only on the underside— so if they are attacked by a predator, they have to bend backward to make their orange belly visible. One theory suggests that some populations of garter snakes feed on these newts and become toxic themselves; that might explain why garter snakes have cryptic

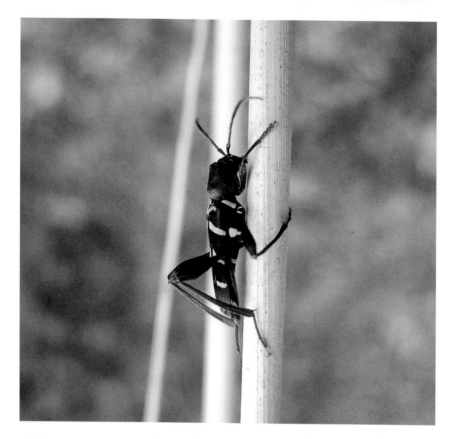

A longhorn beetle hoping
to be mistaken for a wasp.

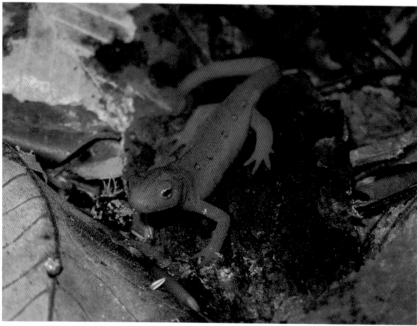

The red eft can be found
in Appalachian forests.

A rough-skinned newt in Oregon.

coloration in some places and bright in others (the brightest one is the particularly colorful subspecies inhabiting the San Francisco International Airport grounds and a few nearby wetlands).

One common defense method among animals is flashing colors; it is used by many moths and grasshoppers. They have well-camouflaged front wings and bright-colored rear wings which are normally hidden under the front ones. If the insect is disturbed, it takes off and in flight becomes very colorful. But if you try to follow that sparkle of color, you'll lose it the moment the insect lands. Even some birds use this defense: willow and rock ptarmigans turn completely white in winter to match their snow-covered habitat, but when they fly, two black spots on their tail become visible.

There are lots of unanswered questions about all these tricks. How can harmless snakes that mimic deadly coral snakes expect predators to understand the consequences of attacking a coral snake, if those that have actually attacked a coral snake usually die without warning others? How do moths manage to land on matching backgrounds if they can't see their own wings and have no way of knowing what they look like? How do octopuses, which are color-blind, change their hue to match the background? Nowadays

The eastern United States has more species of salamanders than the rest of the world combined. They usually don't do much, but their amazing diversity is a spectacle in itself.

scientists usually attack these questions with sophisticated computer modeling, trying to recreate the evolutionary processes at work, but some of them might still be answered by simple experiments that nobody has thought of—yet.

One interesting scientific problem is the mystery of alarm calls. It is fairly clear why group-living animals like prairie dogs have alarm calls: they warn others of a nearby predator. But many solitary animals, such as tree squirrels, also have loud alarm calls that they can repeat for a ridiculously long time. Some species also have visual versions, like the white underside of the tail of a white-tailed deer that flashes when the deer is running.

The current theory is that these calls and flashings are addressed not to other squirrels or deer, but to predators. They tell the predator that it has been spotted, that the potential prey is alert and ready to run, and that it's likely better for both to avoid a tiring and

The io moth usually hides its rear wings under drab front ones, but flashes them if disturbed. Studies have shown that small birds are afraid of owlish "eyes."

A scarlet snake, doing its imitation of a deadly coral snake.

pointless chase. Is this theory correct? There is some supporting evidence, but many researchers remain skeptical.

I'll end this chapter with some amazing little spectacles that even most zoologists have never heard of—brought to us by the fresh-water mussel.

Flounders are camouflage masters extraordinaire. Can you spot this flounder's eyes, both on one side?

This freshwater mussel has mantle edges that look like a small fish. These edges are used to attract larger fish, potential hosts for the mussel's parasitic larvae.

The rivers of southeastern North America have an unusually high diversity of freshwater mussels; many of them have tiny ranges and are critically endangered. These mussels reproduce by ejecting tiny larvae that need to attach themselves to the gills or the skin of a certain species of fish to survive. The larvae are temporary parasites; they grow on the fish for a while, then detach themselves and sink into the bottom mud, sand, or gravel.

Most mussels simply let the larvae take care of themselves, but a few have developed unusual ways of making it easier for the larvae to find a fish. The outer edges of their mantle (the soft folds that line the shell on the inside) look and move like a tiny fish with fins and eyes. In one species, the fat pocketbook mussel, the folds make an amazingly accurate image of a small fish called a darter that lives in the same habitat. If a real fish approaches the lure, the mussel releases a small cloud of larvae, hoping that a few of them will manage to find their way into the fish's gills. Another species called the rainbow mussel has mantle edges that look like crayfish, the favorite prey of its larvae's host, the smallmouth bass. The

This freshwater mussel's iridescent mantle lures fish at dusk.

kidneyshell mussel releases its larvae in tiny packages that look like aquatic insects; if a darter grabs the package, the parcel bursts, filling the fish's mouth with larvae. The fanshell mussel has a wriggling, worm-like structure on its mantle. The snuffbox mussel traps a fish with the halves of its shell, douses it with larvae, and releases it. But the most highly evolved lure is possessed by the orange-nacre mucket mussel. It is a transparent rod of hardened mucus up to

three feet long, ending with a structure that looks like a small fish swimming against the current. If a predator fish bites the lure, it gets a bunch of larvae.

One species called scaleshell mussel turns itself into a lure. When the time comes to release the larvae, it crawls out of the bottom sediment and lies exposed, waiting for a passing fish to consume it and get a mouthful of larvae together with the meal. But this ultimate sacrifice is often in vain. Larvae of scaleshell mussels can develop in the gills of just one fish species, the freshwater drum. So all mussels that get eaten by other kinds of fish die for nothing.

A crayfish trying to scare off a predator.

VIEWING TIPS

- The best places to see **black bears** are in the meadows around the Giant Forest in Sequoia National Park, CA, where you can spot up to thirty per day in late May and early June. **Canadian lynx** and **snowshoe hares** are most easily viewed in the summer near the Arctic Circle, where the lack of darkness forces them to be active in daylight; my favorite place to see them is the Chic-Choc Mountains, QC.

- Colorful **nudibranchs** can be found at numerous dive sites of the Pacific coast, from Kenai Fjords National Park, AK, to Channel Islands National Park, CA. They are also common along the coast of eastern Canada. You can sometimes find them in tide pools—for example, in Salt Point State Park, CA.

The bright colors of this nudibranch warn potential predators that it is covered with stinging cells from its prey, soft coral polyps.

Badgers living in Yellowstone National Park have to "swim" through deep snow to hunt rodents in winter.

- Seeing **coyotes** teaming up with **badgers** to hunt prairie dogs requires a lot of luck. Try Thunder Basin National Grassland, WY, or Aubrey Valley, AZ. The latter is also the best place to look for the rare **black-footed ferret**.

- Viewing bubble-feeding **humpbacks** requires an expensive expedition to the fjords of the Alaska Panhandle, but lunge-feeding is increasingly seen during whale-watching tours in Monterey Bay, CA, particularly in summer and early fall. In winter you can often see **jaegers** chasing other seabirds there. **Frigatebirds** often do the same in Dry Tortugas National Park, FL.

- Walking or bicycling Shark Valley Loop Trail in Everglades National Park, FL, on a summer night is the best way to see **alligators** in trailside ambushes. Cooperative fishing is rare and unpredictable, but you can try Paynes Prairie State Park, FL, in April or May. Alligators hunting with sticks can be seen most easily in Saint Augustine Alligator Farm Zoological Park, FL, and sometimes in Lake Martin, LA.

Alaskan sea otters enjoying a rare sunny day.

○ Mousing **coyotes** and **foxes** can be observed during winter in places with lots of snow and small rodents, such as Lamar Valley in Yellowstone National Park, WY, or almost any large wetland in Canada. **Sea otters** using stones as tools can sometimes be seen up close in Moss Landing, CA, and at Point Lobos State Park, CA. There are many places along the Atlantic and Gulf Coasts where you can see different species of **egrets** and **herons** using various hunting techniques; the best locations are the coastal wildlife refuges of southern Florida.

○ Raptors of some kind can be observed almost everywhere, but many species can be difficult to see up close. Try the campground in Highlands Hammock State Park, FL, for **swallow-tailed kites** and Brazeau Reservoir, AB, Horseneck Beach, MA, and Flamingo,

FL, for **osprey** colonies. Mount Horrid and Mount Pisgah, VT, are recommended for nesting **peregrine falcons**. Peregrines also nest in downtown New York City and Salt Lake City. The largest concentration of nesting raptors in North America is in the Snake River Birds of Prey National Conservation Area, ID.

○ The best place to look for **island foxes** is the campground at Santa Cruz Island in Channel Islands National Park, CA. The largest swarms of feeding **bats** form over the Mississippi River between Natchez, MS, and Baton Rouge, LA, as well as at Wolfe Ranch in Arches National Park, UT.

○ Small octopuses can occasionally be found while diving or checking tide pools along both coasts, but to see a **Pacific giant octopus**, try diving around Vancouver Island, BC. The best dive site is called Wolffish Alley, but the most accessible one is Singing Sands in Comox, BC (you can get directions at local dive shops). Cleaning stations exist along the reefs of the Florida Keys, but they change locations sometimes; local dive shops should be able to give you up-to-date information.

○ **Efts** are common in late spring in woods of the East, particularly after rains; one of the best places to see them is Frozen Head State Park, TN. Western species of **newts** are common in moist coastal forests—for example, in Redwood National Park, CA. The strikingly beautiful **San Francisco garter snake** can be seen with some luck around Crystal Springs Reservoir, at Mori Point in Pacifica, and in the Pescadero Marsh Natural Preserve—all in California. It is an endangered subspecies, so please watch from afar and don't disturb. The best place to see many **salamander** species is Great Smoky Mountains National Park, NC and TN, particularly in May after rains. Fish-luring **freshwater mussels** are becoming increasingly difficult to find, and seeing them in action requires a lot of effort. If you are seriously interested, contact the Freshwater Mollusk Conservation Society, http://molluskconservation.org/.

In winter, map turtles rest deep on the bottoms of rivers and lakes.

LABORERS AND LOAFERS

One oversimplified claim you often hear in nature documentaries and park ranger talks is that wild animals are always trying to conserve energy. That's far from true. If there are no extreme weather events and humans are not putting extra pressure on animals in some way, their life can be relatively easy and relaxed. They can spend plenty of time resting or playing.

How good is their life? There is no simple answer. Diseases, predators, and particularly parasites often make it totally miserable: out of every ten caterpillars hatching from eggs, six or seven will be slowly eaten alive from the inside by wasp or fly larvae, a couple more will be eaten by predators, and only one or two will eventually become a butterfly or a moth—and probably end up getting burned by a street light or poisoned by some pesticide. The amount of innocent suffering in nature is impossible to fathom. But the life of a wild animal has its perks. We can't imagine the myriad ways in which a dolphin can enjoy the ocean, a falcon can enjoy the sky, a soil-living mite can enjoy a nice clump of moldy compost.

Rest and Recreation

Some animals are apparently better at having fun than others, and watching them can be pure joy. Every fall, hundreds of tourists flock to the small town of Churchill, Manitoba, on the western coast of Hudson Bay to watch polar bears. The bay holds the southernmost polar bear population, and these animals have a really tough life: from May until November the bay is ice-free, so the bears can't hunt seals and have to wander the coastal tundra, hungry and bored. In the fall they gather on the shoreline waiting for the sea to freeze, and kill time playing and frolicking in the fresh snow. This is one wildlife spectacle you shouldn't delay seeing: global warming is

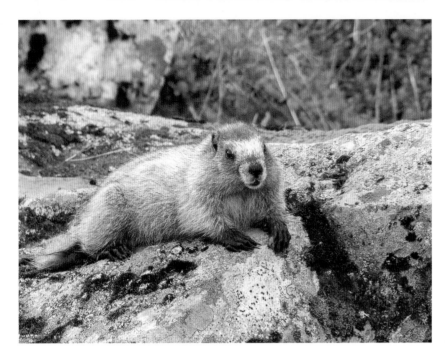

A hoary marmot at rest.

hitting this population particularly hard, and it is expected to go extinct in the near future.

Every summer, juvenile elephant seals come to California beaches to molt. Females just cover themselves with sand and relax, but subadult males spend hours upon hours play-fighting in the surf, getting ready for future battles over harem owner-ship. It is a rare experience to see such huge animals wrestle, and a family-friendly spectacle as well: unlike adult males, subadults never spill blood during fights.

Until recently it was thought that only mammals and birds were smart enough to play, but in recent years play has been observed in crocodiles, turtles, fishes, octopuses, and even insects. It does seem to correlate with intelligence, or, to be more precise, with complex and flexible behavior. (The word intelligence is poorly defined, and in practice usually means the ability to think in the same way as the person measuring it.) In mammals, young animals tend to be the most playful—every summer you can spend hours at prairie dog or marmot colonies watching plump, plush toy-like babies play with each other and their parents. If you are lucky to find a fox, coyote, or wolf den, you can watch the playful cubs. Their parents

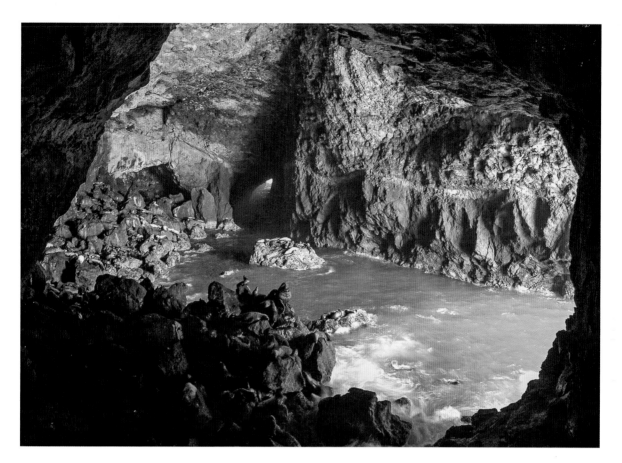

Steller's sea lions find
shelter in Sea Lion Caves,
Oregon, during storms.

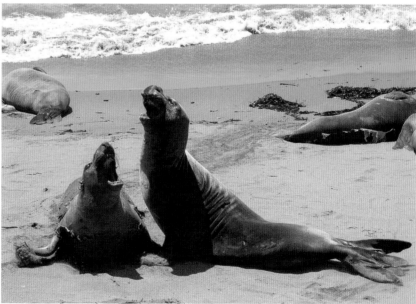

Elephant seals hanging
out on the beach.

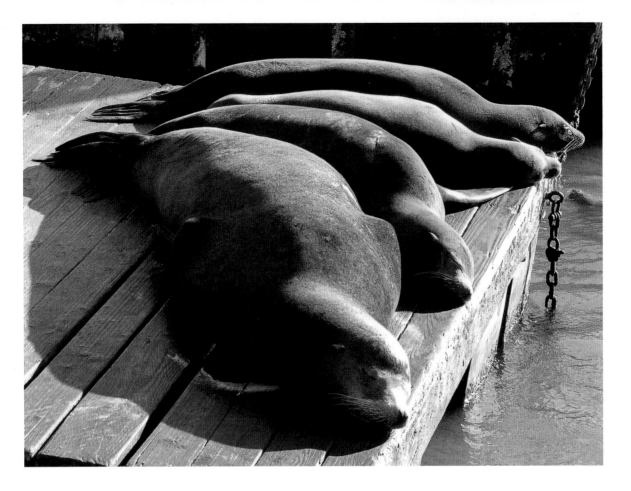

apparently understand that play is important for the cubs' development—wolves in Yellowstone often bring their cubs large tree branches to play with, sometimes carrying them for over a mile and across a busy road. As the cubs grow, the parents begin to bring them live prey animals, so the offspring can learn to catch and kill.

Occasionally you see animals of different species playing together. Many years ago I witnessed fox cubs playing with domestic kittens late at night near a roadside cabin in Colorado. I still smile when I remember them. In many years of studying alligators and crocodiles, I saw them play just a few times, but once it was an alligator playing with a river otter. Of course, it was the otter that initiated play—otters and other members of the weasel family, from tiny least weasels to wolverines, are among the most playful animals known. River otters particularly enjoy slides; if you paddle

California sea lions napping on a San Francisco pier.

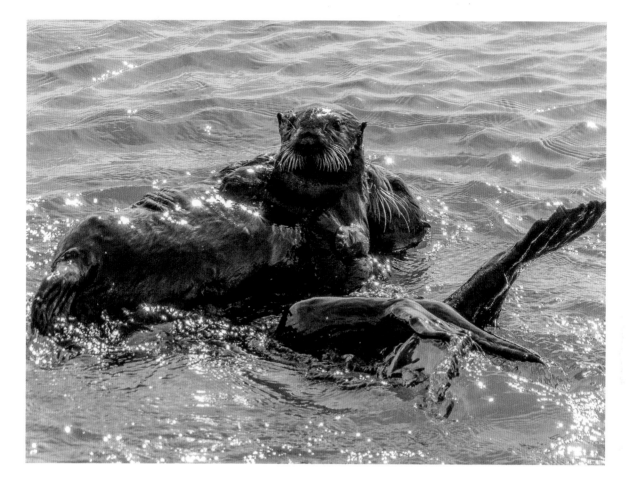

Playing sea otters.

down a quiet river inhabited by otters, you will sometimes see their slides on the banks. Sea otters occasionally approach people to play with them.

Birds and reptiles play more often when they are adults. Crows and ravens are uncommonly playful; there are videos of crows using pieces of cardboard to slide down snow-covered building roofs. They enjoy aerobatics, and will practice for hours around communication towers or tall buildings when the wind is particularly strong.

Many animals prefer to spend their free time sleeping. You would think watching them sleep would be the most boring thing a naturalist could do, and generally you'd be right. A sleeping whale looks like nothing more than a half-sunken log bobbing up and down in the waves. But there are exceptions.

Alligators are often raised by multiple females in communal crèches where juveniles of different sizes can play together. Here, a hatchling enjoys a ride on the back of an older playmate.

Sea otters wrap themselves in kelp before going to sleep to avoid being carried away by the current; they look so snuggly that seeing them is worth a special effort. Anole lizards sleep in trees, shrubs, and tall grass, and can often be found at night with a flashlight. This viewing strategy gives you a chance to see them much better than during the day when they are so agile and alert.

Some species of sharks are known to come to particular locations to sleep. Until recently it was believed that all sharks need to

A kangaroo rat sleeping in its burrow.

swim constantly to supply oxygen to their gills, but now we know that's only true for a minority of species. A few years ago a Canadian diver made a stunning discovery: a secret spot on the bottom of a beautiful small fjord where Greenland sharks come to sleep. These Arctic giants are usually found only in deep waters of the open ocean, but in this particular spot, you can see them lying still on the sandy bottom in just thirty feet of water. The visibility in the fjord isn't always great, and sometimes you literally bump into the sharks before seeing them. But of the few dozen divers who have visited the site, none have been eaten yet, and many (myself included) consider it one of their best diving experiences. The sharks either aren't in the mood for a snack, or somehow can tell the divers from seals—their favorite prey—even though many of the sharks are blind (their eyes get slowly destroyed by parasitic crustaceans). If you don't like the idea of diving in the ice-cold water of Canadian fjords, you can watch sleeping nurse sharks hidden between blocks of coral around the Florida Keys, or larger and meaner-looking sand tiger sharks that inhabit a sunken WWII German submarine off North Carolina.

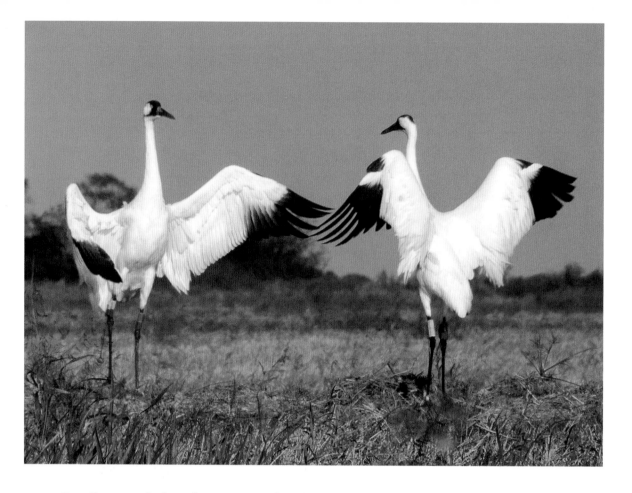

Crane dances can be a part of the courtship, but also a form of play. These whooping cranes are subadults, so dancing for them is just fun.

Reptiles spend a lot of time motionless, but that doesn't always mean they are sleeping or resting. Being cold-blooded, they use solar energy to warm up, and sometimes have to soak up rays for long periods of time. Long "chains" of turtles basking on logs are a common sight in southern swamps. On cold winter days, green sea turtles come out to sunbathe on the remotest beaches of the Florida Keys and the Dry Tortugas. For snakes, basking in the open during daylight hours is dangerous (many predators, particularly hawks, regularly hunt sun-worshipping snakes), so they often try to get warm after sunset by crawling onto sun-heated road pavement. The subsequent road-kill deaths have resulted in many populations going extinct in recent decades. But if you drive slowly on narrow backcountry roads with overgrown shoulders and no traffic during the first two hours after sunset, you can see a lot of interesting

snakes and other creatures, without harming them. Roads near the Gulf Coast and the Mexican border are particularly good for seeing reptiles (just be prepared to be pulled over by suspicious police or border patrol once in a while).

A map turtle at rest deep below the surface.

In winter, forest trees of southern Florida are covered with hibernating tree snails.

Working Hard

Some animals are like stereotypical Americans: they seemingly live to work and never take vacations. The ultimate examples are the social insects: their workers are sterile and slave for the queens. Social insects of North America mostly belong to one of two very different groups: one includes bees, paper wasps, and ants (all of them related), while the other group includes only termites (which are related to cockroaches and praying mantises). These two groups are very different biologically. Worker termites are essentially nymphs that never become adults, while worker ants, bees, and wasps are adult females and take care of maggotlike larvae. They also eat very different things. But they have independently evolved similar social structures and means of propagation. This is particularly obvious after summer rains, when both ants and termites send out the young winged adults to mate and start new colonies. The emerging swarms attract all kinds of predators, from assassin

Collared lizards enjoy the warm temperatures of the Sonoran Desert.

On spring mornings, deserts of the Southwest are full of basking lizards such as this chuckwalla.

A well-camouflaged horned lizard.

bugs to bats to birds; once I even saw a mole crawling on the surface of the ground and munching on the poor termites. An ant, wasp, or bee queen mates once and retains enough sperm for the rest of her life; termite queens keep their kings nearby and repeatedly mate with them as long as they live, so they can lay more eggs throughout their lifetime (millions of eggs in some cases).

Termites feed on plant cellulose; their bellies contain a whole zoo of tiny symbionts that help in digestion. You can easily see these single-cell creatures if you cut a termite open under a microscope. Unfortunately, mating flights of winged termites are pretty much the only part of termite biology you can observe without having a captive colony in a glass container. For millions of years, termites have been trying to evolve defenses against their nemeses, predatory ants (some of which feed almost exclusively on termites). The termites build protective covers above their trails that are similar to tunnels, and seal their nests as tight as they can. If a nest is breached, soldiers form defensive lines and try to hold off the ants for as long as they can, while workers quickly seal the breach behind them, leaving the soldiers to die in battle.

Bees and wasps feed on pollen and nectar, but wasps feed their larvae animal food. Some wasps have open nests, and their lives are easy to observe. Many zoos and nature centers now have bee or ant colonies in glass containers, so you can watch them, although it is often difficult to make sense of what you are seeing. One of the most striking things to observe in one of these glass set-ups is a honeybee dance, a complex series of movements performed by returning bees to let others know where to find good sources of food. They encode the direction relative to the sun and the distance; what is most amazing is that the audience somehow receives all this information in the darkness of a wild hive without being able to see the dancers.

Ant colonies can look particularly chaotic, but if you watch them for a long time and read a few books about their lives, you can learn a lot. One group that is relatively easy to observe is made up of slave-taking ants. These ants never work; instead, they steal pupae from the colonies of closely related wood ants. Once the wood ants hatch inside the slavers' colony, they consider it their own and start bringing food for their kidnappers (although sometimes they revolt for unknown reasons). Slave-taking ants are relatively large and reddish-brown, with jaws resembling curved karambit knives. You know you are looking at a slaver colony when many of the ants appear very different—they are wood ants with black heads and

Roadways are dangerous places for a snake.

Single-cell symbionts in a termite gut.

abdomens and jaws resembling curved shovels. If you find such a colony, watch it for awhile and you'll see a slave-taking raid: an army of slavers will march toward a nearby host colony, attack it and bring back host pupae. Workers of small host colonies usually flee when attacked, but large colonies often fight back, and can sometimes repel the invaders.

There are also ants that don't have permanent nests. They are nomadic hunters, and establish temporal nests called bivouacs.

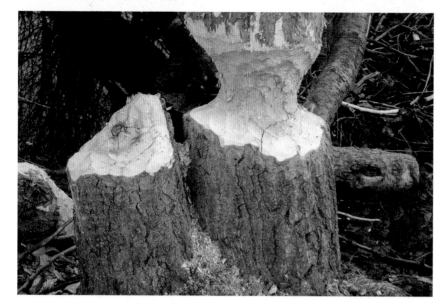

Beavers usually prefer to cut small trees, but can fell a big one if needed.

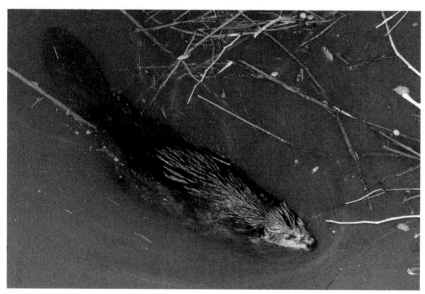

An urban beaver in Martinez, California.

These ants are much less common in North America than in the tropics, but a few nocturnal species can be found in open pine-oak woodlands of the Southwest. They mostly feed on other ants, raiding their colonies and killing every living thing there. You can recognize these ants (reddish, with orange abdomens and tiny eyes) by their habit of carrying their prey underneath their bodies. They travel in large columns, but hunt mostly underground.

If you'd rather watch something bigger than ants and wasps, there are always beavers. They also work hard for a living, particularly in places where their ponds freeze in winter and they have to store enough food underwater during the summer to survive. In Alaska, some beaver ponds stay frozen for almost six months—requiring a lot of pre-freeze work. Since beavers eat only a thin layer of living tissue on the underside of tree bark, they need a lot of trees to keep warm in ice-cold water. But even in warmer places, beavers have to build their lodges and dams, and sometimes dig canals (the canals are used to float trees back to the pond). Beaver ponds are essential for the animals' safety, because the water has to cover the entrance to the lodge. (Some beavers, however, live in rivers and don't build anything. They simply dig long burrows with underwater entrances in steep riverbanks.) Building and maintaining the dams can take a massive amount of work—the largest beaver dam ever found was more than half a mile long.

Until recently, the best way to see beavers at work was to go to the North, where they have to work in daylight in summer. You can still watch them there, but recently beavers have colonized a few cities, and can often be observed from paved streets. Urban beavers can become amazingly tame; people have complained about the buck-toothed animals coming up to them and biting off pieces of their shoes. The best time to see them is late May and early June, when baby beavers emerge from the lodges for the first time.

Other rodents don't go to the engineering extremes of beavers, but many species are skilled builders and work hard to make their living quarters comfortable. Muskrats build lodges similar to those of beavers, only smaller, and also little platforms to sit on while eating. Voles and lemmings build complex colonies with branching trail networks, multi-level systems of tunnels, and special chambers for sleeping, storing food, and disposing of waste. Pocket gophers dig even larger tunnel systems; one such underground city built by just one gopher had almost a thousand feet of tunnels and fifty chambers.

Woodrats build huge nests, often protected with cholla twigs or spiny branches of desert shrubs. Their habit of carrying all kinds

of weird stuff to the nest is of great importance to science; ancient nests preserved in desert caves provide valuable data on the plants, animals, and climate of centuries past.

This network of trails radiates from a lemming burrow.

As with beavers, observing smaller rodents at work can be difficult because they tend to be nocturnal and very shy (although there are many exceptions). But members of the squirrel family (squirrels, chipmunks, prairie dogs, and marmots) are almost all diurnal and easy to observe. Watching them can be a lot of fun, particularly in late spring when babies emerge, and in the fall when they are busy preparing for winter. The Sierra Nevada is probably the best place for observation because over a dozen species occur there. Chipmunks store food in underground chambers, while marmots simply put on a lot of weight. They get so fat by October that some have trouble moving.

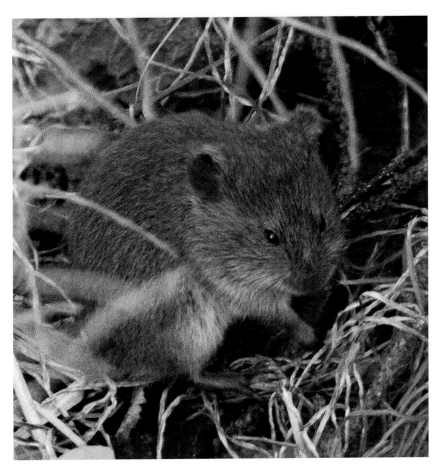

Tundra voles build particularly neat, well-maintained colonies. Their scientific species name *oeconomus* comes from an old Russian word for "manager."

Mysteries of the Night

On Chappaquiddick Island off Martha's Vineyard there is a small bridge that stretches across a lagoon. If you go there on a quiet night in early August, just around the peak of the Perseid meteor shower, you might see thousands upon thousands of luminescent comb jellies being carried by tidal currents under the bridge. Comb jellies are one of the oldest forms of multicellar life on Earth—they've been around for at least half a billion years. The first comb jellies had hard skeletons, were attached to the bottom, and fed by filtering seawater through rows of constantly moving cilia (short hairs that look like tiny eyelashes). The modern ones don't have skeletons, live a planktonic life, and use the rows of cilia (the "combs" they are named after) to swim. Many species can produce weak green-blue

Autumn is a busy time for chipmunks, as they gather winter food stores.

Unlike rodents, pikas store food above ground, making little haystacks between rocks.

Marmots prefer to store body fat rather than food.

Botta's pocket gopher at work.

This rare photograph shows
the outline of northern
right whale dolphins
swimming through sea
sparkles at night.

Scorpions emit an eerie
blue glow under ultraviolet
(UV) light. They are never
exposed to UV light in the
wild, so the purpose of this
phenomena (if there is
one) is a mystery.

light, but they become much brighter if they feed on sea sparkles, the single-cell organisms you often see as tiny flashes of light in the surf or around your arms and legs when you swim in the ocean at night. Sea sparkles flash their light when disturbed. In the shallow mangrove bays of Everglades National Park, they sometimes become so numerous that you seem to be swimming through shimmering liquid fire. Watching a whale or a pod of dolphins move through a cloud of sea sparkles is an unforgettable sight.

What's the purpose of the light? It is a very common natural spectacle, but nobody knows why sea sparkles and comb jellies produce light. Some say sea sparkles are mildly toxic and flash to

A tiny snail exploring its world.

warn off potential predators such as fish fry, while comb jellies try to attract their tiny prey. But these theories have never been tested.

The natural world around us is full of such mysteries! We've been trying to understand these enigmas for millennia but have barely scratched the surface. Every time you head outside, it's possible you could stumble upon some rare or even unknown spectacle, or witness something that will prove to be a clue to some age-old mystery. Of course, you have to be observant and know the basics, so you can realize that you are witnessing something wondrous.

But most important is to get up, get outside, and look around.

VIEWING TIPS

○ **Polar bears** can be seen in Churchill, MB, in October and November—come early in the season to avoid the crowds. Playing **prairie dogs** can be seen in many national parks and wildlife refuges from Montana to Arizona, but the tamest ones are around Boulder, CO. Tame **marmots** of various species can be seen in places like Denali National Park, AK, Mount Evans, CO, Mount Rainier National Park, WA, Olympic National Park, WA, and Yosemite National Park, CA. Playing **elephant seals** can be easily seen in summer a few miles north of San Simeon, CA, and on many beaches of Channel Islands National Park, CA. **Sea otters** are particularly easy to see up close in Moss Landing, CA.

○ Sleeping **humpback whales** are sometimes seen in summer during boat tours of Glacier Bay National Park, AK, and Misty Fjords National Monument, AK. The fjord with sleeping **Greenland sharks** is near Baie-Comeau, QC (ask for Sylvain Sirois once you get there). **Nurse sharks** can be seen sleeping under the wreck of the Sea Emperor near Boca Raton, FL. **Sand tiger sharks** are easy to spot at various wrecks off Cape Hatteras and Moorhead City, NC, especially in late spring and early summer.

○ **Beavers** can now be seen in many places around North America. Try Horseshoe Lake Trail in Denali National Park, AK, Great Dismal Swamp National Wildlife Refuge, NC, Esther Currier Wildlife Management Area, NH, or under the footbridge across the parking lot from the Amtrak station in downtown Martinez, CA. The best place to see many species of **chipmunks** is Yosemite National Park, CA. **Voles** are often active during the day along the boardwalk at North Tufa Towers County Park in Mono Lake, CA, but there are

Before going into hibernation, this wood-chuck (a species of marmot) plays in a pile of leaves.

many other places where you can see voles if you are patient and learn to move quietly. **Woodrats** can be very tame in some places; try abandoned homesteads in the prairies of Colorado and New Mexico, small caves in Capitol Reef National Park, UT, or the summit of Cone Peak, CA. Even more patience is needed to see **pocket gophers**; check out the slope below Lake Yellowstone Hotel in Yellowstone National Park, WY, in September and October, or Point Arena, CA in April and May. **Pikas** can be easily seen on the talus slopes at Hatcher Pass, AK, Mount Evans, CO, Great Basin National Park, NV, Wheeler Peak, NM, Craters of the Moon National Monument, ID, and in the Sierra Nevada above the tree line. My book *Peterson Field Guide to Finding Mammals in North America* has details on observing every species in the wild.

○ **Sea sparkles** are best seen from July through early September; good places include Channel Islands National Park, CA, Florida Bay, FL, and Padre Island National Seashore, TX. To see blue-glowing **scorpions**, bring a source of ultraviolet light to any desert of the Southwest on a summer night.

METRIC CONVERSIONS

Inches	Centimeters
¼	0.6
⅓	0.8
½	1.3
¾	1.9
1	2.5
2	5.1
3	7.6
4	10
5	13
6	15
7	18
8	20
9	23
10	25

Feet	Meters
1	0.3
2	0.6
3	0.9
4	1.2
5	1.5
6	1.8
7	2.1
8	2.4
9	2.7
10	3

Miles	Kilometers
¼	0.4
½	0.8
1	1.6
2	3.2
3	4.8
4	6.4
5	8.0
6	9.7
7	11
8	13
9	14
10	16
20	32
30	48
40	64
50	80
60	97
70	110
80	130
90	140
100	160
200	320
300	480
400	640
500	800
600	960
700	1,100
800	1,300
900	1,400
1,000	1,600
1,500	2,400
2,000	3,200
2,500	4,000

Acres	Hectacres
⅓	0.12
1	0.40
5	2
10	4

Ounces	Grams
1	28.3
5	141.7

Pounds	Kilograms
100	45
200	91
300	140
400	180
500	230
600	270
700	320
800	360
900	400
1,000	460
2,000	910
3,000	1,400

FURTHER READING

The *Wildlife Viewing Guides* series (Helena, MT: Falcon Publishing, and other publishers) offers books for most American states and a few Canadian provinces, although some are much better than others. They have detailed information on viewing many events in the life of local wildlife. Unfortunately, there is no complete list, and some, like *Yukon's Wildlife Viewing Guide* (Whitehorse: Yukon Renewable Resources, 2000), can be a bit difficult to get.

Peterson Field Guides (New York: Houghton Mifflin Harcourt; petersononline.com) are generally the best for identifying North American fishes, reptiles, amphibians, and mammals, plus some groups of invertebrates, and for animal tracks. Their bird guides are also good, and they have CD-based guides to bird songs. Hard-core birders often use National Geographic's *Birds of North America* (Washington DC: National Geographic) or books by Sibley (New York: Knopf; sibleyguides.com). *The Frogs and Toads of North America* by Elliott, Gerhardt, and Davidson (New York: Houghton Mifflin Harcourt, 2009) includes a CD with calls of all our species.

In addition to identification guides, there are guides to finding birds and mammals. For most American states and Canadian provinces there are books with titles like "Finding Birds in [state name]" or "A Bird-Finding Guide to [province name]". Also check out *A Bird-Finding Guide to Canada* by Finlay (Toronto: McClelland & Stewart, 2000). For mammals, the only such book is *Peterson Field Guide to Finding Mammals in North America* (New York: Houghton Mifflin Harcourt, 2015); it has information on the best mammal-watching sites, recommendations for finding each species, and detailed information about viewing spectacles such as elk rut and whale migration.

Sibley also wrote an excellent book, *The Sibley Guide to Bird Life and Behavior* (New York: Knopf, 2009). For mammals there is *Peterson Reference Guide to the Behavior of North American Mammals* by Elbroch and Rinehart (New York: Houghton Mifflin Harcourt, 2011).

There are many books about animal migrations. Note that there is much ongoing research in this area and such books tend to become obsolete very fast. I recommend *The Homing Instinct: Meaning and Mystery in Animal Migration* by Heinrich (New York: Mariner Books, 2015). A very well written and informative book on bird migration is *Songbird Journeys: Four Seasons in the Lives of Migratory Birds* by Chu (London: Walker Books, 2009). For other migratory animals, try *Gulf Stream Chronicles: A Naturalist Explores Life in an Ocean River* by Lee (Chapel Hill, NC: University of North Carolina Press, 2015), *Eye of the Whale: Epic Passage from Baja to Siberia* by Russell (Washington DC: Island Press, 2004), *The Secret Lives of Bats: My Adventures with the World's Most Misunderstood Mammals* by Tuttle (New York: Houghton Mifflin Harcourt, 2015), *Nomads of the Wind: The Journey of the Monarch Butterfly and other Wonders of the Butterfly World* by Arndt, Lieckfeld, and Humer (London: Papadakis, 2009), *Migration Ecology of Marine Fishes* by Secor (Baltimore: Johns Hopkins University Press, 2015), and *Migration of Freshwater Fishes* by Lucas and Baras (Hoboken, NJ: Wiley-Blackwell, 2001).

Books on leks, dances, and other mating spectacles include *Leks* by Höglund and Alatalo (Princeton: Princeton University Press, 1995), *Birds in Love: The Secret Courting and Mating Rituals of Extraordinary Birds* by Leveille (Minneapolis: Voyageur Press, 2007), my book *Dragon Songs: Love and Adventure among Crocodiles, Alligators, and Other Dinosaur Relations* (New York: Arcade Publishing, 2013), *Rut: Spectacular Fall Ritual of North American Horned and Antlered Animals* by Spomer (Minocqua, WI: Willow Creek Press, 1996), *Periodical Cicadas: The Plague and the Puzzle* by Kritsky (Indianapolis: Indiana Academy of Science, 2004), and *Horseshoe Crab: Biography of a Survivor* by Fredericks (Washington DC: Ruka Press, 2012).

For everyday spectacles try an old classic, *A Sand County Almanac* by Leopold (New York: Ballantine, 1986), *Nature's Everyday Mysteries: A Field Guide to the World in your Backyard (The Curious Naturalist)* by Montgomery (New York: Mariner Books, 1993), and *The Forest Unseen: A Year's Watch in Nature* by Haskell (New York: Penguin Books, 2013).

ACKNOWLEDGMENTS

I thank my friend Miyoko Chu for help with developing the concept of this book, my wife Anastasiia Tsvietkova for help with photography, my many naturalist friends for contributing useful information, and my agent Regina Ryan for making the book possible.

PHOTOGRAPHY AND ILLUSTRATION CREDITS

Photography

All photographs by the author, with the following exceptions.

Ted Lawrence, page 100

Anastasiia Tsvietkova, pages 6, 11, 43, 59, 63, 71, 85, 111, 112, 131, 168, 176, 202, 222, 255, 259, 263, 266, 274, 275, 282, 296

Wikimedia

Used under a Creative Commons Attribution-Share Alike 2.0 Generic license

 Kat+Sam, page 106

 U.S. Fish and Wildlife Service Headquarters, page 218

 Bureau of Land Management, page 220

Used under a Creative Commons Attribution-Share Alike 3.0 Unported license

 Larisa Bishop-Boros, page 116

Public Domain on Wikimedia Commons

 Christin Khan, NOAA/NEFSC, page 250

 Everglades NPS from Homestead, Florida, USA, page 175

Illustrations

Maps by FreeVectorMaps.com (http://freevectormaps.com), pages 16, 44, 47, 82, 120

Maps on pages 16, 44, 47, 82, and 120 by Anna Eshelman from material from FreeVectorMaps.com.

INDEX

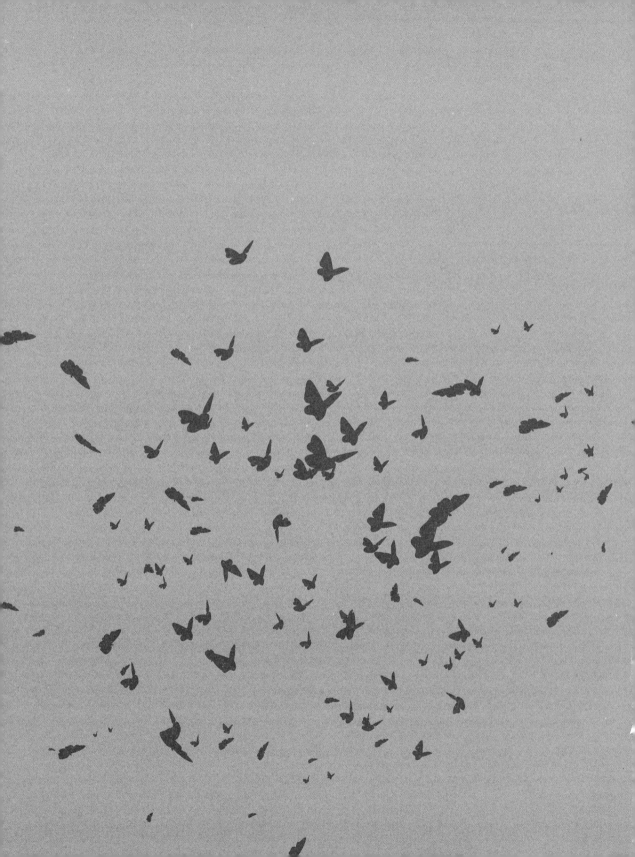